# *P*ictures
## of *R*omance

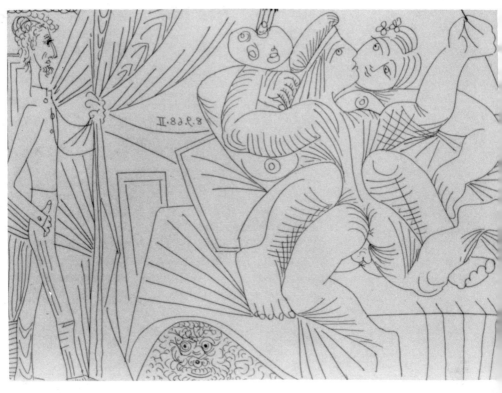

Pablo Picasso, *Eau-forte 8 septembre 1968 II*. Copyright © ARS, New York/S.P.A.D.E.M. 1987.

# Pictures of Romance

## Form against Context in Painting and Literature

Wendy Steiner

THE UNIVERSITY OF CHICAGO PRESS

*Chicago and London*

The University of Chicago Press, Chicago 60637
The University of Chicago Press, Ltd., London

© 1988 by The University of Chicago
All rights reserved. Published 1988
Paperback edition 1991
Printed in the United States of America

97 96 95 94 93 92 91   5 4 3 2

Library of Congress Cataloging-in-Publication Data

Steiner, Wendy, 1949–
  Pictures of romance.

  Bibliography: p.
  Includes index.
  1. Art and literature.   2. Love stories—History and
criticism.   3. Ut pictura poesis (Aesthetics).   I. Title.
PN53.S75   1988        801'.95        87-19023
ISBN 0-226-77229-2 (cloth)
ISBN 0-226-77230-6 (paperback)

*To Gabriele and Henry Hoenigswald*

# Contents

# Illustrations

# Acknowledgments

The research for this book was begun with a summer stipend from the University of Pennsylvania Research Fund and continued with a fellowship from the John Simon Guggenheim Memorial Foundation. Successive grants from the University of Pennsylvania have helped defray the costs of illustrations and manuscript production. For all this assistance I am very grateful.

Portions of chapter 5 appeared in my article, "'There Was Meaning in His Look': The Meeting of Pictorial Models in Joyce's 'Nausicaa,'" *University of Hartford Studies in Literature* 16 (1984): 90–102. Portions of chapter 6 are adapted from two articles: "Divide and Narrate," *Word and Image* 2, no. 4 (December 1986); and "Narrativity in the Work of Roy Lichtenstein," in *Space, Time, Image, Sign*, edited by James Heffernan (New York: Peter Lang Publishing, 1987). I thank the publishers for permission to reproduce this material.

I have received much stimulation and guidance from colleagues and frineds: Vicki Mahaffey, Gerald Prince, Maureen Quilligan, Elaine Scarry, Barbara Herrnstein Smith, and Alan Trachtenberg. The participants in my National Endowment for the Humanities Summer Seminar for College Teachers were a particular inspiration, eager to listen and to teach me: Jeffrey Adams, Donald Benson, Ruth Bohan, Maryann De Julio, Terry Dolan, Wendy Faris, Donald Hedrick, Edward Lowry, Glen Mazis, Ilene Reiner, Chris Soufas, and Susan Strauber. Ann Hostetler's help with the manuscript was invaluable, as was Alison Byerly's assistance with permissions. Finally, I would like to thank my parents and Peter, Emil, and Emma for their love and good humor.

# Introduction

This book interweaves two stories, one about painting (chapters 1 and 6) and the other about the literary romance (chapters 2 through 5). The first presents the Renaissance exile of the multi-episodic canvas and its reappearance in modern art. This exile was the result of a formalist constraint upon art, a constraint determined by the technical givens of the pictorial medium. For from the formalist viewpoint, an atemporal medium should properly represent an atemporal subject matter. When that constraint was lifted in modernism, the issues of narrativity and audience returned, and painting alluded directly to the literary romance, a mode in which these issues are a perennial concern. The romance investigation of visual art, voyeurism, vision, and love is thus the other story told here. It is a fable in which "formal" constraints are released through the immersion of a figure (or text) in its historical or social context. The romance dialogue with painting and painting's checkered narrative past are, I believe, part of a larger ambivalence in Western culture between formalist and contextualist thinking.

Chapter 1 begins with the problem of narrativity in the visual arts. The pictorial medium is temporally static, and thus painting has long stood as a symbol of the transcendent object—beautiful, outside of time's depredations, complete in itself. Yet this symbolism did not always affect the objects represented in painting. In medieval art, for example, single panels often contained temporally discrete sections, with protagonists repeated in several scenes in the same work. The logic of Renaissance perspective largely put a stop to such narrativity in high

art, for the image was to be a perceiver's vision of the world at a single moment in time. With the success of this system, painters were forced to find other means—symbolism, dramatic poses, allusions to literature, titles—to convey their narrative intent. The Renaissance proscription against temporal disunity and narrative unfolding was so powerful, in fact, that the general art-historical use of the term "narrative" seems incomprehensible to literary scholars, for whom such limitations would be the undoing of conventional storytelling.

The opening chapter thus sets out to discover what a strong pictorial narrative would be, that is, what factors in a picture would prompt us to take it as a narrative even without the guidance of its title. Of the many conditions contributing to narrativity, the most important are: that the painting present more than one temporal moment; that a subject be repeated from one moment to another; and that the subject be embedded in at least a minimally realistic setting. This is not to say that all the historical, biblical, and mythological works in post-Renaissance art are utterly nonnarrative, but only that their ability to represent plot and story sequence is weak. They function more fully as revelations of character, the drama of the moment, the monumentality of the past, and so forth.

The three narrative factors—common in painting before the Renaissance and extremely rare thereafter—are importantly related to realism. They involve, respectively, the temporal unfolding of events, the continuity of identity over time, and spatio-temporal assumptions about reality that we normally take for granted. Yet the Renaissance suppressed from painting all but the last of these, in the name of increased fidelity to the look of reality. One might see this suppression, in fact, as an early step toward pictorial abstraction. For if narrative is a realist repetition of identity across time, repetition not modified by time becomes design. In M. C. Escher's *Encounter* (figure 5), for example, a pair of two-dimensional figures from a periodic design "walk" off the wall and onto a three-dimensional platform that bears their weight and their shadows and leads them to a narrative conclusion. They are transformed from repeatable components of a design into single actors in various phases of motion by the inclusion of realist devices and a temporal beginning, middle, and end. At the close of chapter 1, I try to show how powerful a pictorial narrative can result when the three factors are in close concert, as in Benozzo Gozzoli's *Dance of Salome* (figure 6).

The Renaissance proscription against narrative intensifies a number of important oppositions, discussed in chapter 2. We have seen the contrast it establishes between design and narrative. It has a similar polarizing effect on the representation of identity. By prohibiting repeated sub-

jects, painting could depict identity as either a single frozen moment or an eternal essence, but not as a continuity constantly modified by time. Thus, the Renaissance system reinforced the distinction between the isolated or transcendent self and the self modified by circumstance. Further, the scientific and mathematical aspects of perspective widened the split between "objective" perception and vision fueled by desire. The organization of a scene theoretically followed the laws of optics, although the equally conventional "engendering" of the gaze—the painter male, the model female—suggests quite a different kind of structuring. Design versus narrative, essential versus unfolding identity, objectivity versus desire—these contrasts became pronounced as a result of the Renaissance system.

The literary romance has also been concerned with these issues, and hence has made ample use of visual art symbolism. It perennially depicts love through stopped-action scenes: the suspension of the heroine either in prison or in more literal states of immobility as in *Snow White;* the topos of love at first sight as a moment apart from time in which the two viewers are united by pure vision; or the moment of emotional or sexual transport treated as time outside time. Northrop Frye in *The Secular Scripture* points to snow maidens thawed, statues brought to life, and pictures kissed into three-dimensional being. These are romance commonplaces, as are lovers who ascend to the eternal poise of visual art. But in nineteenth- and twentieth-century romances, the opposition of stasis and flow becomes associated as well with the enthrallment versus the empowerment of the viewer. The romance extends the oppositions of transcendence and contingency, atemporality and historical unfolding, perception and desire to the realm of aesthetic response. There another opposition emerges: formalist versus contextualist reading.

Keats's *Eve of St. Agnes,* for example, is full of references to sculpture, tapestry, stained-glass windows, and paintings, and its plot turns on moments of intense watching. The hero watches his lady as she disrobes and lies entranced on her bed, waiting, in turn, for a mental image of her lover to appear to her. These enthralled observers are systematically compared to works of art and to viewers of artworks, and the remarkable suspense of the poem arises from their difficulty in waking up, in switching from passive voyeurs to active lovers. Leo Steinberg's essay "Picasso's Sleepwatchers" in *Other Criteria* describes just such still watchers in painting. In the long history of this topos, the sleepwatcher may serve as a coded metaphor of the pictorial perceiver. Keats turns this topos into a literary theme not only in *The Eve of St. Agnes* but throughout the great odes and *Hyperion.* It is a generic topos in the

romance of this period, a topos that entails a critique of formalist aesthetics and an accent instead on aesthetic reception, the process whereby the viewer actively interprets the work of art.

Hawthorne's fiction, particularly *The Marble Faun*, contains one of the clearest explorations of this idea. The novel's four protagonists are simultaneously artists and the subjects of each other's art, and as such they constantly interrogate the act of looking. Is the proper response to art a mere faithful copying, a thralldom to it, or must one inevitably distort art in order to interact with it? Is looking therefore a violence done to the object seen? How does ideology relate to vision? Is Protestant looking different from Catholic? *The Marble Faun*, which strikes most readers as a rather peculiar novel, brilliantly explores the complicated theoretical issues on which the painting-romance association turns.

In particular, *The Marble Faun* uses painting as a symbol of its own antirealism. Romances violate the causal, temporal, and logical cohesiveness of realist novels with their coincidences, their "impossible" characters or events, and their breaks in narrative continuity. Because post-Renaissance art also represents a suspended moment of perception with an "unnatural" clarity and compression of meaning, it readily serves as a symbol of the romance violation of realist norms. Thus, in *The Marble Faun*, when the narrator deliberately leaves holes in his account of the heroine's doings, he asks us to imagine that she has been stolen away to a "land of picture," a sphere where the continuity of life and story is suspended. Painting serves the romance as a model for its breaks in verisimilitude and, at the same time, as an analogue for its imaginative power.

We should note that in the shift from medieval to Renaissance painting, narrativity was eliminated from visual art in order to create pictorial adequacy to visual perception. The atemporality of stopped-action painting was actually an attempt to achieve pictorial realism—the way things "really" look. It is paradoxical, then, that when literary narratives want to indicate their departure from realism they evoke the symbol of the static visual artwork. The paradox is a very interesting way in which the arts relativize each other's notions of realism.

With modernism, the relation between temporality and visual art changes, and the painting-romance connection registers the change through irony. The "Nausicaa" chapter of James Joyce's *Ulysses*, a parody of the romance, employs the same themes as *The Eve of St. Agnes* and *The Marble Faun*, but presents them in relation to two sets of conflicting pictorial norms. According to his scheme, Joyce devoted his romance chapter to the art of painting, and William York Tindall writes that its

"presiding Muse is the 'bawd of parodies'."[1] Joyce presents an encounter on the beach between Leopold Bloom and Gerty MacDowell, in which they masturbate while staring at each other. Gerty is an inveterate reader of ladies' magazines who sees Bloom as the dark hero of popular romance whom she has dazzled by the feminine technology of ribbon, stocking, and drawers. Bloom undercuts this view with his earthiness and his lack of sentimentality. In the background we hear a Catholic mass celebrating the Virgin, the "lady" of a different kind of love. By playing on notions of time and love, Joyce humorously subverts the romance treatment of painting, and contrasts the Renaissance model of stopped-action art to the modernist incorporation of time in painting. His parody, however, confirms the association between painting, voyeurism, and love that the romance dwells on so consistently. This same thematic complex appears in Picasso's work, particularly *The Vollard Suite,* which provides a veritable anatomy of the possible connections among looking, loving, and painting.

The chapters on the literary romance constitute the center of this study. Though they follow a temporal sequence they do not pretend to be a history of painting-romance connections in the nineteenth and twentieth centuries (a history, I might add, that would be extraordinarily rich). Instead, the three writers and the painter serve a representative function. Keats is a British romancer whom critics have frequently connected with the visual arts, but not thereby to the problem of reception. Indeed, he has been seen as disinterested in issues of audience.[2] Yet Keats works through the various oppositions toward what amounts to a theory of readerly interpretation. Hawthorne's oeuvre shows that much the same thematics appears in the American romance. With Joyce's and Picasso's works, the painting-romance connection is continued into modernism, where the contrasting pictorial norms resulted in irony. No doubt, many other works could have been included— Gothic romances, Pre-Raphaelite poetry and painting, decadent writing, and the postmodernist works mentioned in the conclusion—each yielding different "pictures of romance."

With chapter 6, we return from the romance to painting. Whereas Joyce and Picasso show the adjustment of the romance-painting connection to modernism from a thematic point of view, the task of chapter 6 is to examine this shift in terms of changes in the narrativity of painting. Here I ask what happened to the system of binary oppositions (design/narrative, formalism/contextualism, etc.) once modernism lifted the Renaissance ban on multiple episodes and repeated subjects and destabilized the conventions of pictorial realism. One of the most immediate results was the creation of a new relation between design and nar-

rative (respectively, the abstractive and representational tendencies of repetition). Seurat, Van Gogh, and Cézanne built their compositions out of repeatable minimal units. These standardized building blocks were combined to form representational paintings; in fact, the tension between nonrepresentational dots, brush strokes, or color patches and the brilliant representationality of their combination was an essential feature of early modernism. But Seurat went on in *Les Poseuses* to repeat not only dots but his subject, who appears in three different poses on the same canvas. Through this repetition Seurat reintroduces medieval narrative procedures into modern art, albeit in a highly equivocal fashion.

The problem of identity was also reconsidered in the twentieth century through the painting-romance connection. In the postmodernist context the unique subject is a tenuous fiction. Reality, art, and people become interchangeable tokens of each other, all flat and equally worthless in a world where mechanical repetition has replaced narrative becoming. To dramatize this situation, pop artists frequently frustrate narrativity by repeating identical instances of a crucial scene (as in Andy Warhol's *Five Deaths Eleven Times in Orange*) or by isolating parts of narrative sequences (as in Lichtenstein's paintings of single comicbook frames). Pop art's general strategy of copying readymade images from advertising, popular culture, and high art accentuates the opposition between endless mechanical repetition and the narrative progress of a subject through the differential contexts of a story. By constantly evoking narratives and undercutting their narrativity, Lichtenstein reveals another important function of narrative in regard to images. As in commercials, where a product is embedded in a story, image-products require narratives in order to have value. The comicbook romances and war adventures that pop artists raid are the low-art equivalents of the quest romance, which investigates and problematizes the nature of value.

Thus, when painting returned to representationality in the sixties with pop art, it returned as well to the romance. Just as nineteenth-century writers contrast a formalist enthrallment with the object to interpretive openness, so pop art uses the picture-story opposition in its critique of strict abstractionism. At the one extreme, the painting isolated, self-enclosed; at the other, the work entoiled in the infinite weavings of all texts and readers. Romance tells of the escape from formalism into the (perhaps delusory) breadth of story, history, and context. Since aesthetic theory is now experiencing just such a passage, the painting-romance connection may hold more than an anecdotal interest.

*Nature knits up her kinds in a network, not in a chain; but*
*men can follow only by chains because their language can't*
*handle several things at once.*

Albrecht von Haller

# 1
# Pictorial Narrativity

Ariadne's thread unwinding through the labyrinth, Hansel and Gretel's
pebbles marking out the trackless woods—these and other mythic im-
ages echo von Haller's contrast between nature and human understand-
ing.[1] Knowledge is a path cut through a maze, a line attempting ade-
quacy to a plane, a mere chain seeking dominion over a network. As
such, knowledge is necessarily incomplete; yet the drawing of lines, the
chaining of links, is the only way to reach the point at the center and to
find one's way home again.

Von Haller blames this fact on language, chainlike in the very struc-
ture of its syntagms, and thereby he suggests another object of his anal-
ogy, narrative. For narrative, made of language, also lives by concatena-
tion—both in its medium and in its temporal subject matter. Event
follows event; scene follows scene. The connection between knowledge
and narrative is apparent even in its etymology: Latin *narrare,* to tell,
*gnarus,* knowing, acquainted with, and ultimately Indo-European *gna,*
to know.[2] Narrative, as knowledge, is victimized by its diachrony, yet
seemingly requires diachrony in order to be knowledge in the first place.

But if narrative in this metaphor is the chain of knowledge, painting
is traditionally the natural network—not sequence but pure configura-
tion. It is iconically adequate to the labyrinth of nature, but incapable of
cutting through it—of functioning propositionally, Sol Worth would
say,[3] of serving as a form of knowledge. The inability of painting to in-
clude temporally or logically distinct moments is of course the basis of

7

Lessing's distinction between the spatial and the temporal arts.[4] It is a distinction that explains the iconic limitations of each art: "the catalogue of Western arts is . . . a list of renunciations: with sculpture, of texture and colour; with painting, of volume; with both, of time."[5] One might add: with literature, of visuality and referential density. As Leonardo da Vinci put it, "If you call painting mute poetry, poetry can also be called blind painting."[6]

But much as mythic imagery and neoclassical thought would support this split and its acquiescence to the impoverishment of each art, the necessity that lies behind the division is not as absolute as one might think. It is refuted most clearly by modern linguistics. The view of narrative (and language) as a mere sequence is not tenable in light of recent theory. It is the mistake of the proponents of "spatial form," who identify the novel and narrativity with pure temporal sequence and then are surprised to find other forms of cohesion in the twentieth-century novel (and elsewhere).[7] Virtually every narratologist finds narrative dependent on both its sequential and its configurational qualities.

But no similar body of theorizing is available to the visual arts. In fact, the narrativity of pictures is virtually a nontopic for art historians.[8] Not only is the concept poorly understood, but the pictures that are supposedly governed by it are now out of fashion. The last association that one would have with modern art is the adjective "narrative," and in the formalist criticism of recent years the term has had a distinctly negative value.[9] Yet the narrative potential of the visual arts is an enormously revealing topic. As we shall discover, it can explain some of the most essential facts about Western painting and the imaginative place of art in the literary romance.

The typical art-historical usage of the term "narrative painting" is very loose by literary standards. Sacheverell Sitwell characterizes it as "the painting of anecdote," but applies it to what would more often be called genre painting—typical scenes (fig. 1), homely incidents, instantiations of a theme (fig. 2), perennial activities, and pictorial sequences like Hogarth's *Rake's Progress*.[10] Nancy Wall Moure uses the term not only for genre scenes but for historical and mythological subjects as well (fig. 3), and she contrasts it systematically to portraits and allegories.[11] And a symposium of specialists on ancient art agreed to define pictorial narrative as "the rendering of specific events, whether mythological, legendary, historical, or fictional, involving recognizable personages."[12] It is disconcerting to note that the same term applies contradictorily to both typical scenes and specific events. But the contrastive value of the term to the allegory is interesting. It alerts us to a

perennial though largely unexplored association between narrativity and realism.

In this chapter I would like to use developments in the study of literary narrative to consider the preconditions for pictorial narrative and, once having done so, to examine the "knowledge potential" of a particular narrative painting. I realize that this is a somewhat dangerous procedure, since a theory of narrative developed for verbal art may have only a procrustean bearing on visual narrative. I hope that such will not be the case. Narratologists intend many of their notions to apply regardless of medium. Moreover, they propound a syndrome of narrative characteristics, all of which need not be in evidence for us to take a text as a narrative. One would thus be able to speak of "stronger" or "weaker" narratives according to the number and selection of these characteristics in a work. I hope to show that many of the traits producing strong literary narratives are the same as those producing strong pictorial ones, but that historical developments have made strongly narrative paintings extremely rare. It is not the medium of painting but its conventions that have reduced narrativity to an apparently peripheral concern for art historians.

From a narratological point of view, pictures of typical scenes and perennial activities, such as Sitwell terms "narrative paintings," would be considered particularly low in narrativity. As Gerald Prince points out:

narrative prefers tensed statements (or their equivalent) to untensed ones: something like

Every human being dies

is fine (and may well appear in a narrative) but something like

Napoleon died in 1821

is better or, at least more characteristic of narrative.

Prince goes on:

If narrativity is a function of the . . . specificity of the (sequences of) events presented, it is also a function of the extent to which their occurrence is given as a fact (in a certain world) rather than a possibility or a probability. The hallmark of narrativity is assurance. It lives in certainty. This happened then that; this happened because of that; this happened and it was related to that.[13]

It would seem clear that the genre scenes in question—typical scenes and perennial activities—lack such specificity and actuality or certainty. They are deliberately not shown as singular events—the scenes, in fact, are often not events at all, but what might be termed "humanized landscapes." Indeed, Martin Meisel notes a prejudice among audiences

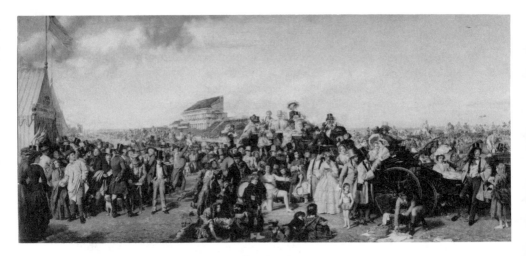

*Fig. 1.* W. P. Frith, *Derby Day*. Tate Gallery, London.

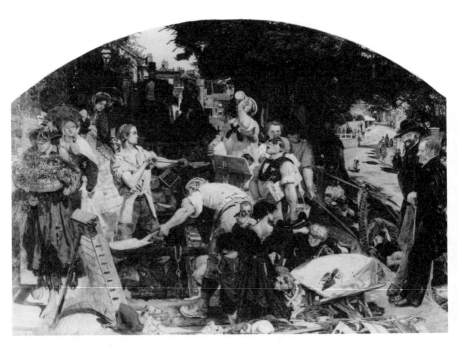

*Fig. 2.* Ford Madox Brown, *Work*. Manchester City Art Gallery.

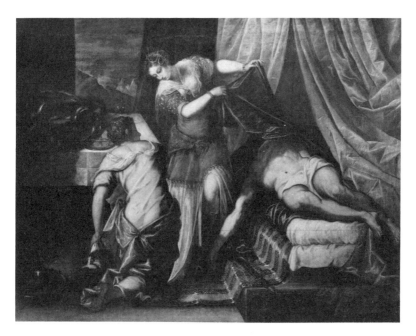

*Fig. 3.* Tintoretto, *Judith and Holofernes*. Prado, Madrid.

against such specificity: "The modern view assumes, paradoxically, that realism is better served by scenes and figures whose individuality does not reach beyond generic activity, by mowers in a hayfield rather than Ruth standing amid the alien corn" (Meisel, p. 352).

The low narrativity of the genre scene also follows from its lack of what William Labov calls an "evaluation," "the means used by the narrator to indicate the point of the narrative, its raison d'être."[14] Though Labov considers the evaluation a nonessential characteristic of narrative—temporal sequence being the necessary trait—he does say that a narrative without an evaluative component leaves itself open to the withering rejoinder, "So what?" "Evaluative devices say to us: this was terrifying, dangerous, weird, wild, crazy; or amusing, hilarious, wonderful; more generally, that it was strange, uncommon, or unusual—that is, worth reporting. It was not ordinary, plain, humdrum, everyday, or run-of-the-mill" (Labov, p. 371).[15] Genre paintings explicitly present themselves as ordinary, plain, humdrum, everyday, and run-of-the-mill, and though the insistence that we attend to the unremarkable might itself be seen as a paradoxical or witty statement—perhaps the only piece of wit proper to naturalism—nevertheless one would hardly respond to such works as narratively compelling. Indeed, they appear to be exactly

the opposite of what we normally take narrative to be. Periods such as eighteenth-century neoclassicism, which elevated history painting over other genres, insisted on the representation of "significant action and strong passions," and downgraded "subject matter wholly devoid of these, such as bowls of fruit, views of countryside without human figures, portraits of unknown men and women, [and] genre scenes in which humble persons engage in trivial activities."[16] (Neoclassicism, however, did not go so far as to allow more than one episode to be represented in history paintings.)

Art historians are perhaps closer to literary usage in including the so-called "conversation piece"[17] among narrative paintings, since these are specific. They are a fusion of genre and portrait, showing particular people engaged in characteristic acts such as walking before their ancestral homes or playing with their children. Yet even here the activity is generic and the narrativity low. We can now understand the insistence of the ancient-art symposium that an artwork render "specific events . . . involving recognizable personages" if it is to be termed "narrative," and also the common use of "narrative art" as a contrast to portrait and allegory.

So far then, we might agree that narrativity is strongest in paintings depicting specific (though not necessarily existent) personages engaged in some singular (in both senses) act. "A story is a specific event carried out by particular characters in a particular place at a particular time," stresses one student of Egyptian art.[18] The addition of a specific place and time introduces another of Labov's narrative components, the "orientation." Speaking of verbal narratives, he describes the orientation as that section of the narrative, often at the beginning but also placed strategically throughout, in which the text identifies "the time, place, persons, and their activity or the situation" (Labov, p. 364). Now we would expect this kind of information to be the realm in which pictorial narrative would excel, since place, circumstance, and atmosphere are those factors for which a picture is indeed worth a thousand words. Even the less "natural" information for painting of specific names, dates, and so forth can be conveyed through iconographic symbolism, and where this is still inadequate, the painting has a title. *Judith and Holofernes, Washington Crossing the Delaware, Cupid and Psyche, The Dance of Salome*—titles provide crucial information for the orientation, as well as functioning as what Labov terms the "abstract," a summary of the story.[19] The title is actually a good analogue to Labov's abstract, since the latter is a combination of narrative functions. As Labov describes it, "the reference of the abstract is broader than the orientation and complicating action: it includes these and the evaluation so that the abstract

not only states what the narrative is about, but why it is told" (Labov, p. 370). Thus, paintings do contain some of Labov's narrative structures, even if they seem far from the literary category of narrative.

The distance between paintings and literary narratives is conventionally explained by the fact that temporal sequence, what Labov calls the complicating action, is the single most essential narrative trait. Without it, there is no verbal narrativity. The insistence on temporality is part of every definition of narrativity, regardless of its philosophical orientation. Thus, where Gerald Prince claims in his formalist, linguistic definition that narrative is "any representation of non-contradictory events such that at least one occurs at time $t$ and the other at time $t_1$ following time $t$" (Prince 1981, p. 61), Paul Ricoeur's revisionist phenomenological definition states: "I take temporality to be that structure of existence that reaches language in narrativity and narrativity to be the language structure that has temporality as its ultimate referent."[20]

But temporal reference in and of itself is not enough to qualify a discourse as narrative. The temporal events narrated must be multiple. Again, as Prince argues,

although many things . . . take time, at least some of their representations do not necessarily constitute a narrative. A fight can take a few minutes and a trip can take a few days yet neither "There was a fight yesterday" nor "It was a beautiful trip" constitute narratives: they do not represent the fight or the trip as a series of events but as one event; they do not recount a sequence of events. . . . narrative is a representation of *at least two* real or fictive events in a time sequence.[21]

This representation of an event in terms of its temporal unfolding is what Prince calls "discreteness" (Prince 1981, p. 64), the division of the event into distinct, ordered parts. The chain, to be a chain, must have discrete links.

It is here, of course, that the visual arts seem least narrative, indeed, definitionally antinarrative. Virtually all post-Renaissance works—however specific or particular their action, characters, place, or time—represent an event through an isolated moment. Tintoretto's *Judith and Holofernes* (fig. 3), for example, shows a frozen moment of action, as do almost all historical, mythological, biblical, and genre scenes—that is, all the categories but the "series" that are covered under the art historians' definitions. This mode of representing temporal events as action stopped at its climactic moment, or at a moment that implies but does not show what preceded and what follows it, Lessing called the "pregnant moment." It gave rise to the literary topos of *ekphrasis* in which a poem aspires to the atemporal "eternity" of the stopped-action paint-

ing, or laments its inability to achieve it.[22] Like the statement, "There was a fight yesterday," ekphrastic painting and poetry refer to temporal events without being strongly narrative. Thus, one might speak of David's *Oath of the Horatii* as a powerfully historical painting without feeling that it was a particularly narrative one, although its narrativity is certainly stronger than a typical still life, portrait, or genre scene.

The discreteness of temporal events is still not enough to create the equivalent of literary narrativity. Events must also be susceptible to a double ordering. The narrative posits an ordering of events[23] independent of its telling them. Any change in the order of story events would thus create a different narrative,[24] although the order in which those events are told is not fixed.[25] The two orderings at issue here are the chronological order of the events referred to and the order in which they are narrated. This is the famous Russian formalist distinction between *fabula* and *sjužet*,[26] which is the basis of virtually every subsequent account of literary narrative. Seymour Chatman names his book on narrative *Story and Discourse*—English equivalents of the French equivalents of Šklovskij's Russian terms—and states that this double ordering is definitional for narrative in any medium:

> A salient property of narrative is double time structuring. That is, all narratives, in whatever medium, combine the time sequence of plot events, the time of the *histoire* ("story-time") with the time of the presentation of those events in the text, which we call "discourse-time." What is fundamental to narrative, regardless of medium, is that these two time orders are independent. In realistic narratives, the time of the story is fixed, following the ordinary course of a life. . . . But the discourse-time order may be completely different.[27]

Since story-time in all but the most deviant modern narratives is tied to the chronological flow of real life, narrative can again be seen as dependent on our ideas of the extra-artistic world, which are institutionalized in art as realism.

It is just this dual temporal structuring (the order of telling versus the chronological order in the told) that has led Chatman and others to consider pictorial narrative as inevitably a contradiction in terms. "We may spend half an hour in front of a Titian, but the aesthetic effect is as if we were taking in the whole painting at a glance. In narratives, on the other hand, the dual time orders function independently" (Chatman, "Novels," p. 122). Certainly this contention would tend to reinforce Lessing's absolute split of the spatial from the temporal arts. What is seemingly missing in pictorial narrative is some way of ordering the visual medium. Even if it is clear that temporally distinct moments are being represented, if no order is indicated among them they will not

function narratively. The characteristic response to such works is always that they are symbolic or allegorical. For example, Nelson Goodman describes Hans Memling's *Panorama of the Passion* as a narrative painting "without beginning or end or marked route [from one depicted scene to the next]. This pictorial organization of events of a lifetime is spatial, atemporal, motivated perhaps both by considerations of design and by regarding these events as eternal and emblematic rather than as episodic or transient" (Goodman, p. 110). Such works, then, fail in realism because they fail to pose a pictorial order against the order of events in Christ's life. They are the proverbial labyrinths, without a linear path marked through them.

Visual artists have contrived several conventions to create this double ordering. In Egyptian art, the surface was often divided into separate registers, with base lines linking figures in each event or linking one event to the next; the base line established a unified plane of action distinct from the others. Figures can also be oriented so as to be looking toward the next event in a series, their eyes in effect directing the movement of ours. Another strategy is to arrange events as stages along a path (fig. 4): this procedure invokes the metaphor of the "path of life," the same metaphor contained in Stendhal's definition of the novel as "a mirror carried along a road." In many paintings, scenes are presented as the various rooms of a building, with their order conforming to either the writing system of the culture involved—left to right and up to down in the West—or some special ordering implicit in the architectural features of the building.

Sometimes technical features of the pictorial medium support the double ordering of narrative. Architectural friezes and frescoes are often too large to be "read" all at once, so that any of the forms of division mentioned above can separate the various scenes of an unfolding narrative progression. The friezes on the Parthenon and the Arch of Titus[28] are paradigmatic cases, as are the Stations of the Cross fixed along the walls of cathedrals. The additive structure of diptychs and triptychs is also conducive to narrative sequence, the order in the latter often not a simple left-to-right progression, but a left-to-right-to-middle sequence with the center hierarchically weighted to bear the climactic ending.

The medium most obviously suited to pictorial narrative, however, is the book. Its division into pages provides a "natural" discreteness which other pictorial media are forced to achieve metaphorically (the walls separating narrative "rooms"), or arbitrarily (the frames of triptych panels or the modern-day comicstrip). Kurt Weitzmann describes the historical progression of ancient narrative art as in fact culminating in the invention of the book:

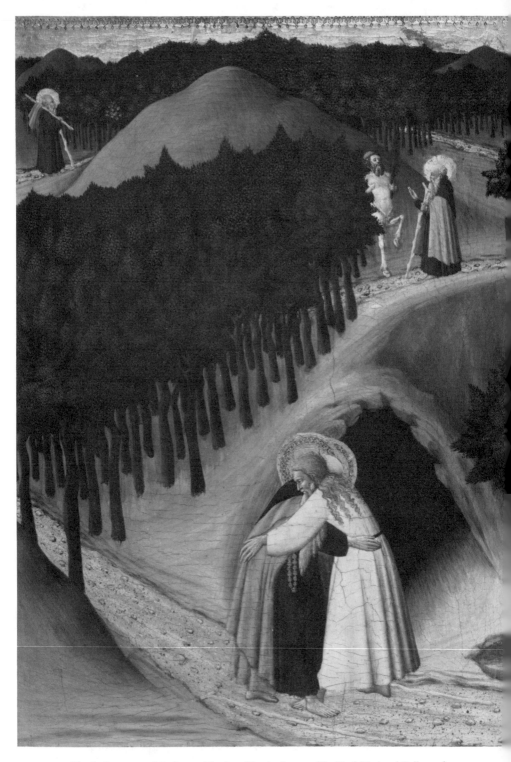

*Fig. 4.* Sassetta and Assistant, *Meeting of St. Anthony and St. Paul*. National Gallery of Art, Washington; Samuel H. Kress Collection.

Greek artists began to line up a series of narrative representations, based either on a single hero's life or some kind of a literary unit, and taking the form of a row of metopes or of a frieze. This is the beginning of the method of the *cyclic narrative* which in the classical period was used on a rather limited scale, and in the Hellenistic period developed into a *continuous narrative* whereby the individual scenes are placed in front of a unifying landscape.

At the end of this long drawn-out process of binding the representational arts and literature still closer together, a new method was invented whereby a single episode was divided into several phases, so that the beholder might follow the various changes of action with the chief protagonist being repeated again and again. The result of this development is an enormous increase in the number of scenes and the formation of far more extensive picture cycles than had ever existed before. This innovation took place in the Early Hellenistic period, and the medium in which the vast expansion of narrative representations could unfold most vigorously . . . is the book. . . . Thus the *art of storytelling in pictures* became inextricably linked with the history of book-illumination.[29]

The structure of the book thus served as the model not only for literary narrative but for pictorial narrative as well, with their need for discreteness and ordering. Picture series such as Hogarth's *Rake's Progress, Harlot's Progress,* and *Marriage a la Mode,* which are reputedly the first picture stories in their own right independent of a previously written narrative (Witemeyer, p. 120), would be unimaginable without the structural model of the book.

Having observed all these pictorial means for rendering events discrete, specific, and temporally successive, we still have not isolated what makes a painting narrative. It is easy to imagine pictures conforming to all these criteria that would not be interpreted as a narrative: a triptych, for example, in which one panel shows a child laughing, another a king fighting, and a third an animal eating. Each scene is discrete, each specific, and each an action, but they lack the most fundamental feature of all narratives—cohesion, and in particular, the continuity of a repeated subject. In visual narrative, the repetition of a subject is the primary means for us to know that we are looking at a narrative at all.

The importance of this factor reveals once more the crucial position of realism in the semantics of narrative. For in reality a person cannot be in two places at the same time, and therefore if a figure appears more than once in a painting we automatically assume that it is shown at various distinct moments. On this basis, Nelson Goodman contrasts the unordered events of Memling's *Life of Christ* with Jacopo del Sellaio's *Psyche:*

Here what is explicitly told takes time, and the telling has a definite order. Several incidents, with Psyche appearing in each, are shown strung across a landscape. The impossibility of the same person being in different places at the same time notifies us that difference in spatial position among scenes is to be interpreted as difference in temporal position among the events depicted. And, as with a written tale, although the whole story is presented at once, an order of telling is plainly established. The main sequence here conforms to linguistic convention . . . [going] from left to right. (Goodman, p. 105)

We know that we are looking at a narrative painting because we see a subject repeated, and because reality repeats only in time.

The repeated subject is equally crucial in literary narrative. As Chatman states, "a narrative may have very little or even no overt description; but a narrative without an agent performing actions is impossible."[30] He goes on to say that the presence of a person in a fiction does not qualify him or her as a character; instead, if he does not figure in the action of the narrative, his function is like that of the setting.[31] With such figures, "their noncharacterhood is a function of their nonreappearance" (Chatman, *Story and Discourse*, p. 140). To be a character is to be a recurrent subject.

Indeed, in narratives where subjects do not recur, the reader is forced to employ interpretive strategies to connect events. Thus, Gerald Prince writes:

Given
John rode off into the sunset then Mary became a millionaire,
for example, I can easily establish a strong link between the two events:
John rode off into the sunset then Mary became a millionaire because she had bet everything she owned—500,000 dollars—that he would. (Prince 1981, p. 72)

What the causal linkage creates here is Mary's involvement or implication in John's seemingly separate act. Mary thus becomes a repeated subject, and the events achieve narrative wholeness. Chatman goes so far as to claim that this kind of interpretive strategy is one of the hallmarks of narrative perception. "In E. M. Forster's example, 'The king died, and then the queen died of grief,' we assume that the queen was in fact the wife of that king. . . . this kind of inference-drawing differs radically from that required by lyric, expository, and other genres" (Chatman, *Story and Discourse*, pp. 30–31).

All genres, of course, have cohesion devices—those factors that identify old information as such, repeat it, and link it to the new. With narrative, however, the achievement of this wholeness is the active

goal of the reader. It is a process or perhaps drive that Barthes terms "proairetism":

What is a series of actions? the unfolding of a name. To *enter*? I can unfold it into "to appear" and "to penetrate." . . . Thus, to read (to perceive the *readerly* aspect of the text) is to proceed from name to name, from fold to fold; it is to fold the text according to one name and then to unfold it along the new folds of this name. This is proairetism: an artifice (or art) of reading that seeks out names, that tends toward them; an act of lexical transcendence, a labor of classification carried out on the basis of the classification of language—a *maya* activity, as the Buddhists would say, an account of appearances, but as discontinuous forms, as names.[32]

This drive for cohesion and elaboration, this interpretive compulsion for both categorization and cataloguing, corresponds to the narrative necessity of a center of action or a subject that continues in time. In painting, this narrative center resides in a literal agent, the carrier of a name.

The all-pervasiveness of the need for a repeated subject in narrative can be seen in historiography as well. Hayden White contrasts modes of history-writing on just this basis, insisting that events merely strung together in annals and chronicles fail to bespeak their meaning, to cohere in a story form, and to close, because they are not organized around a subject. "The capacity to envision a set of events as belonging to the same order of meaning requires a metaphysical principle by which to translate difference into similarity. In other words, it requires a 'subject' common to all of the *referents* of the various sentences that register events as having occurred."[33] The subject (an individual, a state) provides cohesion for all the diverse "predicates" of action, and in doing so allows for closure, either through the natural closure of death or political dissolution or through the story resolution of conflict.

White argues, however, that the conformity of history-writing to narrative is an idealization of human events, and yet that this form of history-writing is the only one that historians credit with truthfulness, scientific accuracy, and objectivity. "It is the historians themselves who have transformed narrativity from a manner of speaking into a paradigm of the form which reality itself displays to a 'realistic' consciousness. It is they who have made narrativity into a value, the presence of which in a discourse having to do with real events signals at once its objectivity, its seriousness, and its realism" (White 1980, p. 27). We might conclude that if White is right in urging that realism conventionally depends upon narrativity, the repeated subject serves as the precondition of that narrativity.

However, we have not isolated—even with the discovery of the importance of the repeated subject—sufficient conditions to create pictorial narrativity. Take the case of subjects repeated to form a design. Escher's lithograph *Encounter* (fig. 5) is instructive here. The black and white figures walk in alternating rows across a wall in an intricate periodic design. A platform with a circular hole cut in it juts out from the wall, and one white and one black figure walk out of the wall and around the hole to meet with a handshake in the middle. But at this point we should ask ourselves why we take the figures in the design to be so many distinct black or white men, when we read the figures walking around the platform as different temporal instances of one black and one white man? In other words, what in this case distinguishes a design from a narrative?

Surely the answer here is that the men on the platform, unlike those on the wall, are represented according to a whole gamut of realist conventions. They have a ground to stand on, they cast shadows, their bodies are three-dimensional rather than flat, they have gained motion and are visible on all sides. At "the end," in the handshake, they even modify their pose, the black figure raising his head and upper torso and the white one inclining his head slightly downward. As I wrote in connection with another work of this sort by Escher, "it is the norms of pictorial realism that allow us to see process in pictures; without them we see mere pattern" (W. Steiner, *Colors of Rhetoric*, p. 169).

In another respect, Escher's lithograph points out the connection between narrativity and realist norms. By participating in a periodic design of the sort that Escher enjoyed so much, the background men perform an infinite rather than a finite repetition. There is no reason why the background could not be extended indefinitely to left and right—at least ideally speaking—whereas any narrative action must have a beginning and an ending. White finds annals and chronicles problematic as narratives, we recall, because they have no internal structuring that allows a proper beginning and ending; they have merely an onset and a termination. The platform figures, in contrast, engage in a finite action. They are frozen in the design wall, but two step off into the platform, and meet in the middle to shake hands. This is almost an archetypal romance plot and it might be read, too, as a parable of racial understanding (with somewhat white-supremacist overtones in the appearance and postures of the two figures). Moreover, because the series of instants cannot be imagined to continue any further (the figures would overlap if they did), this lithograph might even be thought of as an encounter between narrative sequence and the "pregnant moment"!

One might say that the special resistance of pictorial art to nar-

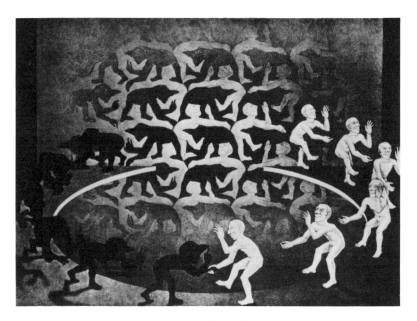

*Fig. 5.* M. C. Escher, *Encounter.* © M. C. Escher Heirs c/o Cordon Art, Baarn, Netherlands.

rativity, which has forced artists to invent forms like the frieze, diptych, triptych, comicstrip, narrative path and building in order to achieve discreteness and dual ordering, has exposed what is essential to narrative with a peculiar force. In no other art is the requirement of the subject's repetition so nakedly set forth, for in no other art is it so nonnormative a component. And in no other art is the connection between narrativity and realism so explicit, because in pictorial art the violation of certain realist norms has the power to transform narrativity into design.

It is worth dwelling a little on the connection between narrativity and realism. We have already seen a variety of ways in which pictorial art reveals their interdependence: the recurrent subject, who signals temporal difference; the realist norms that keep the repeated subject from being read as a design; the chronological time of the story, which is that of temporal flow in reality; the association between historical "truth" and narrative wholeness; and the tendency to read nonordered pictorial events, as in Memling's painting, as symbols rather than narratives.

The narrative-realism connection can in fact be followed throughout the history of pictorial narrative; its elucidation is one of the chief benefits of examining narrative in the visual arts. For whereas in literary narrative the connection is hidden by its very banality, in the "unnatural"

narrativity of pictorial art it is constantly obtrusive. The "pregnant moment" or ekphrastic painting, for example, is typically construed symbolically rather than as an attempt at storytelling. As one expert on Babylonian art states, the most favored narrative method

was allusive rather than explicit, employing the culminating scene—one group of figures, one moment of time, at the climax of a series of events—to stand for the entire story. This was undoubtedly intended to arouse in the viewer's mind recollection of the complete story, and in addition to stand as a symbol of the deeper lying ideas, beliefs, or psychical orientation of the community, as in our own society the crucifix is expected to recall the entire Passion story and also the fundamental Christian belief in the redemption of mankind by the sacrifice of Christ.[34]

In a similar pattern, Frank Kermode adduces the most famous literary ekphrasis, Keats's *Ode on a Grecian Urn,* to illustrate the contrast between narrativity and ekphrastic symbolism:

the first questions we like to ask [of a narrative] resemble those of Keats: "What leaf-fring'd legend . . . ? What men or gods are these? What maidens loth? . . . To what green altar . . . ?" There seems to be a *mythos;* these persons are acting, they seem to be trying to do something or to stop somebody else from doing it . . . , and they are headed somewhere. The *mythos* appears to have the usual relation to *ethos* and *dianoia*. But Keats, and we after him, are unable to discover the plot because the arrangement of the events (*synthesis ton pragmaton*) is not such as to allow us. . . . It lacks a quality we expect in imitations of our world, where heads ache and one may be disgusted. What it lacks is intelligible sequence. . . . The importance of the story on the urn, then, is that in its very difference [from our causal-temporal world] it can tell us, by intruding into our sequence of scandal and outrage, intimations not obvious but comforting.[35]

In Keats's poem, as in all such works, the foiling of narrativity automatically triggers symbolic interpretation. Just as art historians intuitively link narrative art to history and genre, but not to allegory, Kermode presents arrested narrative or ekphrasis as a tool of symbolism.

In contrast, the repetition of figures in a realistic rendering has the power to suggest narrative even when the events shown are not specific. In the high civilization of the Eighteenth and Nineteenth Dynasties of Egypt, the "new compositional scheme developed at Amarna [brought] for the first time renderings in which the same figures appear in several different stages of an event within a coherent spatial setting. . . . the new concreteness and the psychological differentiation so typical of Amarna art give the representations a narrative character even though they do not render specific events that only occurred once."[36]

The association of narrative and realism has led historians into a chicken-and-egg debate as to the origin of "true" realism in the arts, which is traditionally accorded to the ancient Greeks. George M. A. Hanfmann argues that the development of pictorial realism in Greece through perspectival foreshortening, light modulation, and so forth gave rise to the realistic narratives of Homer: "When classical sculptors and painters discovered a convincing method of representing the human body, they set up a chain reaction which transformed the character of Greek narration."[37] E. H. Gombrich disputes this view:

I feel prompted to put forward the opposite hypothesis: when classical sculptors and painters discovered the character of Greek narration, they set up a chain reaction which transformed the methods of representing the human body—and indeed more than that.

For what is the character of Greek narration as we know it from Homer? Briefly, it is concerned not only with the "what" but also with the "how" of mythical events. . . . in a narrative illustration, any distinction between the "what" and the "how" is impossible to maintain. . . . Whether he wants to or not, the pictorial artist has to include unintended information.[38]

Gombrich concludes, "In the whole history of Western art we have this constant interaction between narrative intent and pictorial realism" (Gombrich, p. 131).

This being the case, it is ironic that the institutionalization of pictorial realism in the Renaissance made pictorial narrative as we have defined it an impossibility. In a painting with vanishing-point perspective and chiaroscuro, the assumption is that we are observing a scene through a frame from a fixed vantage point *at one moment in time.* Nothing could be more foreign to Renaissance realism than the juxtaposing of temporally distinct events within a single visual field, as is commonly found in ancient and medieval art. Thus, though narrative was inextricably connected with realism, paradoxically the strict adherence to the norms of Renaissance realism precluded narrativity from the visual arts.

A symptom of this development is the use of the term "story" or "history" in Renaissance treatises on art. Alberti returns to Aristotle to urge that the proper subject of art is significant human action. But he uses *istoria* in a spatial rather than temporal sense, as a whole uniting and organizing the elements within it: "composition is that rule in painting by which the parts fit together in the painted work. The greatest work of the painter is the *istoria.* Bodies are part of the *istoria,* members are parts of the bodies, planes are parts of the members" (Alberti,

p. 70). *Istoria* throughout Alberti is used more as "theme" or "composition" than as "narrated events."

Da Vinci, writing with Alberti's treatise in front of him,[39] does not even mention narrativity as temporal flow, but uses "narrative painting" for the stopped-action historical, biblical, or mythological scene. Everything that he says about such works is predicated, in fact, on the *absence* of temporal flow. In his chapter 58, "Conformity in the Parts of Narrative Painting," for example, he advises against the mixing of happy and sad figures in the same work, "for Nature decrees that with those who weep, one sheds tears, and with those who laugh one becomes happy, and their laughter and tears are separate" (Da Vinci, *On Painting*, p. 60). Here we have an injunction aimed at unity of effect, as if the spectator's experience with the painting were atemporal, so that he should not be called upon to register emotions that cannot be simultaneously felt or unified into a single response. Moreover, in chapter 72, insisting on the artist's diversifying the expression of faces in narrative paintings, Leonardo specifically forbids the repetition of the same figure. He attributes such repetitions to the artist's unconsciously using himself as a model for all his figures. But in enjoining him not to "make or repeat either the whole figure or a part of it, so that one face is seen elsewhere in the painting" (Da Vinci, *On Painting*, p. 66), Leonardo renders pictorial narrative impossible in terms of one of the criteria that we have established, the repetition of the subject.

Where temporal flow is mentioned in connection with narrative art in post-Renaissance treatises, it has a contradictory quality. In the cinquecento dialogue, "The Aretino" of Lodovico Dolce, for instance, Aretino goes so far as to equate pictorial *dispositio* with narrative order itself. "As for disposition", he writes, "it is necessary that the artist move from section to section following the course of time in the narrative he has undertaken to paint, and do so with such propriety that the spectators judge that this affair could not have taken place in any other way than the one he has depicted. He should not place later in time what ought to come earlier, nor earlier what should come later, but lay things out in a most ordered fashion, according to the way in which they succeeded one another."[40] Dolce signals the literary origin of this idea in the response of Aretino's interlocutor, Fabrini: "Aristotle in his *Poetics* gave this same piece of instruction to writers of tragedy and comedy" (Roskill, p. 121).

Dolce's dialogue, one of the central documents in the *ut pictura poesis* argument of the immediate post-Renaissance and neoclassical periods, is as oblivious to the literal implications of its interartistic analogizing as that argument generally was. For despite the explicit mention of sepa-

rate narrative episodes in his discussion of disposition, it is clear that Dolce had no such structure in mind. He is speaking of paintings in which all parts are cotemporal. Thus, in comparing him with Vasari and Alberti, Dolce's editor finds him using the terms "invention" and "disposition" as refinements on the general notion of composition (Roskill, p. 268, note to p. 117). "'La inventione *e* la favola, o historia', Dolce says, as if content were narrowly equivalent to the sum of the narrative elements worked in. Here Dolce's literal-minded adhesion to the sense given to *inventio* in rhetorical theory" (p. 269) allows artists to think of their work as narrative without its including temporally discrete moments and double ordering.

It is clear that both artists and theorists paid a great price for visual realism in their eradication of narrative sequence from the visual arts. Jack Greenstein has shown how central the connection had been between painting and storytelling up to the time of Alberti. He traces the background of Alberti's term *istoria* (*historia* in Latin), showing that its Greek root meant "to see or to know". (Its etymology thus leads us back to the same concept as "narration.") In medieval thought, *historia* became equated with the literal level in biblical allegory, having a meaning both true in itself and signifying other truths beyond it. Moreover, throughout its usage, *historia* had signified both the events depicted and the discourse that depicted them, so that the representation of a history in any medium could be called a *historia*. "By the end of the Middle Ages, the noun *historia* and its Italian equivalents *storia* and *istoria* had taken on, as a secondary denotation, the meaning 'pictorial representation.' Under Dante's influence, *historia* became the generic name for a work of art that depicted a narrative—that is, a biblical—scene."[41] Like history, painting would thus present a story that is literally true and that at the same time points to truths beyond it. By extending the notion of *historia* to cover classical as well as biblical subjects, Alberti was proposing a thoroughgoing analogy between the art of painting and the creation of multilayered allegorical narratives. "[T]he art he described was designed to produce pictures which were convincing as representations of actual events but were effective at the same time in conveying the higher significations of *historia*" (Greenstein, p. 83).

Medieval artists, as Greenstein points out, could create this semantic richness by juxtaposing scenes to each other. But how could post-Albertian artists do so if they were limited to one scene? Greenstein describes how Andrea Mantegna contended with this problem in his *Circumcision of Christ*. Mantegna "recognized that the sacred setting used by medieval artists to bring out the sacramental significance of the Circumcision was incompatible with the representational fidelity of pic-

torial *historia*. Yet, to delete the sacred setting would have . . . [rent] the rite from the context that conveyed its timeless significance. To resolve this incongruity . . . Mantegna invented a *historia* that conflated the Circumcision and the Presentation in the Temple" (Greenstein, pp. 100–101). The details of this accommodation are not relevant to this discussion, but Greenstein's work illustrates the semantic struggle that painters were forced to take on in exchange for Albertian realism. The results of the struggle were often magnificent, and carried powerful historical meanings, but these meanings resulted from different pictorial strategies than the multi-episodic narratives of pre-Renaissance art.

Arduous as it proved to be, however, the proscription against multi-episodic narrative in painting was extremely effective. Renaissance handbooks on art, as we have seen, either ignored narrativity or used it in an automatized rhetorical move as a substitute for composition. The paintings conceived at this time followed suit. Works with repeated subjects or temporally distinct events are not to be found in Italy much after 1500, when the logic of the advances in perspective, chiaroscuro, and figure modeling prevailed.

This prohibition has controlled Western high art until very recently. The exceptions are so famous and so remarked upon that they more than reinforce the rule. Poussin's *Israelites Gathering Manna in the Desert* is the most notable. As Bryson states, it

> juxtaposes within the same image scenes of misery from the time before the manna was found, with scenes of youthful enthusiasm and elderly hesitation from the time after its discovery by the Israelites. This temporal dislocation was in fact a source of criticism at the 1667 debate on the painting at the Académie, and Le Brun produced . . . [this] defence: "The historian communicates by an arrangement of words, by a succession of discourse which builds up the image of what he has to say, and he is free to represent events in any order he likes. The painter, having only an instant for his communication . . . sometimes finds it necessary also to unite several incidents from different times, to render his scene intelligible." . . . Poussin is the only painter before Watteau to have risked undermining the temporal *vraisemblance* of a scene. [Bryson, p. 85][42]

Watteau's *Meeting in a Park* is also a radical exception. It contains a repeated female figure, accompanied in one appearance and solitary in the other, so that a general narrative of unhappy love is suggested. Still, the painting does not differentiate the episodes into separately zoned scenes, but runs them together in a continuous landscape.

Perhaps in part as a response to even this limited loosening of temporal unity, Lessing stressed in *Laokoön* the instantaneous and hence

unitary nature of the pictorial moment. Art theorists were profoundly influenced by Lessing. Martin Meisel writes that "nineteenth-century academic theory in England seems to have taken seriously only two books in its library: Lessing's *Laocoön* (1776) and Sir Joshua Reynolds' *Discourses* (1769–1791)" (Meisel, p. 18). Accordingly, the pronouncements of the Royal Academy frequently concerned the temporal status of the represented scene. "[Charles] Leslie and [Charles] Eastlake discuss duration as an attribute of the subject and of the finished representation, but only in its two limiting phases, the instantaneous and the permanent, zero and infinity. Neither artist challenges the idea that the frame of the painting embraces only coexistent objects and simultaneous events" (p. 20). Thus, when John Martin exhibited his *Belshazzar's Feast* in 1821, it was criticized for combining three separate scenes in a single canvas (p. 22). Despite the extensive interartistic connections in nineteenth-century British art that Meisel describes, the possibility that a single painting could take on the multi-temporal richness of literary narrative was still ruled out. And the fact that so many periods and styles—Renaissance, baroque, neoclassical, and romantic—had felt it necessary to restate this prohibition indicates just how repressive a measure it in fact was.[43] This is not to say, of course, that post-Renaissance art is utterly nonnarrative, for historical painting as a genre contains many of the characteristics that Prince and Labov enumerate. However, this art was weakly narrative; it proscribed multiepisodic canvases and found repeated subjects indecorous. As a result, it could imply or call to mind a narrative, but not represent a narrative in all its unfolding richness.

What is crucial to note is that there is nothing inherent in the media of the visual arts to require unitemporal subjects. In fact, even the notion that vanishing-point perspective entailed the effacement of narrative sequence dawned only gradually on Renaissance painters. Between the fully realized perspective of Leonardo and medieval art, where "the simultaneous depiction of consecutive episodes . . . was a characteristic . . . method of pictorial narration,"[44] lay a transitional period, the early and middle quattrocento. During this time, painters were teaching themselves the elements of realism without as yet understanding that these techniques ideologically ruled out the narratives that they wished to paint. For this brief time in Italy, realist techniques and narrative sequence came together in some extraordinary works by Fra Angelico, Filippo Lippi, Benozzo Gozzoli, and others. Because of the special status of these early Renaissance works—between the nonrealist narrativity of the Middle Ages and the nonnarrative realism of the Re-

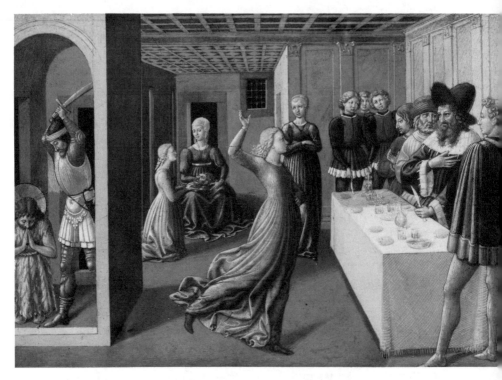

*Fig. 6.* Benozzo Gozzoli, *The Dance of Salome and Beheading of St. John the Baptist.*
National Gallery of Art, Washington; Samuel H. Kress Collection.

naissance—we might examine the semantic potential of narrative paint-
ing through them. It is a potential that was tapped only briefly, and not
reassessed until the nineteenth and twentieth centuries.

Benozzo Gozzoli is one of those artists straddling the boundary be-
tween medieval and Renaissance conventions. Bernard Berenson de-
scribed him as "gifted with a . . . spontaneity, a freshness, a liveliness in
telling a story that wake the child in us. . . . His place . . . in spite of his
adopting so many of the fifteenth-century improvements is not with the
artists of the Renaissance, but with the story-tellers and costumed fairy-
tale painters of the transition."[45]

The work of Benozzo's that I have particularly in mind is *The Dance
of Salome and the Beheading of St. John the Baptist* (fig. 6). It is one of five
predella paintings from an altarpiece whose main panel depicts the Vir-
gin and Child enthroned (fig. 7). Each of the predella works, the small
paintings decorating the frame below the main panel, illustrates the life
of one of the saints in the main work. The contract for the altarpiece
that Benozzo signed in Florence with the Confraternity of the Purifi-
cation of the Virgin makes the fairly conventional relation between

predella panels and central work explicit: "And the said Benozo [sic] must with his own hand . . . paint at the bottom, that is in the predella of the said altar-piece, the stories of the said saints, each under its own saint."[46] Thus, the nonhistorical simultaneity of the Purification, in which the saints assemble like courtiers before the Virgin, is unraveled, so to speak, into its distinct temporal strands in the predella panels. The traditional structure of the altarpiece highlights the opposition between eternal, nonnarrative art and historical narrativity, and fittingly, every one of the predella compositions except that depicting the life of the Virgin (an echo of the atemporal main panel above it) contains two or more separate episodes.

The predella concerning John the Baptist contains three: 1) the dance of Salome on the right, 2) the beheading of the saint on the extreme left, and 3) Salome's presentation of his head to Herodias in the left-

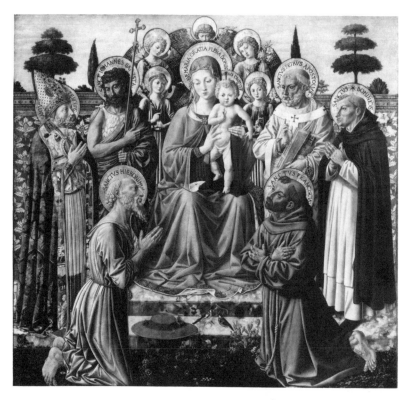

*Fig. 7.* Benozzo Gozzoli, *Virgin and Child Enthroned among Angels and Saints.* Reproduction courtesy of the Trustees, National Gallery, London.

central background. The repetition of figures, so crucial to narrative recognition, is especially obvious here. Salome not only appears in both the first and third scenes with the same clothing, but her face is repeated in exactly the same profiled attitude (except for her streaming hair in scene 1). Like a cameo relief, she connects the beginning of the story with the end, and so similar is her face in each case that one wonders how to construe the fact that the same look that bewitches Herod is trained on her approving mother.

This bivalent look is all the more significant when compared to the mother's appearance in each of her two occurrences. Unlike Salome, Herodias wears different clothes and headdresses in the two scenes in which she figures. Though Salome should have been unveiled in the course of her famous dance, the painting instead uncovers the mother to reveal the harlot's red below. She looks away from her dancing daughter in scene 1 toward the cubicle where John is being beheaded. Of course, at the time that she looks he is not being beheaded, but in the simultaneity of the painting she does appear to have her eyes upon him, while her daughter, with the same colored clothing as the executioner, her arm raised in a mirror image of his arm clenching the sword, looks away from the future scene. In terms of Salome's gaze, the dance's effect is the gratification of her mother in scene 3. In terms of Herodias's gaze, the dance's effect is the decapitation of the saint. Though Herodias studiously looks "through" the dance into the future, she directly meets Salome's gaze in scene 3. And in that scene the kneeling Salome becomes a parody of John kneeling in prayer to his God and prefiguring the Son of that God. If Salome in dancing mimics the executioner, Salome in kneeling mimics the sacrificial victim. She is her own executioner. And her mother, who cradles the grotesque severed head in her lap, is a disturbing parody of the classical *pietà* or perhaps the figure of the madonna and child with adoring saint. John's eyes, in sharp contrast to everyone else's in the painting, are closed in both his appearances. Vision, eye-contact, lust, and murder are all interimplicated through the figures' eyes, but John eschews this play of worldly vice by closing his eyes and short-circuiting the visual intercourse that dominates the painting.

Like gazes, clothes create a set of symbolic connections. We have already noted the twinning of Salome and the executioner through their blue and gold attire. The association of these colors with the Virgin is again a source of irony. Herodias sheds her green mantle in the passage from scene 1 to 3, ending up in the harlot's color red, like Herod and two of his attendants in scene 1. The gold of Salome's hair and her mother's headdress in scene 3 reach a supernatural intensity in John's halo in scene 2, reflected as well in his killer's armor. If color-echoing

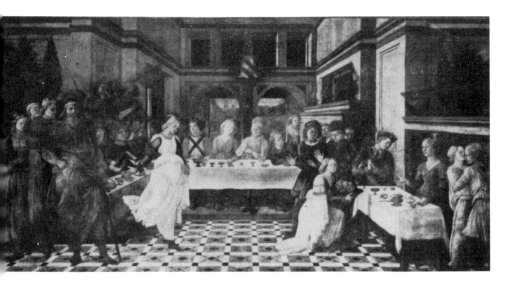

*Fig. 8.* Filippo Lippi, *Banquet of Herod.* Fresco, Prato Cathedral.

creates certain equations among characters, John's intense goldness in
a sense betrays the earthly gold of the others, as do, in reverse, his
"shaggy" garments next to their elegant robes.

Thus, if the central painting of the altarpiece celebrates the Purifica-
tion of the Virgin, the predella panel presents John the Baptist's murder
as a terrible parody of that Purification and a mocking, in fact, of the
very motherhood that Mary epitomizes. Herodias—an incestuous
adulteress—pimps her daughter in order to martyr Christ's precursor.
The sinfulness of the mother is here instilled in the daughter, and their
perfect complicity is sealed in the gratified look of the mother and the
happy answering gaze of the daughter so anxious to please. I would
stress that though all these interpretive possibilities are implicit in the
story of Salome's dance, they are made explicit in this painting through
specific pictorial techniques that depend on the repetition of characters
and the presence of temporally distinct moments.

We might at this point return to the repeated figure of Salome, whose
face is so exactly echoed in the two episodes in which she appears that it
might be more proper to speak of her formula there than her figure. As
far as I can tell, Benozzo does not employ such exact repetition elsewhere
in his multi-scened narratives, nor do other painters of his time. Fra
Filippo Lippi, for example, in a nearly contemporary *Banquet of Herod*
(fig. 8) that may well have been the immediate stimulus for Benozzo's
*Dance of Salome,* repeats his Salome in each of the three episodes, but

not as if she were a stamped figure. Thus, though in Lippi we read the repeated character as an identical self at different moments in time, the issue of identity and difference does not dominate his painting. In Benozzo's, I think, it does. The identity of Salome as sexual temptress and dutiful daughter immediately sets up the parodic and symbolic mechanisms that we have been noting, and hence the play of narrative flow and the subject's identity are crucial to the thematics of the whole painting. Salome's look in temptation is the meaning of the look of filial gratification at the end; what that beauty really meant is that severed head so proudly presented to Herodias in scene 3.

Not only does the repetition of Salome's face help us to locate the past in the present and vice versa, but it dictates the particular meaning of that past and present, conditioning their interpretive possibilities. This procedure is important because we are dealing with a story which predates its pictorial telling and which has a long interpretive history. Its story wholeness, in the sense of its having a specific beginning, middle and end, is an accomplished fact. Moreover, it already has a prototypical principle of story wholeness available to it—that of anyone's life. This "biographical model" is the totality that links countless medieval narrative paintings into wholes: the assumption of the central figure's life as the narrative that the episodes actually rendered demarcate. Thus, Sassetta's three paintings of St. Anthony joined on a panel (*Meeting of St. Anthony and St. Paul* [fig. 4], *St. Anthony Leaving His Monastery,* and *St. Anthony Distributing His Wealth to the Poor*) belong together, narratively speaking, because we automatically impose upon them an unspoken interpretive strategy that analogizes life to a plot. Benozzo, however, does not make use of this principle of wholeness; instead, he performs a virtuoso act of recounting the story of John's death. This approach was perhaps necessary, in part, because Benozzo was working in Florence, where John the Baptist was the patron saint and hence where paintings of his dramatic death abounded. The predella was thus particularly directed toward the conditions of its reception. As Paul Ricoeur writes, "As soon as a story is well known . . . retelling takes the place of telling. Then following the story is less important than apprehending the well-known end as implied in the beginning and the well-known episodes as leading to this end" (Ricoeur, p. 179). Not only does Benozzo allow us to read the end in the beginning but he stamps the same likeness on the two—the likeness of Salome, however, not John.

The subject of the narrative has been shifted from John to Salome, and its point (Labov's "evaluation" has shifted accordingly, too. The lameness and inconsistency of the painting's titles illustrate this fact, the work being called variously *The Dance of Salome and the Beheading of*

*St. John the Baptist,* sometimes just *The Dance of Salome,* and sometimes *Herod's Banquet.* These are merely the formulaic titles for paintings of the saint's death. They fail to capture the evaluative point of Benozzo's work because they fail to mention scene 3, which is the end and culmination of the story. *The Gloating over the Head* or *Filial Duty* would seem to be more appropriate titles, but even they do not do full justice to the irony palpable in the central episode. This is clearly not John's but Salome's story, though the significant event is the murder of a holy man for the basest of reasons.

By presenting his story this way, Benozzo has not only achieved a unique and powerful narrative, but a narrative whose historicity competes with its aesthetic self-containment. If, as Hayden White argues, "the reality which lends itself to narrative representation is the *conflict* between desire, on the one side, and the law, on the other" (White 1980, p. 16), commentators have mentioned only one side of this conflict in Benozzo's painting—desire. The figure of the dancing Salome captures everyone's attention, especially since other Florentine painters at this time were concentrating on the human figure in motion. "But the light-footed swiftness of Benozzo's figure sets it apart. There is a special freshness and eagerness in her whole body as she gracefully alights on one foot, her left hand airily resting on her hip and her right darting up in salute to King Herod" (Shapley, p. 78). The same writer sees the composition of the painting as a reinforcement of the dance within it, which she takes as the central theme. "The weaving of the three episodes from foreground to background and then again to foreground is in perfect harmony with the dominant theme of the painting, *The Dance of Salome*" (p. 77). From this standpoint, Benozzo would appear to be recasting an event of prime historic significance into a common romance of lust, manipulation, and murder, exploiting the saint as an occasion to celebrate the beauty of a young dancing girl—a "typical" Renaissance aestheticizing of momentous events. Indeed, Salome served just such a purpose in the nineteenth century, when she functioned as a symbol of art—oblivious to reality, morality, consequences.[47]

However, my account of the painting's "point" would suggest quite a different relation between the work and historicism. Let me quote White more fully to explain:

[W]e cannot but be struck by the frequency with which narrativity, whether of the fictional or the factual sort, presupposes the existence of a legal system against or on behalf of which the typical agents of a narrative account militate. And this raises the suspicion that narrative in general, from the folktale to the novel, from the annals to the fully realized "history," has to do with the topics of law, legality, legitimacy, or, more generally, *authority.* (White, p. 17)

Certainly, the biblical story of John's execution contains ample references to the law and authority. Herod is the lawgiver whose promise, once made, is irrevocable. Moral law—both in the Ten Commandments and in matters of less serious social convention—is also trespassed against in the story. By including the third scene and structuring it as he does, Benozzo is dramatizing the whole issue of authority. Not only does desire conflict with authority in the story, but authority conflicts with authority. Where does a child's allegiance lie—with mother or king or God? Where does the individual's allegiance lie—with immediate self-interest or with morality and the ages? It seems to me that Benozzo's Salome is not only an embodiment of youth and grace but of the conflict between the personal and the transpersonal sphere, and that her strongly marked identity to herself in her two appearances before king and mother is a sign of this conflict.

Moreover, the shift of focus from John to Salome—and the moral bankruptcy of her desire to obey and gratify her mother—draws the painting into history in another way. Just as John the Baptist's importance was as a precursor—the one whose personal history gave way to another's and to a whole new principle of history—his story here gives way to Salome's and provides a moral meaning for her act of treachery. It lends the mother-daughter grouping in scene 3 a sinister chill that goes beyond their act of murder to the parodying of the entire system of values for which the *pietà* and the adoration of the child stand. Rather than settling on the close-of-a-life model that John's story offered, Benozzo implicates John's death in Salome's story and ultimately in all of sinful humankind's. In doing so, he operates in the normative historicist's fashion, sacrificing the finitude of the individual to the overarching story in which he or she figures. The significance of this merging of individual into society is marked:

we know how much Heidegger emphasizes the nontransferable character of being-toward-death and that this uncommunicable aspect of dying imposes the primacy of individual fate over common destiny in the subsequent analysis of historicality. Yet it is the primacy that the analysis of narrativity calls into question. . . . After all, is not narrative time a time that continues beyond the death of each of its protagonists? Is it not part of the plot to include the death of each hero in a story that surpasses every individual fate? (Ricoeur, p. 188)

Much as this might sound like an argument for Benozzo as a precursor of Derrida and for the painting as an example of the infinite regress of meaning and storytelling, I have gone through this discussion of Salome's formulaic repetition and the crucial last scene in order to show the narrative potency of this work and, metonymically, of pictorial art

in general. Beyond Labov's "complicating action" essential to any narrative, *The Dance of Salome* contains an extremely rich evaluative system that provides meaning and wholeness to its sequential flow and ties it to the archetypal narrative systems of both fiction and history. Moreover, this system draws in the inert details of the orientation, such as appearance and clothing, and semanticizes them, turns them into evaluative details. Prince's narrative criteria of conflict, discreteness, factuality, wholeness, gestalt-like totalizing meanings, stress on origins and ends, inversions of expectations, and desire (Prince 1981) are all to be found in this work, and not just because the literary source contains these features. On the contrary, the painting makes into a striking narrative a story that is very meagerly set forth in the Bible.

We have still not exhausted the devices for wholeness in Benozzo's work, and certainly not in pictorial art in general, and at this point I would like to interrupt the discussion of *The Dance of Salome* to examine them. We have seen the cause-and-effect relations created by the directionality of gazes, especially Herodias's, and the implication of the beginning in the end in the echoing of clothes, colors, and Salome's face. As in literary works, these metonymic and metaphoric linkages are crucial to the project of narrative wholeness. They operate on different kinds of wholes. Herodias's gaze establishes story sequence and causality: first Salome dances and then John is executed; because of Salome's dance John is executed. The metaphoric matchings reinterpret details. The echoing of pose and attire between Salome 1 and the executioner imply that to dance temptingly is to execute a saint, that allure is sin.

Allied to the metaphoric device is a strategy for wholeness that we might term typological. In many medieval and early Renaissance paintings, for example, Giovanni di Paolo's *Annunciation* (fig. 9), scenes are juxtaposed because they lend meaning to each other as episodes in the Christian vision of history. In di Paolo's painting, Adam and Eve are expelled from the Garden, driven by Gabriel from the left "toward" the annunciation scene in the center. The annunciation redeems the fall of man, as signalled by the replacement of nature by inspired architecture, of violent angel by civil angel, of nakedness by rich clothing. Thus, though there are no literally repeated subjects, the typological strategy implies that all events are unified through Christ into the story of man's fall and redemption. There are no events, in theory, that are not part of the same story. Temporal disjunction and the lack of repeated subjects are irrelevant, since all characters are versions or types of each other in a universal story that overarches all time and space.

A less ambitious version of this strategy is the biographical model, for example, Sassetta's depiction of scenes from the life of St. Anthony.

We can read these episodes as a single narrative because we superimpose upon them the plot of a life, a whole in which they figure significantly, composing the totality that renders them meaningful as narrative components in the first place. The third of Sassetta's scenes (figure 4) employs a special device for suggesting this wholeness—the road. The winding path is one of the devices that Nelson Goodman mentions (Goodman, p. 110) as indicating an order of telling distinct from story order. And of course the "path of life" is a metaphor so shopworn that the picaresque novel and the painting of a life along a road hardly seem metaphoric structures at all. But the implications of this strategy in particular pictorial manifestations can be very powerful. As one commentator writes of Sassetta's *Meeting of St. Anthony and St. Paul:*

High at the upper left, the little figure of the saint makes his appearance, passes behind a hill, meets a pagan centaur whom he rebukes and converts to an amendment of life, and finally embraces his fellow saint in greeting in the lower foreground, having passed downward in the meantime through a

*Fig. 9.* Giovanni di Paolo, *Annunciation.* National Gallery of Art, Washington; Samuel H. Kress Collection.

gloomy wood, in miniature a recall of Dante's "*selva oscura*" of the first lines of the *Divine Comedy*. . . . The eye makes a journey through the imagined world of the picture; its movement in harmony with the imagery makes possible the illusion of the passage of actual time; the time-element produces a feeling of authenticity in the narrative. And the narrative finally enriches the sense of spiritual experience.[48]

The sense of sequence created by the continuity of the road is at the same time broken by the road's *dis*continuity. The road is interrupted by the hill, by the edge of the painting near the centaur episode, and finally by the dark wood. It returns, however, in a great sweep across the bottom of the painting where the saints embrace. The road thus functions as an analogue for the narrative flow of the painting itself and the embattled life of the holy man. No temporal flow can be narrated through anything but broken episodes which must be connected by some interpretive strategy. Just as the connecting path is made whole in the meeting of the saints at the bottom, so the episodes themselves are resolved in that meeting. We begin with the isolated figure of St. Anthony; then find him meeting his spiritual opposite in the centaur; and finally, joined in an embrace with his spiritual like, St. Paul. It is as if the whole aim of the holy life, as presented in this picture, is to pass from isolation through conflict to love. The structural properties of the pictorial composition, including the broken path, reinforce this meaning. Such an interpretation seems particularly defensible given the anachronistic "Gothic style" of Sassetta's painting, which is narrative not only in repeating its central figure in temporally distinct episodes but also in making little attempt to combine those episodes into an integrated landscape. "A charming storyteller, [Sassetta] chose to ignore the recently discovered rules of perspective and methods of rendering form realistically."[49] This deliberate eschewing of spatial unity in the interests of narrative continuity was still an unthreatening possibility for late medieval narrative art.

However, the winding path was obviously a doomed narrative strategy for any painter intrigued by the burgeoning techniques of pictorial realism in the early quattrocento. If one were to adopt this realism with its requirement of spatial coherence, how could one indicate the discreteness of the separate events composing the narrative? It is at this point that the multi-compartment building becomes so important as a structuring device for narrative, for it is full of discrete simultaneous units, and, with all its right angles, it is also ideal for the virtuoso treatment of perspective, light, and volume.

Indeed, the conception of narrative as a procession through the rooms of a building has a long and impressive currency. The word "stanza," of course, means room. And one might see in the building the

contrast between the spatial and temporal arts themselves. A building is as spatial as anything one can imagine, with its floorplan and facades each present to us in a single moment of perception. At the same time, its perception involves temporality, since one cannot see all of its three-dimensionality in one moment. The experience of walking through a building, of being a participant in it rather than an external observer, is a temporal progression from stopping place to stopping place, these ordered by structures significantly called "passages" and hall-"ways."

Literature has been fascinated by this relation between narrative and architectural structure. The *Hypnerotomachia* is a Renaissance text depicting the feverish pursuit of a woman through room after room of a palace. In *The Faerie Queene,* Spenser more than once creates an analogy between the quest and the progress through the rooms of a house, and the ambivalent value of stopping versus continuing is an integral part of his allegory. As Patricia Parker describes this, "Spenser frequently expresses the desire for rest in architectural metaphors, images which turn the temporal process into an edifice, or edification. The constantly reiterated quality of 'stedfastnesse' is an index of the wanderer's constancy. But the 'stedfast state'. . . of the 'Heavens' in Acrasia's bower is a sign of the wrong kind of end."[50] Poe's *Masque of the Red Death* is another narrative ordered precisely as a progression through chambers, and Keats's House of Soul-Building projects the growth of the mind as a journey from one spiritual room to another.[51]

The competition between path and building as narrative symbols in the quattrocento transition is apparent in the mixed metaphor employed by Cennino Cennini, author of *The Craftsman's Handbook,* a work that sounds particularly old-fashioned next to Alberti's nearly contemporary *On Painting.* Cennino, metaphorically torn, advises the aspiring artist: "Mind you, the most perfect steersman that you can have, and the best helm, lie in the triumphant gateway of copying from nature."[52] As Cennino's editor notes, "He seems to have had some half-formed conception of his course of study as an architectural layout, with steps rising and gates opening; but this is confused with ideas of journeys, by land and, as here, by sea" (Cennini, fn. 1). In Cennino's confusion, I believe, we see the passage from one aesthetic paradigm to another. The building is the archetypal symbol of the structure. It changes a narrative into a simultaneity, makes temporal order problematic, and thus serves as the natural transition to the purging of temporal flow from painting altogether. By the late quattrocento and the cinquecento, not only multi-episodic but multi-roomed buildings have become rare in European painting.

But in the transitional period, the building had a multitude of nar-

rative functions. Not only did rooms serve to demarcate episodes, but often inside was contrasted to outside for just this purpose. In Fra Angelico's *Healing of Palladia by St. Cosmas and St. Damian,* the saints effect their cure inside a building on the left, and St. Damian accepts a gift outside on the right. A more interesting treatment of outside versus inside can be seen in Filippo Lippi's *St. Benedict Orders St. Maurus to the Rescue of St. Placidus.* There the order for the rescue is given inside on the left and the rescue itself is shown outside on the right. The discontinuity between inside and outside serves to distinguish cause from effect, earlier event from later one.

In the *Annunciation* by di Paolo, outside and inside are even more potent symbols. In the Expulsion on the left nature is rendered flatly, as if it were a tapestry pattern; the Annunciation itself takes place in a self-consciously (if faultily) perspectival interior; on the right, Joseph sits before a fire in a somewhat naturalistic courtyard, the "cubicle-space" used by "Giotto and the Sienese before 1350. This ability to shift and choose styles of space is a remarkable aspect of Late Medieval painting" (Seymour, p. 16). The medieval, heraldic handling of the Expulsion renders it a scene "of the past," "of the passé," in fact, for the announcement being made in the center will reinterpret that moment and redeem the pathetic outcasts. Accordingly, the Annunciation is set in a discontinuous interior whose space is inconsistent in every sense with the space on the left. Joseph on the right, warmed by the fire and sheltered by the Dove, is simultaneous with the Annunciation scene and hence continuous with the architecture that encloses it. But he is cut off from that scene both by a wall and a convention. His rendering belongs to the not-quite-contemporary conventions of the previous century, and the contrast between the shared punishment of the "first parents" on the left and the separate, unequal status of the redemptive parents on the right is striking.

In *The Dance of Salome,* Benozzo also uses architectural framing to divide his episodes. Unlike Hans Memling's *Panorama of the Passion,* in which episodes of the life "populate" the buildings of an entire city, Benozzo's scenes occupy what appears to be a single room with antechambers. His faulty perspective—whether intentional or not—helps give the impression that all the action is simultaneous. Herodias 3, for example, appears to be sitting almost beside Herodias 1, especially because her recessed figure is, if anything, larger than her earlier standing self. The recession into deep space of scene 3, marked by the lozenged ceiling, suggests recession in time—into the future. And the cutting off of the execution from its cause in scene 1 and its effect in scene 3, by the peculiar little chamber with only a single wall, is significant. It is the

ugly reality that interprets Salome's two attractive poses: dancing temptress (executioner) and kneeling donor (victim). The play of continuity and separation achieved by the architectural setting again both establishes the temporal displacements and shows the implication of one event in another. Temporal flow itself is semanticized.

In Filippo Lippi's *Banquet of Herod,* the three scenes not only occur in the same building but in a single room. The three sides of the banquet table demarcate the episodes: the dance in the middle; Salome's receipt of the head on the left around the corner from the table; and her presentation of the head to her mother in another version of the central table shown perpendicular to it on the right. Like a stage set, all the scenes are carefully oriented toward the viewer, with Salome 3's and the major domo's eyes gazing directly outward. This painting presents the dance and its outcome as staggering events for everyone but the self-possessed Herodias. The enormity of the execution is registered on almost every face, and there is none of the insensitivity of Benozzo's figures here. Instead we are presented with speaking looks, an atmosphere of sorrowful mystery as one commentator puts it,[53] that is a far cry from the painful ironies of Benozzo's work.

The semantic thrust of the two renderings is quite different and is carried by the distinct handlings of space. In Lippi's continuous treatment, with the subject Salome repeated in each episode, one has the impression of a unified tableau in which every section bespeaks the same horror. In Benozzo's separate rooms, or at least alcoves, the meanings of dance, execution, and presentation are both differentiated and juxtaposed, acquiring as a result symbolic interpretations through each other. The contrast between beginning and end established in Benozzo through foreground and background is also missing in Lippi. The semantic emphasis on centers goes in Lippi's work to the dance, whereas in Benozzo's it stands divided between the dancing girl and the gloating mother. The decision whether to integrate three scenes in a single room or to zone them in separate alcoves and spaces results in radically different overall meanings for the same story. The demarcation of space in Benozzo becomes immediately a demarcation in time and invites the interpretive possibilities of double ordering. Here spatial organization becomes an evaluative device, in Labov's sense.

Moreover, in Benozzo's work, even the ordering of events is problematic. Lippi places the dance in the center and its two outcomes—Salome's receipt of the head and her presentation of it to her mother—on the left and right, respectively. With the three events more or less on the same plane, this order is straightforward. But Benozzo's is anything but straightforward. Seymour Chatman describes the order at "face

value" as follows: "Salome dances for Herod in the right-most section of the painting, and a later event—a soldier holding the sword over John's head—occurs in the leftmost portion. It is in the middle that the final event occurs, Salome presenting the head to her mother" (Chatman, *Story and Discourse*, p. 34). Thus, whereas Lippi's order would be 2-1-3, Benozzo's would be 2-3-1. But since Benozzo's events do not all occur on a single plane, one could just as easily "read" the painting as occurring on two registers, a foreground with the ordering 2-1 and a background with the third scene. Moreover, as I stated earlier, though scene 3 as a whole is more centered than either of the others, the figure of the dancing Salome in scene 1 is dead center in the painting. The ambiguity as to center—tempting dancer or unnatural mother—is in keeping with the ironic and symbolic meanings already discussed. The fact that we cannot specify the order of telling without ignoring either the stressed depth of the third scene or the actual left-right orientation of the scenes on the picture plane is an interesting addition to this ambiguity. The interchangeability of end and beginning, their competition for semantic centrality, and the self-enforced blindness of Salome and her mother to the outcome of her dance are all suggested by the problematic ordering of episodes in this architectural simultaneity.

Thus, Benozzo's painting fulfills in virtually every respect the requirements, not only of a narrative, but of a strong narrative. It has an order of telling distinct from the order of happening. Its episodes have discreteness, wholeness, and evaluative point. It manages to suffuse all its elements with narrative power, so that they imply a meaning greater than themselves.

Still, in the gradual transition from medieval to Renaissance conventions signaled by the shift from path to building, the fate of narrativity in painting is apparent. The next step is to integrate the whole building temporally as well as spatially, so that the viewer so eagerly accosted by the gazes of Lippi's figures becomes the orientation point for the appearance of everything in the painting. At that moment, the perceptual wins over the narrative in painting, not to cede place again until the late nineteenth century.

We might return to our original metaphor of network and chain, noting that painting at a certain historical moment was faced with a choice. It could express its knowledge potential either as distinct stages of action and understanding or as an atemporal configuration. It chose the latter. The mutual exclusivity of identical repetition and realist norms was certainly never a part of Renaissance orthodoxy—quite the contrary in fact. And yet this mutual exclusivity was the logical outcome of the Renaissance model of painting. In assenting to the restrictions of

the perceptual model, visual artists split picture from narrative, space from time, and cohesion from sequence in an attempt to insure adequacy to reality. Conventional as we know Renaissance realism was, its lack of iconic adequacy to reality[54] lies less in what it represented than in what it excluded. For certainly reality, from any viewpoint, is pervaded by temporality. To equate reality and its representation, realism, with atemporality is to destroy the logical basis of realism—the concept of identity as a repetition traversing time.

*No man has been able to avoid the shafts of Love, nor will be able, as long as eyes can see and beauty reigns. And may the god of Love grant us power to tell the loves of others in all purity of heart.*

Longus

# 2 "As Long as Eyes Can See and Beauty Reigns": The Visual Arts in Romance

The realignment of pictorial norms in the Renaissance polarized a number of aesthetic categories. The oppositions between image and story, design and narrative, and repetition and progression were deeply embedded in the structure of pictorial art and destined to play an important role in the symbolism of the literary romance. That symbolism utilized one further aspect of the Albertian model: the relation it establishes between the perceiver and the work of art, and correspondingly, the one between the lover and his lady.

It goes without saying that the perceiver plays a crucial role in shaping the pictorial scene in the Renaissance conception of painting. The elaborate geometrical instructions in Alberti's treatise *On Painting* as to the placement of the "centric point" serve to insure that "both the beholder and the painted things he sees will appear to be on the same plane" (Alberti, p. 56). Similarly, when Alberti states "that a painted thing can never appear truthful where there is not a definite distance from seeing it" (p. 57), he is speaking of a distance, obviously, that involves a perceiver.

But if the painting is composed by the viewer, determined in effect by his or her position and orientation, it is also a composition that has to be construed. Thus Alberti instructed that a figure within the picture should point its meaning, that is, organize the objective view into an authoritative interpretation. As he put it, "I like to see someone who admonishes and points out to us what is happening there; or beckons with his hand to see; or menaces with an angry face and with flashing

eyes, so that no one should come near; or shows some danger or marvellous thing there; or invites us to weep or to laugh together with them. Thus whatever the painted persons do among themselves or with the beholder, all is pointed toward ornamenting or teaching the *istoria*" (Alberti, p. 78).

The painting is thus a visual construct dependent on the perceiver, which also gives back the perceiver's image through a commentator capable of teaching the meaning of the pictured world. The pictured perceiver can be taken as an image of the painter, or of the viewer once educated by the painting. As Alberti's editor notes: "Not only is the perspective construction to form a spatial link between the painting and the observer, but the commentator is to establish the emotional link. The image of man in the microcosm is in contact with man in the reality of the macrocosm" (Alberti, p. 26).

A model of communication is implied by the Albertian system that involves a mutual creativity of meaning on the part of viewer and painting. The viewer creates a meaning by interpreting the painting. The painting does so by modeling an ideal observer who reacts to the scene that he or she observes. This ideal viewer is part of the painting that real viewers interpret, so that the act of interpretation is part of the matter to be interpreted. But rather than implying a modernist infinite regress of meaning, the Renaissance model suggests an educative role for the painting and a training in response for viewers, who should come to match the response or responses they witness.

For example, in Filippo Lippi's *Coronation of the Virgin,* a female figure on the right gestures toward the coronation of the Virgin, and the spectators exhibit a variety of reactions to the holy event. The angel in the right foreground touches a ribbon with the words "Perfecit opus ist" ("The work is completed"), a biblical gloss on the scene. Three figures in the foreground look out directly into the viewer's eyes, as if marking our presence as witnesses, turning away from the scene to be viewed to the viewers of it. Likewise in Lippi's *Banquet of Herod,* the facial expressions and gestures of everyone but Herod and Herodias indicate horror at John the Baptist's beheading. Salome on the right looks out at us sadly, as does the oversized major domo on the left, whose finger points toward Salome's presentation of the severed head to her cold mother.

The incorporation of pictorial reception into the subject matter of painting could be followed throughout art history. The figures pointing in Ecce Homo scenes would be typical, as would the subgenres of the self-portrait or the artist's studio (*Las Meniñas* is an obvious example). The *Fensterbild* is another case in point, where a figure is pictured gazing

*Fig. 10.* Albrecht Dürer, *Draftsman Drawing a Reclining Nude,* from *Instruction in Proportion.*

out of a window at a scene beyond.[1] It is natural that paintings involving the window should serve as models of pictorial perception, since Renaissance perspective was conceived as just such a view through a transparent frame. Here the viewer interrogates the reticent landscape with a gaze, asking it to be an answer.

As the *Fensterbild* suggests, however, the optimism of Albertian communication was not always shared by artists operating in this model, nor was its assumption that viewers would embrace the response of the pictured perceiver. For into this idealized, formal exchange of information comes the problem of desire. After illustrating at length the various techniques and advantages of the Albertian system in his *Instruction in Proportion,* Dürer satirizes purely formal communication in a famous woodcut (fig. 10). He shows a draughtsman viewing his model through a screen, with each simultaneously posed before a window, the symbol of the framed world of the Renaissance painting. But whereas in the Albertian model and in the woodcut the pictured scene contains an observer, in Dürer's draughtsman's drawing this observer will be missing. The draughtsman's subject is thus left to "speak for itself"—in this case "herself." And though she speaks all too eloquently to us, she seems to have little power over the draughtsman. His is a technical involvement with his subject, as is proper no doubt for an artist intent on learning the principles of perspective. Yet a purely technical involvement with what is lying in his line of vision seems curious, to say the least, and it is hard to imagine what the proper response would be to the drawing that he is producing. Here the pictured perceiver emphatically fails to provide anything but a formal interpretation of the subject, and Dürer

seems to be issuing a comic warning that a merely geometrical reading of Alberti's precepts, ignoring the communicative impact of the subject, will produce derisive painting.

The realization dramatized in Dürer's woodcut depends on a sexual politics of vision. Norman Bryson writes that "within a 'heterosexual' optic where specialized functions are assigned to each sex, pleasure in looking is broken between active (= male) and passive (= female). Thus in both [Boucher's] *Venus and Mars Surprised by Vulcan* and *Venus and Vulcan* the females lower their lids to conceal the eye, the males raise their pupils to reveal the eye. . . . [This difference] clearly announces the division of roles: Woman as Image, Man as Bearer of the Look" (Bryson, pp. 96–97). This division of roles is akin to that in courtly romance, where the lady first appears to her love as a disembodied dream image, a portrait, or a figure seen "from afar." The problem for the serious artist—whose most important tools, according to Diderot, are morality and perspective (Fried, p. 93)—is how to elicit an act of gazing upon the beautiful that is not prurient, overtly erotic.

Here the moral value of perspective is apparent. For perspective creates a distance between viewer and object that denies contact with the object or an appropriation of it, as in the romantic topos of consummation in a glance.

Imagine a body [Bryson suggests], of whatever desirability, located in the tangibility and recession of perspective, with perspective lines running through flooring, windows, tables, chairs, anchoring the body in its own space outside the picture-plane; however erotic, the anchoring functions as erotic obstacle, for the image cannot be easily dislodged from its surrounding world and accepted by the viewer as though made solely for his possession. (Bryson, p. 93)

This was Dürer's artist's view through his screen: what *we* see anticipates the languorous postures of rococo art.

But the problem then arises as to how to arrest, attract, and enthrall a viewer who at the same time must keep his distance from what he is enthralled by. The answer, as Fried presents it, was to depict a subject totally oblivious to the viewer because so involved in the momentous events of the scene. It was not that the painting should no longer present a "speaking subject," but rather that that subject should speak as if in a soliloquy, be overheard but not heard. As Diderot states, "In a painting, I rather like a character who speaks to the spectator without coming out of the scene" (Meisel, p. 84).

This limitation on the speaking subject produced some rather interesting neoclassical double-talk. The subject of Susannah and the Elders, the theme of which is "illicit beholding," is a special problem for Di-

derot, who admits that when he looks at Susannah, "far from feeling abhorrence toward the elders, perhaps I have wished to be in their place" (Fried, p. 96). Therefore, in order for the painter to save Diderot from lustful feelings he and his subject must pretend that Diderot is not looking. If the artist has Susannah cover herself from the view of the elders, and in the process uncover herself to Diderot's gaze, everything is fine. "Susannah is chaste and so is the painter. Neither the one nor the other knew I was there" (p. 96). This statement was representative of a "powerful reaction against the rococo in the name of artistic and moral reform" (p. 71)!

Thus, the obverse of Dürer's oblivious viewer is the oblivious subject, and the most oblivious states for that subject—short of death—are blindness and sleep. Fried mentions both of these as prime absorptive attitudes. A further refinement of such poses is to represent the sleeping subject being observed by a figure inside the artwork. In the topos that Leo Steinberg calls the "sleepwatch," the observer regards a reality that is unaware of him, rapt in a dream and unconscious of the world. The helplessness of the subject viewed and the potential for violence or violation by the viewer are all too obvious, as in Tintoretto's *Judith and Holofernes* or in the pictures of sleeping nymphs and voyeuristic satyrs that Steinberg describes.[2] The pictured viewer imposes upon the subject in such cases, rather than participating in a mutual fulfillment. The analogy between sexuality and pictorial perception could hardly be more direct.

In the sleepwatch paintings and in Dürer we are dealing with incomplete versions of the Albertian model. There, the picture speaks its meaning through the observer's modeling of the proper interpretive response: admonishing, beckoning, menacing, showing, inviting, and so forth. In a work like Dürer's, the pictured observer compulsively limits the meaning of the subject to an exercise in the geometry of perception. And in the sleepwatches, the meaning that the observer wishes to impose on the observed subject is not a meaning that the subject intends or even knows about. Insofar as these are images of pictorial perception as such, a purely technical approach to observation or an approach involving only desire cuts the observer off from the object of vision, and by analogy, from love and understanding. Thus, the topic of pictorial perception is implicated in a larger complex of ideas concerning communication, intersubjectivity, voyeurism, desire, and love.

We might now return to Longus's words in the epigraph: "No man has been able to avoid the shafts of Love, nor will be able, as long as eyes can see and beauty reigns. And may the god of Love grant us power to tell the loves of others in all purity of heart."[3] These lines, taken from

one of the world's earliest romances, crystallize the ideology of the mode.[4] Here the beloved functions as a visual object with the peculiar combination of the passivity that every object has and the might that the beautiful object exercises over our senses. The romance shows love victimizing us through beauty's power over the eyes, with vision, aesthesis, and love interimplicated. As the record of beauty's deliciously innocent victimizing, the romance seeks to stand outside all hint of prurience and enticement in its "purity of heart." But aware that it can raise the same heat in its audience as the beloved does in the gazer, it insists that it tells "the loves of others." It is both a *love* story and a love *story*, a beautiful but artificial rendering of beauty's might, whose relation to what it tells is always problematic. The romance puts love on show, just as the beloved is a feast for the lover's eyes, and hence the reader's response to the romance is part of its very thematics. Painting, as the image of the beautiful, serves as a symbol—if often a cautionary one—of the problem of sorting out vision, voyeurism, love, and aesthetic response. Paintings remind the reader that the romance is not merely the story of love but the story of love perceived.

Because of the romance's analogy to its subject—both are demonstrations of beauty's power—paintings in romance function ambiguously as symbols of both the beloved and the romance as a work of art. Paintings are archetypal images of stasis. By eliminating multiple incident and repeated subjects, Renaissance painting diverged even further from literary narrativity and from the treatment of identity as a sameness traversing time, until character became a frozen, atemporal appearance. Yet this appearance had a compressed power, the kind that in a religious context leads to idolatry. Paintings in romance thus symbolize the endangered self—frozen, suspended, imprisoned, enthralled—and also the essential self—removed from the vicissitudes and contingencies of life, raised to a higher purity of being. The romance, similarly, presents itself as both a blighted artifice and a sublime reality.

Because of the central place of painting in its thematics, the romance scrutinizes the act of seeing and emphasizes the conventional split between image and story. Norman Bryson claims that in the European tradition, love "is transmitted through the eye, as plastic presence and visual spectacle, never as *récit* . . . the work of the *récit* is resistance *against* the body and a taming or controlling of the body by and through speech" (Bryson, p. 92). The romance, however, subjects the image to story. Any number of romances, including *The Story of Daphnis and Chloe*, begin with a mysterious picture, dream image, or statue that is "explained" by the plot in which it becomes entoiled, only to be replaced by another image of vastly magnified truth. "The poet's goal," Giamatti writes of

*The Faerie Queene,* "is to distinguish between magic and miracle, between what is only vain appearance and a moment of divinity. He wants to reform our sight from that of *voyeurs* to that of *voyants,* from the gaze of spies to the visions of seers, always teaching us to see at once beneath and beyond what appears."[5]

Since even the revelation of truth in romance comes through the mediation of language, the distinction between *voyeur* and *voyant* is always a matter of striving. "The passage from false appearance to truer vision is accomplished through story, but neither story nor its revelations should be mistaken for the naked truth. They establish a project for the reader which is the act of reading itself."[6] Romance sets up a path from one image to another of greater value, to still others, and ultimately to the world beyond the work of art altogether. This wandering punctuated with miracle is analogous to the contrast between story and image, difference and identity.

The romance dialectic of plot and image falls in effortlessly with the history of Western painting, which also exiled narrative from the image in the search for a more perfect truth, and then called on the viewer's hermeneutic skills to put the two together. Thus, perhaps no literary mode has been more sensitive to the relation between painting and identity than the romance. Pictures and mirrors abound in romance as symbols of the state of a protagonist's identity. Northrop Frye associates this symbolism with the archetypal structure of the romance—its pattern of descent and re-ascent in which the hero loses his or her identity and enters a world of chaos, only to achieve a renewed identity at the end in a state of heightened order and meaning. Frye notes that the initial loss of identity, which freezes or paralyzes the hero, is often rendered by his merging into a work of art or into a mirror image.

The myth of Narcissus provides the pattern for the dialectic between image and story. According to Frye, "What Narcissus really does is exchange his original self for the reflecton that he falls in love with. . . . The reflecting pool is a mirror, and disappearing into one's own mirror image, or entering a world of reversed or reduced dimensions, is a central symbol of descent. . . . Modulations of the mirror image bring us to the pictures, tapestries, and statues which so often turn up near the beginning of a romance to indicate the threshold of the romance world."[7] Correspondingly, by the end of the romance, when the hero has escaped from "a closed circle of recurrence" to a "recreation of memory" (Frye, p. 183), we find "statues coming to life, . . . snow maidens thawed out and sleeping beauties awakened" (p. 155). The static perfection of the work of art gives way to the living contingency of the beloved.

Alberti himself connects the Narcissus myth to painting, elevating

the status of the art through a rather willful reading of Ovid's story. *"Painting was given the highest honour by our ancestors,"* he writes. *"For, although almost all other artists were called craftsmen, the painter alone was not considered in that category.* For this reason, I say among my friends that Narcissus who was changed into a flower, according to the poets, was the inventor of painting. Since painting is already the flower of every art, the story of Narcissus is most to the point. What else can you call painting but a similar embracing with art of what is presented on the surface of the water in the fountain?" (Alberti, p. 64). Alberti is quite sanguine about the Narcissus analogy, but in the literary romance the frozen identity of visual images is a danger that heroic striving must overcome. It is a danger, too, that the literary structure of romance must avoid, for such paralysis, obviously, is the antithesis of plot. It is the absence of action or predication. It amounts to mere tautology: A is A.

This is Narcissus's tragedy as well. In Ovid's account, he realizes that his reflection is not another, but himself. "Alas! I am myself the boy I see. . . . What I desire, I have. My very plenty makes me poor. How I wish I could separate myself from my body! A new prayer this, for a lover, to wish the thing he loves away!"[8] This intolerable paradox, caused by the collapse of subject and object, haunts the romance. "Narcissus is the patron saint of courtly love if only because all dialectics of subject and object depend upon some kind of projection, a relation in which a subject is literally 'subjected' to an object or end" (Parker, p. 90).[9] The romance quest is in some degree always a flight from solipsism, or narcissism, toward an idealized form of intersubjectivity—love. It is frequently as well a progression from the enthrallment of pictorial aesthetics to an engagement with life.

The tautology of Narcissus's self-love also introduces the issue of repetition: he is doomed to love a copy of himself as punishment for spurning other lovers. Echo is the most important of these, a nymph whose loquacity kept Juno enthralled while Jove philandered. Juno punished her verbal fluency by reducing it to mere repetition. Echo could not then initiate speech, but only repeat it, and as a result, she could not win Narcissus for herself. Nemesis's sympathy for her and Narcissus's other rejected lovers brings on Narcissus's punishment. The goddess punishes him for not returning what was extended to him by making him love himself (self-reflexivity always involving a failed subject-object relationship). Likewise, Echo, who misused her dialogic powers, is deprived of them, made unable to reciprocate speech with speech, but only to match it with feeble copies. Narcissus's sins against love freeze him into a spatial tautology; Echo's, into a temporal one. As we saw with Es-

cher's *Encounter,* one needs a repeated subject in order to have narrativity, but if the repetitions are identical, one has not story but design.

In *The Metamorphoses,* which presents reality as an eternal flux where everything "comes into being as a transient appearance" (Ovid, p. 339), perfect spatial or temporal repetition is in conflict with nature. It conflicts with art as well, for what Ovid narrates in his often ironic history of the world is a history of *artistic* metamorphoses. And love, in this archetypal source for romance, is the natural force that generates change. Thus, love is antithetical to the static image or the suspended identity, although such frozen moments, paradoxically, so often initiate love. The changes catalogued by Ovid, moreover, are utterly contrary to our notions of natural possibility, indicating the contradictoriness of the romance's claims to verisimilitude. Ovid's is an artful, artificial view of life, specifically of life seen as governed by two views of time: constant flux driven by the engine of animal passion, versus the eternity and poise of idealized love and art. Ovid in fact ends *The Metamorphoses* by imagining his immortality as the author of a book that insists on the subjugation of all human existence to the destructive hand of time.[10]

The importance of identity, as frozen tautology or dynamic continuity, and hence of the romance plot itself as the enlivening of a picture, is paramount in this thematics. The romance, concerned with love, metamorphosis, action, is inevitably drawn to the picture, the mirror, the statue as images of love gone wrong, metamorphosis thwarted, action frozen.[11] At the same time, as art, the romance shares the ideality of the visual arts, escaping the temporal finitude of the mortal that creates it. As both a narrative of characters and events and a self-conscious artifice, the romance is repelled and fascinated by the visual artwork and the unchanging identity that it represents.

The preoccupation of the romance with identity, time, and repetition has been noted by a wide variety of commentators. Hayden White terms the romance a "drama of self-identity,"[12] and Michail Bakhtin describes the Greek romance as a necessary correlation between the peculiar time-space complex (chronotope) that it employs and its notion of identity:

How indeed can a human being be portrayed in the "adventure-time" . . . where things occur simultaneously by chance and also *fail* to occur simultaneously by chance, where events have no consequences, where the initiative belongs everywhere exclusively to chance? . . . in this time, an individual can be nothing other than completely *passive,* completely *unchanging. . . .* all the character's actions in Greek romance are reduced to *enforced movement through space* (escape, persecution, quests); that is, to a change in spatial location. . . .

[Still, the character] *endures* the game fate plays. And he not only endures—he *keeps on being the same person* and emerges . . . with his identity absolutely unchanged. *This distinctive correspondence of an identity with a particular self* is the *organizing center* of the human image in the Greek romance.[13]

Bakhtin points to the prevalence of recognition scenes, disguises, presumed death or betrayal, and tests of character as proof of the romance's preoccupation with identity. "The hammer of events shatters nothing and forges nothing—it merely tries the durability of an already finished product. And the product passes the test. Thus is constituted the artistic and ideological meaning of the Greek romance" (Bakhtin, pp. 106–7).

Bakhtin finds the chronotope of the medieval chivalric romance similar to that of Greek romance, with the difference that the chivalric hero is both individualized and symbolic. The result of this symbolic overlay is to intensify, even reify, his identity. Galahad as a type of Christ is locked into a mode of behavior, as is Lancelot, the valiant sinner. Consequently, these characters exceed the imaginations of their creators and become the property of any author who needs them. The Arthurian cycles grow from this univocal notion of identity, a whole system of narratives generated from the continuity of identity across time.

The absolute constancy of identity in romances leads to a peculiar feature of their plots. Much as they might seem a linear sequence—one adventure after another—the romance shows its end in its beginning and its beginning as a prefiguring of its end. Eugène Vinaver insists on this point, and connects it to the special identity of the romance hero in the intricately interlaced plots of medieval romance: "We are in an age [the twelfth and thirteenth centuries] when character has no existence outside destiny, and destiny means the convergence of simultaneously developed themes, now separated, now coming together, varied, yet synchronized, so that every movement of this carefully planned design remains charged with echoes of the past and premonitions of the future."[14] What Bakhtin described as the ideology of romance time, space, and identity is here equated with textual structure itself and the extratextual notion of destiny.

Paul Ricoeur discovers similar connections in confessional memoirs such as those by Augustine, Rousseau, and Proust. In such works, the narrative string is fused with the circling time of identity. Constancy of identity and the narrative wholeness of romance again are shown to be inseparable correlates.[15]

White, Bakhtin, Vinaver, and Ricoeur all agree on the connection between the self-sameness of the subject and the "artificial" narrative cohesion found in romance. This connection is another reason for the

frequent recourse to visual artworks in romances, for if identity and static artwork are equated, both may signify the romance plot conceived as an atemporal totality. Thus, Vinaver argues for an analogy between medieval interlace designs and the plot structures of contemporary romance. And in modern art, the Proustian structures of which Ricoeur speaks are said to possess the "spatial form" of paintings because of their intricately interconnected plots: "the spatial-form novel is an alternative to the *Bildungsroman*. It offers a *Bild,* a picture; it portrays someone who has *already* developed, who is largely past change. Without development, the narrative's 'and then' has atrophied to simply 'and.' . . . The progress of the narrative, then, involves uncovering a more or less static picture."[16]

Paintings symbolize the mode of narrativity to be found in romance, and at the same time contrast the "flow of events" that one naively imagines in realism. Indeed, Vinaver has proposed the idea that medieval romance comes into existence specifically at the moment when the plot "strings" of French epic, for example *The Song of Roland,* were transformed into the cyclical narratives that we have been describing, in which sequence has a meaning and hence a beginning, middle, and end. "The marriage of matter and meaning, of narrative and commentary, was the key to the new kind of narrative poetry—the poetry that assumed in the reader both the ability and the desire to think of an event in terms of what one's mind could build upon it, or descry behind it" (Vinaver, p. 23). This switch corresponds to White's shift from annals and chronicle to history-writing proper (White 1980, pp. 5–27). And Todorov comments on the frequency of special possessors of meaning in the quest romance, such as sages, hermits, recluses, and so forth, who cannot act but only know, interpreting the meaning of the hero's acts. Thus, "one half of the text deals with adventures, the other with the text which describes them. Text and metatext are brought into continuity."[17]

In this respect, the romance has made a part of its overt thematics what is always a feature of narrative, a feature that we might term its semiotic circularity. As Robert Scholes describes it: "Narrative is always presented *as if* the events came first, the text second, and the interpretation third, so that the interpretation, by striving toward a recreation of the events, in effect completes a semiotic circle. And in this process, the events themselves have become humanized—saturated with meaning and value—at the stage of entextualization and again at the stage of interpretation."[18]

This constant circling back of the text on itself, this implication of memory in event, embeds the chain in the network, the thread in the labyrinth. It teaches us that the episodic and the configurational are

always interdependent. As Ricoeur puts it, "the humblest narrative is always more than a chronological series of events and . . . in turn the configurational dimension cannot overcome the episodic dimension without suppressing the narrative structure itself" (Ricoeur, p. 178). As a result, "the temporal implications of this two-fold structure of the plot are so striking that we may already conjecture that narrative does more than just establish humanity, along with human actions and passions, 'in' time; it also brings us back from within-time-ness to historicality, from 'reckoning with' time to 'recollecting' it. As such, the narrative function provides a transition from within-time-ness to historicality. The temporal dialectic, then, is implied in the basic operation of eliciting a configuration from a succession" (p. 178).

Though all narrative, insofar as it possesses wholeness, elicits a configuration from a succession,[19] one might say that the romance differs from the realist narrative in calling attention to this fact, in supporting the fiction that realism is mere sequence, and in exploring the nature of the configuration as a fact of imaginative life.

Romances often signal the difference between configuration and succession by juxtaposing inconsistent temporal modes. *Sir Gawain and the Green Knight,* for example, opens and closes in what White would call history as chronicle: a genealogy of the kings of the ancient and medieval world leading from Aeneas to Arthur at the beginning, and a projection from Arthur up to the "present" of the writing of the text. Embedded in this terminating, but not culminating, sequence is the Gawain tale proper, a story opening at a typical romance "crack in time," the shift from the old to the new year. Into this suspension of temporal flow comes the Green Knight with his miraculous power to be killed and rise again, and his challenge to Gawain to seek out the same fate in a year-and-a-day's time.

To represent the passage of a year and a day, the text switches from adventure narrative into what might be called a lyric of temporal flow. Season gives way to season in pure sequentiality, with no circling back upon itself, no teleological or subject wholeness such as narrative or history proper requires. The only end supplied is that required by the surrounding narrative, which frames this mere chronological sequence and gives it a particular meaning. It breaks the flow to suggest a circle: we are at the same time a year later, and Gawain must go forth to be tested. His trials demonstrate who he is—a worthy but imperfect man—and the girdle that he gains marks both his fallen nature and that of everyone, whose heroism is always infected with original sin. In the contrast between nature's flux and the formal coherence of adventure time, iden-

tity emerges. Then the frame returns to chronicle time in bringing the flow of kings to the present of the writer.

Virginia Woolf's *To the Lighthouse* inserts the staggeringly beautiful flow of years in "Time Passes" into the book's structured quest, in which the painter Lily Briscoe not only comes to understand past feelings but to express them in her art. Like *Gawain*, *To the Lighthouse* juxtaposes these modalities of time as if to show the interrelation of sequence and pattern, of events and memory, of flow and stasis.

Painting itself helps to symbolize these oppositions. Lily Briscoe is not able to finish her "portrait" of Mrs. Ramsay as long as events and characters appear to her merely as a flow. It is not until she connects past and present and understands her own feelings toward Mrs. Ramsay that the configuration of shapes in her composition can be completed. Again, the potency of the symbol of painting is apparent. Though Lily's canvas is not itself narrative but abstractive, it forms the final "episode" in the overall sequence of works of its artist. This narrative interpretation is precisely the technique used by art history to attribute meaning to single works, turning them into episodes in the narrative of a painter's career and ultimately in the history of a culture's art. Lily's static canvas is the product of a story that supplies its ultimate meaning.

In sum, a long-standing system of connections exists between painting and the romance. These take the form of tensions: between exact repetition and "repetition with a difference," arrest and narrativity, voyeurism and vision, narcissism and love. The modeling of pictorial perception in painting and the romance preoccupation with reader response extend these contrasts to the realm of aesthetic theory. Is the artwork a formal entity to be appreciated with "disinterested interest" as complete in itself and beyond historical contingency, or is it to be appropriated by its perceiver, drawn into a new human context each time it is interpreted and enjoyed? The romance, as we shall see, pits formalist against contextualist aesthetics by means of visual art symbols, to which it has a very contradictory relation. On the one hand, paintings symbolize the romance's artificiality, cohesiveness, ideality, and aesthetic nature; on the other, they conflict with its realism, narrativity, contingency, and eroticism. These oppositions in painting, exaggerated by the Renaissance separation of perspective from narrative, echo in the literary romance and make it a profoundly theoretical mode. In the next three chapters I shall show how these problems are handled in key romanticist and modernist texts.

*Men marveled at her divine loveliness, but as men marvel at*
*a statue fairly wrought.*
—Apuleius

# 3 Empowering the Perceiver: Keats

The meaning of the painting-romance relation depends, of course, on
the normative system(s) governing the visual arts at any given historical
point. When the Renaissance separated perspectivalism from multi-
episodic narration, the various oppositions explored in romance (for ex-
ample, image versus story) stood out in high relief. In modernism, on
the other hand, these contrasts appear in quite different configurations.
The next three chapters will be dealing with texts on either side of the
modernist rift: Keats and Hawthorne at the end of Albertian domi-
nance and Joyce after its demise. These writers' romances chart the dis-
ruptions caused by shifting normative systems and the resulting ambiva-
lence between formalist and contextualist thinking.

We enter the history of the romance-painting connection with Keats,
at a moment when it could hardly have involved a more troubled set of
issues. After over two hundred years, the critical orthodoxy of *ut pictura
poesis* had been exploded by Lessing, whose *Laokoön* had so sensitized
critics and artists to the differences between artistic media that the
analogy of spatial painting to temporal literature now seemed counter-
intuitive. Moreover, if M. H. Abrams is to be believed, the switch from
a mimetic to an expressive aesthetic theory had turned attention to mu-
sic as the art analogous to literature, and away from painting, the para-
digmatic mirror of reality.[1]

However, far from eliminating paintings from romantic symbolism,
the dichotomizing of the spatial from the temporal arts and of mimesis

from expressivity instead focused new interest on the romance's use of pictures. Poets fixed on the dual nature of the romance as a temporal flow and as an aesthetic configuration exempt from time's depredations—a genre specifically concerned with both process and epiphany. The concept of identity followed this debate—at once the *Bildung* of time and experience and the *Bild* of memory.

Not only in the romance, but in criticism as well, the complex of issues involving painting and literature seems to have captured the romantics' imagination:

To argue that the decline of the traditional pictorial theory in the early nineteenth century is paralleled by a corresponding decline in overt allusion to painting is misleading. In spite of Coleridge and Hazlitt's perception of the limits of painting and the limited validity of the traditional analogy, painting, even considered in this negative role, still remained the dominant analogy in the critical writings of the romantic period, and was still employed as illuminative of the essence of poetry.[2]

Martin Meisel's study *Realizations* demonstrates the extent of pictorial and narrative interconnection in nineteenth-century England. He describes the popularity of Hogarth's pictorial series, frequently reproduced, dramatized, and imitated by such artists as Morland, Northcote, and Thomas Cole. The Pre-Raphaelites reintroduced the triptych and other multiply-framed forms as narrative structures for painting. And with the establishment of the Shakespeare Gallery, the Poet's Gallery, the Milton Gallery, and later the Gallery of Illustration, all dedicated to the commissioning and exhibiting of graphic illustrations for narrative works, the nineteenth century showed itself to be one of the great ages of illustration. Drama in this period teemed with pictorial elements, from the frozen action of the tableau to the theatrical "effect" itself, a striking appearance described as "the impression produced upon the mind by the sight of a picture, or other work of Art, at first glance, before the details are examined" (Meisel, p. 72). Meisel goes so far as to identify "the pervasive collaboration of narrative and picture in the culture [of nineteenth-century England], as the matrix of a style and as a way of structuring reality" (p. 68).

The nineteenth century thus seems to be not a hiatus in the painting-literature connection, but a critical and artistic laboratory for the redefinition of the relationship. The number of pictures, portraits, busts, statues, tapestries, tableaux vivants, stained-glass windows, and buildings occupying symbolic space in nineteenth-century literature is staggering, and the connection of these to the romance, particularly as a foil

for the realistic, psychological novel, is very clear. Not only are these artifacts the stage-props of the Gothic romance, but they served "serious" novelists as a negative example of their own undertaking.

Jane Austen's *Emma* is one of many works that might be cited in this regard. Emma, in her matchmaking zeal, paints an idealized portrait of her friend Harriet, showing her taller and more sublime than Harriet ever aspires to be. But rather than causing the targeted male to fall in love with Harriet, the portrait increases his admiration for Emma. In an illustration made to order for *The Mirror and the Lamp*, the portrait is valued not for its mimetic object, but for its expressed author. Emma's intention, paradoxically, is subverted by her audience's very concern to read her in her work, and Jane Austen humorously reveals the aesthetic consequences of being out of step with one's audience and time. The lesson in interpretive sensitivity set for Emma is the lesson of the expressive theory itself: that behavior, speech, and art are to be taken as tokens of the personality behind them. And this interpretive mode is represented not by the archetypally expressive art, music, but by painting.

Austen's choice here indicates her association of the expressive lesson with common sense and its aesthetic correlate, realism. For Emma's problem, of course, is that she is trying to read reality as a romance. Elated by the success of matching her governess with a good man above her station, Emma imagines her life's work as the authoring of a string of such happy endings. The governess married to the man of property is a good beginning, but Harriet presents an even more challenging romance potential because she is illegitimate. Emma immediately imagines her as the fruit of a noble mésalliance and so the proper wife for a man much above her current social station—could the truth but be known. Hence Emma paints the picture and engages in her foolish plots, only to learn that Harriet has come of rather common stock, and that her own matchmaking has almost robbed the two girls of future matrimonial happiness. Only by leaving behind such romance stereotypes can Emma hope for true love and a happy ending.

Of course, Austen herself arranges for the marriage of a governess and a lord, finds the right mate for Harriet, and bestows Emma, disabused of her romantic fantasies, upon the noble Knightley. She obviously would brook no competition from her heroines when it came to the romance, and so created a lesson in realism for her presumptuous romancer that left Emma a realist romance heroine. This piquant paradox is by no means uncommon in the love novels of the nineteenth century. Their dependence on romance formulas and their simultaneous disdain for the literary romance are definitional. Indeed, the actual romances of the day seem suspiciously similar in intent. As Tilottama Ra-

jan has argued, though the romance is an "antimimetic mode," it "is perhaps the form most central to Romanticism itself, considered as an aesthetics of corrective illusion."[3]

Keats, drawn into this romance ideology, was also faced with the heritage of pictorial symbolism within it. He shows an awareness of the connection early on in his work, where vision and the visual arts are consistently associated with romance. What is "More full of visions than a high romance?" he asks in *Sleep and Poetry* (l. 10).[4] In *Endymion* he associates "needle broidery, / And minstrel memories of times gone by" (I, 434–35), and also moongazing and romance (III, 142–69). And in an early fragment, *The Castle Builder*, he prefers "a Gothic waste / Of eyesight on cinque-coloured potter's clay" to "the marble fairness of old Greece" (ll. 36–38). The complex of visual art, romance, love, the moon, and sight are assembled here in opposition to a classicist coldness and precision that endanger them.

However, more often than not, Keats stresses the dangerous power of romance vision. His notion belongs with Frye's romance archetype of descent and frozen identity, for in poem after poem he explores the fragile line separating transcendence and enthrallment, rapture and enchantment. The role of art, paradoxically, is to cast a spell of words in order to ward off enchantment, to be ideal in order to return us to reality.

> For Poesy alone can tell her dreams,—
> With the fine spell of words alone can save
> Imagination from the sable chain
> And dumb enchantment.
> *(The Fall of Hyperion: A Dream,* I, 8–11)

As the preeminent romance symbol of spiritual enslavement, the visual arts undergo a programmatic scrutiny in the major works of 1819 that is surprising for anyone trained to think of the sister-arts analogy as passé.[5] Indeed, I would argue that virtually every one of Keats's masterpieces is concerned with redefining imaginative activity in terms of the visual arts and with saving vision from stasis and enthrallment.[6]

The perennial romance theme of identity arises here, not only because the romance temporarily freezes the self in a mirror image or painting, but also because, in its opposition to realism, the romance insists on the confusion of reality and illusion, and hence, on the radical uniqueness and isolation of any person's imaginative creation of the world. "In many works of fiction reality is equated with the waking world and illusion with dreaming or madness or excessive subjectivity. . . . but . . . such a standard marks the ascendancy of realism. The ro-

mancer, *qua* romancer, does not accept these categories of reality and illusion. Both his idyllic and his demonic worlds are a mixture of the two, and no common-sense assumptions that waking is real and dreaming unreal will work for romance" (Frye, p. 53). The relevance of this statement to Keats, who not only remarked on the episode in *Paradise Lost* where Adam awakens from his dream of Eve to find it true[7] but structured the central episode of *The Eve of St. Agnes* as a waking dream, should be obvious. Keats's *Eve* is a consummate exploration of creativity, imagination, and individual identity as they are thematized in the romance.

To achieve the treatment of these issues that he wanted, however, Keats was forced to revise the romance. He did so by building on two sources of "old romance," one religious and one pagan. These are the life of St. Agnes and the story of Cupid and Psyche as rendered in Apuleius's *The Golden Ass*. The saint's life serves to express the dangers of enthrallment that come with religion and old romance, whereas the Latin myth celebrating the transcendence of the individual psyche is closer to Keats's views, but contains a Neoplatonic idealism that Keats undermines in his poem. The interplay between the saint's life and the neoplatonic myth undoes both sources.

The contrast between the two stories suggests another ideological opposition: that between the old and new "religions" of the ancient world. As Keats wrote, "Psyche was not embodied as a goddess before the time of Apuleius the Platonist who lived after the Augustan age, and consequently the Goddess was never worshipped or sacrificed to with any of the ancient fervour—and perhaps never thought of in the old religion—I am more orthodox than to let a hethen [sic] Goddess be so neglected."[8] Erich Neumann points out the significance of this shift not only as a change within the ancient world, but one from the medieval to the Renaissance world as well:

The tale of Psyche represents a development which in an extra-Christian era, without relevation and without church, wholly pagan and yet transcending paganism, symbolizes the transformation and deification of the psyche. It was another fifteen hundred years before it again became possible and meaningful, under entirely new circumstances, to speak of a deification of the human psyche. It was only after the medieval ban on the feminine-earthly side of psychic life—a ban laid down by a spiritual world one-sidedly oriented toward celestial-masculine values—began to be lifted that the divine in earthly nature and the human soul could be rediscovered.[9]

Keats amends the omissions of both old religions by redeeming the Catholic saint's life to a radical individualism through the myth of Psy-

che, and in fact going that myth one better. Hence the appropriateness of Harold Bloom's characterization of Keats as not among the Catholic classicist poets represented and promoted by Eliot, but among the Protestant radicals running from Spenser to Milton to the Romantics, who portray "the autonomous soul seeking its own salvation outside of and beyond the hierarchy of grace." [10]

Keats transformed the Catholic story of St. Agnes into the mythic romance most centrally concerned with the mind, the individual imagination, love, the relation between dreaming and waking, and the opposition of stasis to visionary passion. *The Eve of St. Agnes* and the other works of 1819 are an imaginative rescue of the soul from the static enthrallment symbolized by painting and the other visual arts, and at the same time, a wistful appreciation of the inhuman completeness and permanence those arts nevertheless offer. As such, the 1819 poems "seem to be ironic and sentimental at the same time, to deconstruct and yet cling to illusion" (Rajan, p. 101). But far from being merely confused or ambivalent on these two positions, Keats shows them as the two building blocks of imaginative experience, operating in an unavoidable oscillation. No sooner does the spirit achieve a momentary touch with the real than the moment becomes enclosed, shaped, structured, with a beginning, middle, and end—the hypostatized, static object of memory or art. The person then attempts to merge this dream with the real once more, but the achievement will inevitably revert to a finished product, and so on indefinitely. Keats symbolizes the process by nesting artworks one within the other in his poems as records of transcendence reified in an ongoing struggle. This pattern is, in effect, Keats's version of reader reception. With similar intent, he takes the St. Agnes and Psyche stories and creatively remakes them from their static remains.

The legends of Agnes and Psyche both contain paradigmatic scenes of viewing. The virgin who abstains from food and keeps her eyes fixed before her in the rites of St. Agnes's Eve will be granted a vision of her future husband, just as St. Agnes, who disdained worldly lovers, achieved such a vision of her heavenly Spouse. Psyche, married and bedded in the dark, loses her husband when she finally sneaks a look at him as he sleeps, only to regain him through a typical romance set of ordeals. Gazing asleep or entranced and gazing on the sleeping or entranced other are structural givens of the two sources which Keats exploited for his thematics of pictorial vision and romance.

Beyond the legend of St. Agnes's Eve with its paradoxical promise of a virginal vision of the spouse, the story of Agnes's martyrdom itself is echoed in Keats's poem. According to *The Golden Legend,* in approximately the year 304 Agnes refused to wed the son of the Roman prefect

*Fig. 11.* Jean Pucelle, *St. Agnes Receiving a Robe from an Angel. The Belleville Breviary.*

and was denounced as a Christian. On being called before the prefect, she boasted that she already had a lover: "He has placed his ring upon my finger, has given me a necklace of precious stones, and has clothed me in a gown woven with gold. He has graven a sign upon my face, to keep me from loving any other than Himself, and He has sprinkled my cheeks with His blood. Already I have been embraced by His pure arms, already His body is with my body. And he has shown me an incomparable treasure, and has promised to give it to me if I persevere in His love."[11]

In order to change her mind, the prefect ordered Agnes to be stripped and taken to a brothel. But on the way her hair miraculously grew to cover her nakedness and "when she reached the house of shame, she found an angel awaiting her, holding a tunic of dazzling whiteness [fig. 11]. Thus the place became for her a house of prayer, and the angel cast about her a supernatural light" (Jacobus de Voragine, p. 111). She was next burned at the stake, but emerged unharmed. After each of her trials, the prefect's son fainted or died, and Agnes miraculously brought him back to life. Finally, on January 21, she died by being stabbed in the

throat or beheaded. "Her heavenly Spouse claimed her for His Bride, having decked her with the crown of martyrdom" (p. 112). Eight days after her burial she appeared among a choir of angels at her grave, accompanied by a snow-white lamb. She addressed the mourners as follows: "Look upon me, in order that ye may not mourn me for dead, but may rejoice and be glad with me; for I have been admitted henceforth to sit in the midst of this company of light" (p. 112). Agnes's feast day, January 21, is observed by a blessing of lambs, whose wool is woven into the pallia of archbishops.

All saints' lives are metamorphoses, transitions from a physical to spiritual state. In this case, the transformation is merged with a marriage, and both depend upon fidelity to a visionary image of a beloved. Everything in St. Agnes's story contributes to the polarization of opposites—earthly versus heavenly marriages, physical versus spiritual love, this life versus the next, brothel versus house of prayer, and so forth. This polarization is presented throughout as the choice between spirituality and the fallen world, whereas Keats's achievement in *The Eve of St. Agnes* is to introduce the spiritual into the real world. Agnes must die to achieve transcendence, but Porphyro and Madeline have theirs in this life—they wake and find the dream true.

Thus, Keats remakes the saint's life. The sign that Christ placed on Agnes's face (the sprinkling of her cheeks with His blood) and the decking of her head with the crown of martyrdom are repeated in the moonshine cast through the stained-glass window as Madeline kneels in prayer. The window is Gothic and "triple-arched" like a Catholic triptych. However, its designs are only partially religious with their "twilight saints," but otherwise distinctly secular, full of fruits, flowers, rich colors, and heraldic devices. In their midst "A shielded scutcheon blushed with blood of queens and kings." Romance and Catholicism blend in this glass through which the pallid "wintry moon" of enthralling romance shone down

> And threw warm gules on Madeline's fair breast,
> As down she knelt for heaven's grace and boon;
> Rose-bloom fell on her hands, together prest,
> And on her silver cross soft amethyst,
> And on her hair a glory, like a saint:
> She seem'd a splendid angel, newly drest,
> Save wings, for heaven.
>
> (ll. 218–24)

Here Madeline becomes Agnes decked in Christ's favors. She is also the reflection of romance.

These favors are presented as sterile and even sinister, however, for the sight of Madeline so decked makes Porphyro grow faint—immobilized, bereft of consciousness—and the qualification that Madeline is an angel without wings indicates that hers is an imperfect form of transcendence. In the stanza immediately before the casement description, Madeline's emotion at the thought of the vision to come yearns vainly for expression, "As though a tongueless nightingale should swell/Her throat in vain, and die, heart-stifled in her dell" (ll. 206–7). The failure of expression is the crucial problem with orthodox religiosity in this poem, and Keats expresses it through the immobilized image of Madeline "painted" by the romantic "faded moon" (l. 253) in the red and purple that will later render the passion of Porphyro and Madeline's love.

Agnes's appearance in the brothel, covered with her newly grown hair and angelic robe and bathed in a supernatural light, is echoed in the scene of Madeline's disrobing. Madeline innocently strips before the eyes of Porphyro, who with the help of Madeline's nurse Angela has hidden himself in her chamber. The parallel here to a procuress and client is obvious, and the poem keeps oscillating between two expected assessments of the scene—prurient voyeurism on Porphyro's part, or his self-annihilating worship of the still, enthralled dreamer. The poem condemns both these possibilities, insisting on a vital, active love instead.

The ironic treatment of the St. Agnes details works against both prurience and enthrallment. Madeline's disrobing is described in unmistakably sensuous fashion: she removes the pearls from her hair and the warm jewels from her body "one by one" (l. 228), and "Loosens her fragrant bodice; by degrees / Her rich attire creeps rustling to her knees" (ll. 229–30) until she stands "Half-hidden, like a mermaid in sea-weed" (l. 231). Her hair is down, but she remains, unlike Agnes, only half-hidden, and after she enters her curtained bed Porphyro is left in his hiding place gazing not upon her decked in a celestial robe but upon "her empty dress" (l. 245). Neither glorious transfiguration nor sexual exposure has occurred. The scene achieves only nonexpression, nonrevelation, and nonfulfillment.[12]

This state of suspension suggests a pun on the word *Eve* in the title of the poem. Patricia Parker points to the association between evening and pendency: after Milton, "the countless Odes to evening . . . move . . . away from polar opposites and the immediate pressures of a decision Either-Or. . . . The suspended realm of evening or twilight, therefore, is not only the archetypal space of romance but, for English poets after Milton, an inevitable recall of the lingering 'Twilight gray' of *Paradise Lost*" (Parker, p. 12). Parker then leads us to an association of evening

with Milton's Eve, as she stares at her image in a pool immediately after "waking up" from the sleep of her creation. She, like Madeline, has been dreaming of her future husband, but instead she is confronted with an image of herself. "The obvious literary echo of the passage—noted from the earliest commentaries—is Ovid's description of Narcissus, the figure whose fate Eve suggests and then avoids by turning from self-reflection to the one 'Whose image' she is. But, though the association is only indirectly introduced through the possibility of a pun on 'Eve,' this moment of self-reflection and turning also recalls that interval of decision which Patristic tradition described as 'evening' or 'twilight' vision" (p. 115).

*The Eve of St. Agnes,* if read through this pun, makes Madeline an Eve, engrossed in her own image but soon to awaken to a better vision, her husband. Keats of course compares her to Adam, who awoke to find his dream of Eve true. The rejection of narcissism in favor of love, a perennial romance move, is here dramatized in the moment of suspension of this eve. Moreover, the entire poem, which bears this name, becomes an image of pendency. The romance work of art is just such a suspension, leading either to self-absorption or a turning outward to life.

With Madeline entranced on her bed, Porphyro, in the "dim, silver twilight" (l. 254), rather than Agnes's "supernatural light," prepares the exotic feast that is described in the poem's next stanzas. This feast, never consumed, is parallel to the promised "incomparable treasure" that Agnes boasts will come to her if she remains faithful to Christ. It involves the same exoticism and romance as the stained-glass windows, and is as ineffectual a means of transfiguration as that window. Neither the sensuous feast nor the purely spiritual treasure is the reward for transcendent love; instead a mingling of these contradictories is needed.

Finally, whereas Agnes's apotheosis allows her "to sit in the midst of this company of light," Madeline and Porphyro are left as totally alienated from the reveling company as they began, and in fact flee in terror out of the castle into the cold of winter. The transformation that their love achieves isolates them and ultimately deserts them; it does not promote a community or even a continuity of faith or vision. In this view, transcendent passion is a radically individual, temporary, imaginative act, another way in which the Catholic story of St. Agnes is revised in Keats's romance. Whereas orthodox Catholic vision recreates reality forever and for everyone, transcendence in Keats turns into a moment frozen in time and isolated from the ongoing lives even of those who have experienced it. Whereas Agnes becomes an immortal saint singing eternally with the angels and appearing with her lamb before the faithful,

Porphyro and Madeline fade into shadows, fleeing into the snows of the distant romance past.

Romance thus proves to be of a piece with fallen religion. The rites of St. Agnes's Eve are "enchantments cold" and both religion and romance are ashy remnants of real passion. The very names that Keats chose serve to create these connections. "Madeline" recalls religion through its source, Mary Magdalen, and suggests the ironic connection between Agnes and Keats's heroine, who both figure in brothel or brothel-like scenes. "Porphyro" is related to Porphyrius, a Neoplatonic philosopher who would have been associated for Keats with Apuleius's Platonism and who was central to the medieval debate as to the relations between universals and sensibles, the ideal and the material.[13] The hero's name suggests Porphyrion as well, a titan wounded by Cupid who then tries to rape Hera. He is one of the cold immortals who enters the world of "breathing human passion"—though he does so abortively. Porphyry is a rock, a symbol of pure materiality. Finally, "Porphyro" is associated with the color purple and hence with the rare and valued. This color and Magdalen's harlot red are the two hues of the consummation scene.

The Cupid and Psyche myth merges into this system (and one might even wonder whether a sly pun might be implied between *The Golden Legend* and *The Golden Ass*). The imaginative proximity of the religious and pagan subtexts is also apparent in paintings of this myth. One of Luca Giordano's Cupid and Psyche canvases, "which Keats could well have seen," "shows Psyche being worshipped in a manner that seems to parody pictures of the Adoration of the Virgin Mary" (Jack, p. 211). This association is paradigmatic for romance, given the connections between mariolatry and courtly love.[14] James Joyce makes direct use of it in his takeoff on romance in the "Nausicaa" chapter of *Ulysses*, where Bloom's voyeuristic masturbation with Gerty MacDowell occurs against the backdrop of a mass for the Holy Virgin.

Like the story of Agnes, the Psyche and Cupid myth involves marriage. It is told in *The Golden Ass* to a girl who has been stolen away on her wedding day. She has just dreamt that her bridegroom was killed by bandits, and the old woman guarding her advises: "You must be cheerful and stop worrying about dreams. The dreams that come in daylight are not to be trusted, everyone knows that, and even night-dreams often go by contraries."[15] The frame of this tale thus involves the conflict of imagination and reality and the suspension of a marriage, which creates the space for romance adventure. The story that follows is a triumphant merging of dream and waking in marriage, and the entire plot is dependent on the symbolism of the visual arts.

Apuleius initially presents Psyche as a mortal maiden so beautiful that people neglected Venus to worship her. "Human speech was all too poor to describe her beauty, or even to tell of its praise. . . . [Crowds] were struck dumb at the sight of such unapproachable loveliness. . . . they worshipped her with prayers of adoration, as though she were the goddess Venus herself" (Neumann, p. 3). The silence of the crowds and the response of adoration rather than desire involve the same enthrallment and religious awe that characterize Porphyro's initial response to Madeline. This is also the standard response to art, which must be overcome in Keats's revised romance. Apuleius himself signals the aesthetic import of Psyche: "Men marveled at her divine loveliness, but as men marvel at a statue fairly wrought" (p. 6). Psyche's beauty is so great that it creates cold distance rather than warm connection, the dumbness of the crowds itself echoing the dumbness of a statue—for Keats's generation the sign of incomplete aesthesis, the impoverished painting or sculpture as "mute poem."

Accordingly, Psyche, despite her beauty, is unable to attract a husband and becomes the enemy of love itself in the person of Venus. The psyche that becomes reified and static, like a statue, is antithetical to love, and Venus's jealousy toward Psyche signals this state. She sends her son Cupid to punish Psyche, but he instead falls in love with her. Her parents, having heard from an oracle that Psyche will marry a monster and despairing of ever finding her a mortal husband, arrange for her marriage to an unknown being under the peculiar conditions imposed by Cupid—that the wedding party conduct Psyche to the top of a mountain and leave her there. She walks to the mountain "with the air of a woman going to her grave, not her bridal bed" (Apuleius, p. 118). As was the case for Agnes, marriage and death are here condensed, and the sinister quality of this connection is especially stressed in Keats's *Eve of St. Agnes,* where Madeline's stillness, her disdain of the material world, and her desire for a purely spiritual image of her future husband make her a combination of statue and madonna, and turn Porphyro himself into a paralyzed gazer.

Psyche's bridal chamber, like Madeline's bedroom, contains gorgeously embroidered and engraved decorations. In both, a feast appears out of nowhere. But the most salient similarity is the importance of looking, and in particular of looking upon a sleeping loved one. The condition under which Psyche lives with Cupid is that he appear to her only at night, in the dark, when she cannot see him. He claims that if she does see him, the child they will conceive will be mortal rather than a god like him. At first happy under this arrangement, Psyche is soon

convinced by her sisters that her husband must truly be the prophesied monster, and Psyche takes a lamp and knife to Cupid's bed. For the first time, she gazes on him—on her husband, on a god. She is so overcome with love, falling in love with love itself, or with the still, sleeping image of it, that her hold on the lamp falters and a drop of hot oil burns Cupid's wing. He wakes up and angrily flies off to his mother, abandoning poor Psyche. The forbidden act of vision, the beholding of him as statue and god, loses Cupid (love) for Psyche, at least temporarily. It is only through Psyche's heroic persistence that she eventually overcomes Venus's malice, evokes Cupid's pity, and effects her own transformation into an immortal. Like Agnes, she is joined with her heavenly husband, but not through death and passive martyrdom. She instead goes through the series of romance ordeals that fashion the Soul, and emerges into marriage a goddess herself. The speechlessness of the crowds and of Psyche as fascinated gazer upon Cupid, and the sightlessness of the initial love scenes, are overturned in the final transcendent unity of Soul and Love whose offspring—Pleasure—*is* immortal, however temporary its human correlate.

The climactic sleepwatching episode in the Cupid and Psyche story is the key connection between the myth and Keats's poem. Keats dictates the meaning of gazing raptly on the motionless beloved by references to religion and the visual arts. His opening stanza sets up the connection between the two. It gives us the scene of January coldness with motifs straight out of the pictorial iconography of winter: the owl, the hare, the frozen grass, and the flock standing silent. In the midst of this chill, the Beadsman prays with numb fingers; his breath rising frosted "Like pious incense from a censer old, / Seem'd taking flight for heaven, without a death, / Past the sweet Virgin's picture" (ll. 7–9). He is gazing upon the image of his spiritual spouse, his breath rising—or seeming to rise—toward her. Given the Spenserian stanzas here,[16] the word "seemed" acquires a suspicious cast and we might doubt the unity between earth and heaven to be achieved through prayer. Likewise, the association between chilled breath and the incense released from the "censer old" connects this prayer to ancient mysteries and outdated spirituality—a superstitious world that is as cold and imaginatively sterile as the January scene described. This illusory spiritual breath passes by a picture of the Virgin, the first artwork in the poem. Its religious subject suggests the denial of the fleshly world that Madeline initially emulates. Here static art and flesh-denying religion come together.

After the Beadsman finishes his prayers, he walks back through the church aisle, passing tombs as he goes, just as his prayer passed the Virgin's picture by on its seeming progress to heaven. On these tombs,

> The sculptured dead, on each side, seem to freeze,
> Emprison'd in black, purgatorial rails:
> Knights, ladies, praying in dumb orat'ries,
> He passeth by.

<div align="right">(ll. 14–17)</div>

I believe that a pun is in operation here between "freeze" and "frieze,"
to be countered later on in the poem by the word "frees" as Madeline
looses the pearls and lets her hair hang uncontrolled in one of the most
unbearably ambiguous images of the poem—the virgin, the Agnes-
figure with her hair protecting her purity, shown in her unwitting strip-
tease before the closeted Porphyro. The pun on "frieze" and "freeze"
parallels the sculptures themselves, which are doubly dead, because they
are statues and because they are statues of the dead—the dead figures of
romance knights and ladies, in fact, depicted in the act of prayer. Their
dreary chill makes the Beadsman's prayers seem even more a failure of
vital spirituality, again a double death—the mere static image of the de-
luded act of prayer "in the *dumb* orat'ries" (italics added).

The Beadsman turns away from the music that he hears coming from
the debauched revelers in the castle beyond the chapel, but the carved
angels below the cornices, in contrast, watch the scene of revelry "eager-
eyed" (l. 34). Still, because they are statues, even though showing eager-
ness rather than deathly prayer, they are "*ever* eager-eyed" (italics added);
like their audience, they are archetypally static viewers. What they look
upon is life itself—vitality and physical pleasure—which are symbolized
by music. But no sooner does the poem establish this connection than it
insists that the purely physical is as much an illusion as its spiritual
opposite.

> At length burst in the argent revelry,
> With plume, tiara, and all rich array,
> Numerous as shadows haunting fairily
> The brain, new-stuff'd, in youth, with triumphs gay
> Of old romance. These let us wish away.

<div align="right">(ll. 37–41)</div>

The revelers are like shadows; their gaiety is the false appeal of old
romance, as the heraldic "argent" suggests. They are to be merely
wished away.

And with that, the poem shifts to Madeline and her yearning for the
"visions of delight, / And soft adorings from their loves" (ll. 47–48)
that St. Agnes's Eve should bring. Like us, she turns away from the se-
ductive music of romance to the still vision of ascetic love promised by
religion. She, like Agnes, rejects physical lovers for a dream. As the

poem directs us to see, she is "Hoodwink'd with faery fancy; all amort, / Save to St. Agnes and her lambs unshorn, / And all the bliss to be before to-morrow morn" (ll. 70–72). She is as fooled ("hoodwinked") and as paralyzed ("amort") as the Beadsman.

Porphyro meanwhile is riding to the castle praying to the saints for the mere "sight of Madeline, / But for one moment in the tedious hours, / That he might gaze and worship all unseen" (ll. 78–80). However, what begins as a parallel wish to Madeline's—that he might have a fleeting glimpse of his beloved and worship her unseen—soon escalates into the desire for a much more physical connection: "Perchance speak, kneel, touch, kiss—in sooth such things have been" (l. 81). An enemy of the reveling company, his only friend is Madeline's nurse Angela, whose name and false virtue tie her to the carved angel voyeurs and the failed spirituality of religion that open the poem. She tells him of Madeline's intent to perform the ritual of St. Agnes's Eve, and upon hearing this "he scarce could brook / Tears, at the thought of those enchantments cold, / And Madeline asleep in lap of legends old" (ll. 133–35). For Porphyro, the true lover, Madeline's plan is a self-delusion antithetical to love.

Porphyro, hidden in Madeline's bedchamber, begins his watch of the virgin. She is mute in accordance with the St. Agnes's Eve rites—like a tongueless nightingale who dies "heart-stifled, in her dell" (l. 207). Here Madeline becomes a mute poem or a "tuneless dittie." Her obedience to ritual freezes her from life. This commerce with dream resembles her later visionary state, as suggested by the ambiguous symbol of the stained-glass window. Not only does it evoke the parallel with St. Agnes transfigured by her heavenly Spouse, but it is described in a breathtakingly beautiful piece of poetry. In the context of the string of artworks included in the poem, the window evokes the world of romance and hence frozen art. It is full of heraldic devices and romance kings and queens whose reflection is projected upon Madeline by the light of the romantic moon. The window thus is connected with all the dangerous forms of delusion and enthrallment that old romance and religion represent. Yet at the same time, the colors cast upon her—"gules," "rose-bloom," and "soft amethyst"—are a hushed version of the red and purple that signal the passionate consummation of love later on. The window thus transforms life with a pale copy of the transcendence that passion brings. It is like memory or any of the other reifications of passion that we have considered—enthralling because they are so like the passion they bloodlessly record.

The trappings of religion and romance turn Madeline into a "splendid angel, newly dresst, / Save wings, for heaven" (ll. 223–24), so po-

tent an image of purity and beauty that Porphyro grows faint at the sight. His enthrallment to this still perfection threatens to make him into a still image as well. However, "Anon his heart revives," and he proceeds to play the voyeur after Madeline slowly and tantalizingly takes off her clothes. She lies on her bed and daydreams of St. Agnes in her bed, who was in turn daydreaming of her heavenly Spouse. Thus, Porphyro keeps watch near Madeline who is "watching" St. Agnes who is herself engaged in vision. This regress of vision and voyeurism is presented as somewhat sinister, though infinitely attractive. Parker points out the parallel of Satan watching Eve asleep or Iachimo before Shakespeare's Imogen (Parker, p. 168). When Madeline finally falls asleep, her obliviousness to reality is complete: "Blinded alike from sunshine and from rain, / As though a rose should shut, and be a bud again" (ll. 242–43). She has returned to a state of mere potentiality, losing the ripeness and wholeness that a more complete love should give her. Porphyro steps out of his closet, peeps at Madeline through the bed curtains, and prepares the feast.

When all is ready, Porphyro goes to wake Madeline. But he clearly has not calculated the power of her enchantment. He calls her his "seraph" and makes himself into a version of the Beadsman, saying "Thou art my heaven, and I thine eremite" (l. 277). Just as he has shown himself susceptible to enchantment, his feast itself a romance convention, she is totally lost in her enthrallment to dream, and her inability to wake up entoils Porphyro "in woofed fantasies." Thus, enchantment and tapestry are connected in another stock element of romance symbolism associated with entrapment in a maze.

Suddenly, however, inspiration strikes, and Porphyro hits upon the charm of music to break the charm of vision. He sings her "La belle dame sans mercy," a medieval ballad about a knight enchanted by a cruel lady. The music certainly does free Madeline from her sleep, but it has just the opposite effect on Porphyro: "Upon his knees he sank, pale as smooth-sculptured stone" (l. 297). The knight's enthrallment in the song settles upon its singer, and Porphyro becomes the equivalent of a statue. Madeline, now awake, is amazed to behold "the vision of her sleep" in waking life, with the difference that the waking spouse-to-be is not the vital lover of her dream but a static, frozen worshipper "Who knelt, with joined hands and piteous eye, / Fearing to move or speak" (ll. 305–6). Seeing this "painful change," Madeline weeps.

> "Ah, Porphyro!" said she, "but even now
> They voice was at sweet tremble in mine ear,
> Made tuneable with every sweetest vow;

And those sad eyes were spiritual and clear:
How changed thou art! how pallid, chill, and drear!
Give me that voice again, my Porphyro,
Those looks immortal, those complainings dear!"

(ll. 307–13)

Madeline begs Porphyro to be other than a mere image—to speak, to move, to be a vital man rather than a worshipper, a statue, or a watcher. And just as Agnes proved the power of her vision by bringing the prefect's son back from the dead, Madeline's words empower Porphyro to match and then outdo her dream by being real:

Beyond a mortal man impassion'd far
At these voluptuous accents, he arose,
Ethereal, flush'd, and like a throbbing star
Seen mid the sapphire heaven's deep repose;
Into her dream he melted, as the rose
Blendeth its odour with the violet,—
Solution sweet.

(ll. 316–22)

Instead of the partners' alternation at playing static image and enthralled voyeur, here Porphyro and Madeline not only enact the dream but share it, both lovers experiencing a common reality and vision, a unity of the physical and spiritual that gathers in the separate elements of rose and violet, sight and sound, and dream and sexuality. Passionate as this moment may be, Porphyro is "Beyond a mortal man impassion'd far." In this moment passion and vision are one.[17]

But after this consummation, chill reality closes around the lovers. The wind blows, the moon sets, and Madeline fears that Porphyro will leave her. He vows to be her eternal lover and they decide to run away to his home on the moors. They must evade the revelers sleeping under an "arras, rich with horseman, hawk, and hound"—for once a visual artwork commenting significantly on them, as prey fleeing from their hunters. They escape, but as their escape is effected they turn into the very stuff of romance: "They glide, like phantoms, into the wide hall; / Like phantoms, to the iron porch they glide" (ll. 361–62). And as soon as they leave they fade into the past quite literally, with the historical present ceding to the narrative past of times gone by: "And they are gone: aye, ages long ago / These lovers fled away into the storm" (ll. 370–71). The fullness of experience, no matter how perfect, becomes mere memory, and memory dwelt upon is the lure of old romance, old religion, and "eternal" art. Whereas Madeline and Porphyro

escape in phantom form, everyone else is left to embody the exclusionist error he or she symbolizes. The reveling Baron and all his company are beset by grisly, even deathly nightmares. Their dreams, in other words, reveal the meaning of *their* escape, as does the death of Angela, "palsy-twitch'd, with meagre face deform" (l. 376), and that of the Beadsman, "after thousand aves told," sleeping forgotten in his cold ashes. Though transcendence turns into mere memory, it is at least the stuff that dreams are made on and not mere death or oblivion.

The fading away of the adventure into the historical past is one of the clearest indications, I think, that Keats was describing a model of artistic experience in which aesthetic rapture gives way to memory and the surrounding chill of normal, unheightened experience. Rajan sees the narrator's sudden appearance at the end as destroying "what one might call the realist illusion," for "The presence of the narrator prevents Keats's poem from coinciding with the lovers' dream. It compels this poem . . . to live in the space of a discontinuity between the real and the ideal, between the empty verbal sign and the thing it evokes but does not possess" (Rajan, p. 107). Rather than living in this space, however, the poem is the record of the transformation of the ideal yearnings of the lovers into their real breathing passion. Yet, as a mere record, it dramatizes the slipping of the real back into the ideal closure and inhuman form of the work of art that it is. As Rajan notes, "a decorative, antinaturalistic diction and a sense of the tale as existing in a naive genre, whose flatness and resistance to complexity make it alien to the structure of our own consciousness, prevent the narrator from making his dream credible either to his readers or to himself" (p. 115). The narrator's dream is not credible because it is only a dream, because it can be real only for the lovers who live it. They awake and find it true, but we hear only the romance record of it, artificial of necessity. Unless we can somehow live that dream, perhaps through the imaginative intensity of aesthetic perception, or, better, through actual passion, we will remain worshippers and voyeurs in the chill friezes of static vision.

The poem thus sets up a consistent meaning for the visual arts by merging the experience of visual aesthetic perception with that of passive enthrallment. It establishes an implicit hierarchy within the arts, with painting at the very bottom, then frieze and sculpture, then stained-glass window with its blending of material artifact and spiritual light, and then tapestry with its connection to weaving, text, and process art. Better than all of these is voiced song, though as we have seen, it contains dangers as well. Whatever transcendence is possible in life is antithetical to the closed, eternal beauty of these arts. Such transcendence

is momentary and unrecoverable, and whatever trace it leaves behind is an enticing illusion that can enthrall but never fulfill in the way that Porphyro and Madeline's living dream could.

To get a clearer sense of how Keats understands transcendence, we might compare his revision of Psyche's sleepwatching in *The Eve of St. Agnes* with the original by Apuleius. Psyche, we recall, takes lamp and knife to face the monster whom she believes her husband to be. However,

as soon as the lamplight revealed the secrets of the couch, she saw the kindest and sweetest of all wild beasts, Amor himself, fairest of gods and fair even in sleep. . . . But Psyche at the marvel of that sight was all dismayed, her soul was distraught, a sickly pallor came over her, fainting and trembling she sank to her knees and sought to hide the blade in her own heart. . . . Weary and desperate, fallen from her health of mind and body, she gazed again and again upon the beauty of that divine face and her soul drew joy and strength. . . . Then, as her passion for passion's lord burned her ever more and more, she cast herself upon him in an ecstasy of love, heaped wanton kiss on kiss with thirsty hastening lips, till she feared he might awake. . . . [The lamp burned Cupid and] the god . . . flew away with never a word. But poor Psyche, even as he rose, caught hold of his right leg with both her hands, clung to him as he soared on high, and would not leave him, but followed him for the last time as he swept through the clouds of air, till at last overwearied she fell to earth.

(Neumann, pp. 25–27)

Here Psyche beholds the divine image of love illuminated by her lamp, and sickens at the sight, like Porphyro. Then, gaining strength, she gazes "again and again" upon him. But unlike Porphyro, who awakens his love with art, Psyche wakes Cupid with the heat of her passion. No mutual transcendence follows. Instead, Cupid flies up, towing Psyche with him until she cannot hold on any longer and falls to earth. Apuleius's discovery scene is thus like one-half of the transcendence scene in *The Eve of St. Agnes*. It stresses the incommensurability of the waker and the dreamer, the mortal and the immortal, through the prohibition of sight. It allows Psyche a taste of transcendence in her upward ascent with Cupid, but because she has not melted into his dream, because she is not adequate to his immortality, she falls down after the ecstatic vision and flight. Her final transcendence—her flight to Olympus and immortality—is achieved only after she has descended to the underworld, held her own against Venus, and proved her love for Cupid.

What Keats does, in contrast, is to make the sleepwatching scene reciprocal. Porphyro watches the rapt Madeline; Madeline awakens and watches the paralyzed Porphyro. Then, just as he had sought to awaken her through his song, she seeks to enliven him by speaking of the vision

she has had of him in her dream. At this point, the transcendence is achieved. What Apuleius spins out as the plot of his romance, Keats condenses into one spiraling moment. And whereas Psyche's transcendence into immortality is permanent, Porphyro, though "beyond a mortal man impassioned far" for his and Madeline's moment, soon fades into a phantom fleeing on the moor. Real people cannot exist in the eternal realm, and their experience, once complete, takes on the finished, cold perfection of a work of art. It can be worshipped though not loved.

The attitude toward this cold perfection is symbolized by sleepwatching not only in *The Eve of St. Agnes* but throughout Keats's poetry, where seers gaze enthralled at immobile figures who are compared to statues. Endymion is shown paralyzed by sadness through just such imagery:

> But in the self-same fixed trance he kept,
> Like one who on the earth had never stept.
> Aye, even as dead-still as a marble man,
> Frozen in that old tale Arabian.
>
> (*Endymion*, I, 403–6)

Endymion, in turn, frequently stares upward at the unmoved Diana, an image of boundless and self-contained value, and she comes down to gaze upon him in sleep. In *The Fall of Hyperion: A Dream,* the speaker's encounter with the fallen gods Saturn and Thea in the presence of Moneta makes the pathos of the sleepwatcher's position all too vivid:

> Long, long these two were postured motionless,
> Like sculpture builded-up upon the grave
> Of their own power. A long awful time
> I look'd upon them: still they were the same;
> The frozen God still bending to the earth,
> And the sad Goddess weeping at his feet;
> Moneta silent. Without stay or prop
> But my own weak mortality, I bore
> The load of this eternal quietude,
> The unchanging gloom and the three fixed shapes
> Ponderous upon my senses, a whole moon;
>
> (I, 358–68)

The association between the still shape and sculpture and between both of these and death is here quite explicit, as is the spiritual toll upon the perceiver of contemplating such an image.

The sleepwatcher motif functions throughout Keats as an image of artistic perception itself, especially the perception of the visual arts.

Transcendence can occur only when the perceiver is released from enthralled gazing upon an opaque and static object, only when he encounters a processual art, dream, or consciousness into which he can enter, melt. Better than any of these is real experience and the mingling of the physical and spiritual in love. Art, even the visual arts, can simulate this ecstasy, but the simulation freezes rather than frees one.

Leo Steinberg has described the importance of the sleepwatching motif in Picasso's work, and in doing so summarizes its functions in earlier art. I shall quote him at length here, for if sleepwatching is a symbol of artwatching, its appearance in the visual arts should be all the more revealing.

Where meetings of watchers and sleepers occur in ancient art they represent unplanned or delicious encounters. Somnolent nymphs are unveiled by lewd satyrs; everdozing Endymion is visited by the lovesick moon goddess Selene; Dionysus comes upon Ariadne asleep and decides to get married. Invariably the encounter with sleep implies opportunity. And with a few rare exceptions this principle holds again in post-Renaissance art.

But Renaissance artists complicated the fortunes of sleep. They showed dreamers harangued by dream visions, and they dwelled with fascination on stories in which Old Testament heroines take advantage of an enemy's slumber to cut him down. . . . But whether the intrusion is tender or murderous, the one caught napping, victim or beneficiary, is the butt of the action. Sleep is the opportunity of the intruder.

In post-Renaissance art the satyr theme was often modernized and domesticated: we observe a young spark as he lights on a catnapping maid or peeks through a bedroom door left ajar. Inevitably in these situations a helpless sleeper is exposed to the relative omnipotence of an intruder; and the imbalance of power provides the whole plot.

When this imbalance no longer obtains, whenever a confrontation of watcher and sleeper suggests matching powers, the chances are that the scene has shifted from the narrative and literal level to a symbolic plane.[18]

It is this symbolic plane that fascinated Picasso, Steinberg argues, from his earliest use of the motif in a 1904 self-portrait, *Contemplation*. The painter here shows himself watching a girl asleep: "Her radiance suggests the pure bliss of the body, his perplexed consciousness becomes a condition of exile" (Steinberg, p. 93).

The spiritual exile of the viewer's watch (fig. 12) is precisely the state that Keats depicts in his sleepwatchers. Moreover, the need to reform art in such a way as to overcome this exile is the problem of both these artists, and I believe of romanticists and neoromanticists in general. The transference of this motif from the realm of love to that of art is equally characteristic. Porphyro's voyeurism, which Angela fears is prurient,

*Fig. 12.* Pablo Picasso, *Boy Watching over Sleeping Woman by Candlelight*. Etching, c. 1935, no. 26 in the Vollard Suite. Copyright © ARS, New York/S.P.A.D.E.M. 1987.

is in fact the occasion first of worship and then of oneness with the beloved, a recapitulation of Steinberg's history of sleepwatchers culminating in Picasso. In examining this theme in Keats, then, we are witnessing a definitive presentation of an artistic/love problem that has preoccupied artists throughout the nineteenth and twentieth centuries.

This preoccupation is associated with another complex of issues in the visual arts, which Michael Fried has characterized as the opposition between "absorption" and "theatricality." Fried claims that Diderot's revolt against the rococo ushered in an aesthetic in which painting was to draw its beholder in, paradoxically, by creating the fiction of the painting's obliviousness to that beholder. "For Diderot and his colleagues . . . the painter's task was above all to reach the beholder's soul by way of his eyes. This traditional formulation was amplified by another . . . .: a painting, it was claimed, had first to attract (*attirer, appeller*) and then to arrest (*arreter*) and finally to enthrall (*attacher*) the beholder" (Fried, p. 92). This language of enthrallment sounds strikingly like Keats as he contemplates the dangers of romance. But the other side of Fried's paradox sounds even more like Keats. In order to create the enthrallment,

the artwork could not obviously signal the viewer's presence, for that would be to signal its own artifice. Hence, "for French painters of the early and mid-1750s the persuasive representation of absorption entailed evoking the perfect obliviousness of a figure or group of figures to everything but the objects of their absorption. Those objects did not include the beholder standing before the painting" (Fried, p. 86). Among the subjects that these painters found particularly compelling in their absorption were sleepers, figures overcome with melancholy, love, or other passions, or characters engrossed in a work of literature or art.

Indeed, at times Fried's list seems like a catalogue of Keats's poetic subjects, from the *Ode on Melancholy* to *On First Reading Chapman's Homer*. Even the language of Diderot seems a foreshadowing of Keats. Diderot praises Van Loo for his evocation of solitude and silence, in contrast to the rococo Boucher whose "compositions make an insupportable racket for the eyes. This is the most deadly enemy of silence that I know" (Fried, p. 41). Keats's urn, in contrast, is a "bride of quietness," a "foster-child of silence and slow time" (*Ode on a Grecian Urn*, ll. 1, 2). Its ideal silence and absorption draw Keats deeply and frustratingly in: "Thou, silent form! dost tease us out of thought" (l. 44).

In many respects, then, Keats is the unwilling heir of an absorptive aesthetic. He writes of silence, melancholy, enthrallment, rapture, and sleepwatching as if anatomizing the tendency in eighteenth-century painting just prior to the dramatic Davidean tradition. Like Diderot, who was promoting these themes to attack the rococo art of erotic surfaces, Keats pictures his absorptive themes in order to test the ground between voyeurism and vision. The great odes and *The Fall of Hyperion* are a systematic treatment of the relation between painting and the romance, and encompass the entire array of issues it entails.

Helen Vendler's central thesis in *The Odes of John Keats* is that *The Fall of Hyperion* and the odes form a conceptual unity. "I believe that the most important context for each of the odes is the totality of the other odes, that the odes enjoy a special relation to each other, and that Keats, whenever he returned to the form of the ode, recalled his previous efforts and used every new ode as a way of commenting on earlier ones." [19] I would extend this claim to *The Eve of St. Agnes*, a conceptual source for all the poetry to come in 1819. It is Keats's most extensive and explicit presentation of romance concerns, connecting the visual arts, voyeurism, vision, love, and the meaning of narrative closure, in an extraordinary summary of romance ideology.

The *Ode to Psyche* openly signals its relation to one of the central allusions in *The Eve of St. Agnes*, the myth of Psyche and Cupid. Here and in the other odes Keats examines the frozen record of transcendence in art.

In fact, the difficulties with the Psyche ode—"there remains the problem of what exactly it is about" (Jack, p. 201)—are greatly reduced if we read it as a sequel to *The Eve of St. Agnes*. It deals with the aftermath of Apuleius's story, the part that is encompassed in the "happily ever after" that ends normative romance. It is a treatment of what is left after transcendence, what value those ashy remains of romance, religion, and art have for the artist or for his audience.

Everyone has noticed that the *Ode to Psyche* seems to have little to do with the Psyche and Cupid story. It is not as though Keats were unacquainted with the tale. Critics have traced his reading of Mary Tighe's and William Adlington's translation of Apuleius,[20] and they have searched out available pictorial representations of the myth from Spence's *Polymetis* to Tassie's gems, to Luca Giordano's and numerous other artists' paintings and prints (Jack, pp. 209–12). Keats knew of Apuleius's Platonism (see his *Letters,* number 123) and according to Finney at least (Finney, p. 291) he considered himself a Neoplatonist, in the tradition of his protagonist Porphyro's earlier namesake.

More directly, Keats had already told the Cupid and Psyche story himself in *I Stood Tiptoe upon a Little Hill*. There he tries to describe the sense of spiritual transport that nature has provided, charming "us at once away from all our troubles" (l. 138). Note the sensuousness of this version of Apuleius, and in particular the kissing of the eyes—the passionate transformation of cold vision:

> So felt he, who first told, how Psyche went
> On the smooth wind to realms of wonderment;
> What Psyche felt, and Love, when their full lips
> First touch'd; what amorous and fondling nips
> They gave each other's cheeks; with all their sighs,
> And how they kist each other's tremulous eyes:
> The silver lamp,—the ravishment,—the wonder—
> The darkness,—loneliness,—the fearful thunder;
> Their woes gone by, and both to heaven upflown,
> To bow for gratitude before Jove's throne.
>
> (ll. 141–50)

Not only is the story of Psyche and Cupid a record of transport and spiritual metamorphosis, but Keats focuses on Apuleius's telling of the story, which creates the same transport in Keats himself. It is the aesthetic perception of transport rather than the direct experience of it that Keats discusses. This same framing of the story occurs in the *Ode to Psyche*.

After a short invocation, the poem opens with a vision of the now-

immortal Psyche and the poet, in the same state of merged dream and reality that Madeline and Porphyro achieved when he melted into her dream. "Surely I dreamt to-day, or did I see / The winged Psyche with awaken'd eyes?" (ll. 5–6). The speaker sees the goddess and Cupid embracing in the grass, their arms and wings entwined in a typical romance bower.[21]

> Their lips touch'd not, but had not bade adieu,
> As if disjoined by soft-handed slumber,
> And ready still past kisses to outnumber
> At tender eye-dawn of aurorean love.
>
> (ll. 17–20).

They are still, as if asleep, suspended between one moment of lovemaking and the next, symbols of the perpetual love and passion that the happy outcome of their troubles has made possible.

The poet then claims that Psyche is fairer than any of the Olympians, though she was never worshipped. She is the great paradox, an unworshipped goddess, the soul whose immortality is achieved through love, not enthrallment, and is perpetually renewed through love. But the poet's response to Psyche's unworshipped state is to become himself her votary, indeed, her very religion:

> So let me be thy choir, and make a moan
> Upon the midnight hours;
> Thy voice, thy lute, thy pipe, thy incense sweet
> From swinged censer teeming;
> Thy shrine, thy grove, thy oracle, thy heat
> Of pale-mouth'd prophet dreaming.
>
> (ll. 44–49)

This religion will not be the passive enthrallment of the Beadsman, with its associations of repression and death. Instead, the poet's mind itself will become Psyche's shrine, his soul housing her Soul. His thoughts "new grown with pleasant pain" like Madeline and Porphyro's equivocal ecstasy, will be the trees in the shrine's grove; his "working brain" and Fancy will serve as gardeners. As a final touch he will provide "A bright torch, and a casement ope at night, / To let the warm Love in!" (ll. 66–67). Thus, Psyche and Cupid will reenact each night within his mind the lovemaking of their marriage, but with the mutuality that the discovery scene made possible. As Harold Bloom points out, "There is a play, in these final lines, upon the familiar myth of Eros and Psyche which Keats has put aside in the main body of his ode. The mythical

love of Cupid and Psyche was an act in darkness; the bright torch burns in the natural tower of consciousness which Keats has built for the lovers' shrine. The open casement . . . emphasizes the openness of the imagination toward the heart's affections" (Bloom, p. 407).

But Keats has not so much put the myth aside as completed it. Psyche and Cupid exist through a perpetual renewal of love and passion, and the legacy their finished romance leaves us is the possibility that we ourselves will be perpetually renewed through the story, by melting into its dream, or into it as dream. Thus, not only will Keats's shrine let Cupid in to visit Psyche, but it, as the poet's mind, will let love in for him as a version of Psyche. And as the casement window is the archetypal image of Renaissance painting, his mind becomes the willing audience of art. Amidst his shadowy thought the brightness of art's beacon will shine and the legacy of love's romance will grow.

It is as if Keats were charting the effects of the revised romance through *The Eve of St. Agnes* and the *Ode to Psyche*. In the first he explores the minds of the lovers, who imaginatively envision each other, melting into each other's dream, making their minds into each other's shrine. But they and their experience are for us no more than ancient history, the faded world of old romance, unless we, like the speaker of the Psyche ode, can merge them with our own imaginations and hence envision, constitute, and live that transcendent state. The passage from Agnes to Madeline to Psyche to the poet-speaker is symbolic of poetic reception itself and the value of vivid, processual art; for such art constantly transfigures earlier art to merge it into its own dream, and we, as interpreters, constantly transfigure the product to merge it into ours.

This model of aesthetic experience is precisely the opposite of the perception of the static visual artwork, but it is striking that the impetus to the poet's imaginative transfiguration is just such a still image: Cupid and Psyche spied at the moment of repose between kisses. The poet's dream thus grows out of sleepwatching, but a vision of sleep as the poise between passionate wakings. It is quite possible, moreover, that Keats had particular visual images in mind here. As already noted, Ian Jack points to a number of paintings and engravings of Psyche and Cupid that Keats would have known (Jack, p. 209). Seemingly, it is not that the still image or sleeping subject lacks imaginative potency or inevitably enthralls and transfixes the perceiver. Rather, stillness must be imaginatively reconstituted by the perceiver so that it is processual, so that the warm Love can come in. Keats is dictating a mode of aesthetic response that rejects all notions of perceptual stasis and equilibrium and insists instead on the intense involvement of perceivers in constituting and reconstituting both the artwork in relation to themselves and them-

selves in relation to the artwork. In this respect he is the imaginative source for Hawthorne in *The Marble Faun* (see chapter 4).

But as Helen Vendler points out, at the end of the poem Psyche "is not yet visible there, nor is Cupid: the close of the poem is an entreaty and a promise" (Vendler, p. 61). Like so many romances, the *Ode to Psyche* spells out the formula for consummation but does not contain it. The interaction between static artwork and active interpreter never ends, or does so only in the cold death of the idolatrous Beadsman of *The Eve of St. Agnes*.

If the *Ode to Psyche* is an examination of aesthetic reception, the *Ode on a Grecian Urn* considers in full detail the imaginative potential of the static visual artwork. The opening question of the ode establishes the oscillation between stasis and action. On the one hand, the urn's marriage to quietness is not yet consummated ("still unravished bride"), and its kinship to silence and slow time is that of a "foster child" rather than a lineal descendent. It is also a "sylvan *historian*" and the teller of a "flowery *tale*" (italics added). On the other hand, through the ambiguity of "still," the urn is quiet, silent, and atemporal. It is a perfect absorptive artifact.

Bryson notes that relief space, in which the figures are parallel to the surface of the painting, frieze, or urn, negates depth, keeping the viewer out of the work (Bryson, pp. 228–29). And Fried says of painting imitating classical space (such as that in the urn), that "it is the antique and in that sense manifestly esthetic tenor of the painting as a whole that gives that closed and self-sufficient structure its hermetic character" (Fried, p. 64). As with any absorptive image, the more closed and complete the urn appears, the more anxious Keats becomes to enter it. His breathless questions—"What men or gods are these? What maidens loath?"—are never answered. One cannot know whether a specific legend is depicted, or merely a genre scene, and thus the wild action stopped on the urn is impossible to complete with any imaginative certainty. The urn painting resists transformation into a narrative. Like Lessing's "pregnant moment," it catches action at its emotional peak; unlike that notion, it does not contain its past and future within it. If it has any narrative to tell, it is a narrative that the urn cannot contain: the process of interpretive conjecture that it sets into motion in the reader's mind, as in the *Psyche* ode.

In the second stanza, the speaker turns from the literary analogy to the musical one.

> Heard melodies are sweet, but those unheard
> Are sweeter; therefore, ye soft pipes, play on;

> Not to the sensual ear, but, more endear'd,
> Pipe to the spirit ditties of no tone.

The urn's music bypasses the senses to sound only to the spirit. Though such a spiritual song, as the rest of the stanza goes on to show, can never bring about fulfillment, by the same token it can never result in disappointment or oversatiation. The joys of such a state are sung in the third stanza, yet with such vehemence that one begins to mistrust them. "More happy love! more happy, happy love! / For ever warm and still to be enjoy'd, / For ever panting, and for ever young" (ll. 25–27). The ambiguity of "still" at the beginning makes its appearance here far from unequivocal, and indeed, the whole stress on the banishment of the senses and of physicality in general seems very uncharacteristic of Keats. Though "All breathing human passion far above" sounds like *St. Agnes*'s "Beyond a mortal man impassioned far," the Grecian urn fails to enact Porphyro's immortal passion: "he arose, / Ethereal, flushed, and like a throbbing star, / . . . Into her dream he melted." The urn's virtue is that it permits unalloyed, untainted emotion, but the price it pays for this purity—or rather the price *we* pay as perceivers of it—is eternal unfulfillment.

In a letter written to George Keats some two or three months before composing the *Ode on a Grecian Urn,* Keats presents the urn vision as only half of a spiritual dialectic. Discussing *The Eve of St. Agnes,* he writes: "The man who ridicules romance is the most romantic of Men— . . . he who abuses women and slights them—loves them the most— . . . they are very shallow people who take every thing literal[;] a Man's life of any worth is a continual allegory." [22] And then, as if to illustrate this notion with his own experience, he describes his state of mind while lazing about the house recovering from a black eye:

In this state of effeminacy the fibres of the brain are relaxed in common with the rest of the body, & to such a happy degree that pleasure has no show of enticement & pain no unbearable frown. Neither Poetry, nor Ambition, nor Love have any alertness of countenance as they pass by me: they seem rather like three figures on a greek vase—a Man and two women—whom no one but myself could distinguish in their disguisement. This is the only happiness; it is a rare instance of advantage in the body overpowering the mind. [But then Keats recalls that Haslam's father is dying.] . . . This is the world—thus we cannot expect to give way many hours to pleasure.

<div align="right">(<em>Letters,</em> pp. 78–79)</div>

Keats made his daydream into the *Ode on Indolence,* with its shadowy, half-recognized figures likened to those on a Greek urn. In this ode and the original fancy, there is something suspicious about the state of un-

alloyed pleasure in which all Keats's most intense concerns—poetry, ambition, and love—become mere images on a Greek vase, whom none but he can identify. We might recall from Apuleius that Cupid prohibited Psyche from looking at him by warning that their child would not be immortal if she did. Though her trials ultimately won Venus's forgiveness and permitted Psyche and presumably her child, Pleasure, to supersede mortality, the transience of pleasure is a thematic legacy of the Psyche story. Welcome as its relief from the strain of mortality may be, static pleasure is only half of that play of contraries that makes life "a continual allegory." It comes of the body overpowering the mind, as the Grecian urn's pleasure comes of the spirit's overcoming the body. But it is the merging of the two that creates whatever personal and artistic transcendence is possible.

The fourth stanza of the *Ode on a Grecian Urn* again poses a series of unanswerable questions, all of them suggesting the pathos of the urn's arrested state. The speaker asks who the participants in the sacrifice are, where the altar is to which they are going, and what the town is from which they set forth. The identity, future, and past of these figures is all a mystery. The scene is cut off from experience because of its silence and atemporality. It is a fragment, almost in the literary sense of the word, and the romantics' propensity for such incompletion is perhaps a symptom of the dangerous attraction of this hypostatized, inhuman condition. In lines prophetic of the turn in *Ode to a Nightingale,* Keats emphasizes the emptiness of this state: "And, little town, thy streets for evermore / Will silent be; and not a soul to tell / Why thou art desolate, can e'er return" (ll. 38–40). The town is inaccessible, unaccountable, an imaginative void. It is unwitnessed, like Psyche unworshipped, but with the difference that its witnessing can never take place.

In this respect, the atemporality of the urn becomes paradoxically analogous to the narrative digressiveness of romance. Where the urn's narrative remains incomplete because of the arrested motion of visual art, narratives like *The Faerie Queene* remain incomplete because of their frequent resistance to resolution. Thus, Parker describes *The Faerie Queene* as "all middle: Gloriana's court, beginning and end of all movement, never appears. The respite period of 'dilation' is figured in a poem where the end of wandering is more envisaged than attained—Britomart and Artegall still only betrothed, the consummation of Scudamour and Amoret still to be enjoyed, Arthur both still in the making and still in search of the original of his dream" (Parker, p. 76). This irresolution is typical of romances from Spenser to Joyce, Pynchon, and De Palma. The "still only" of romance narrative is a close cousin of the "still unravish'd bride of quietness" in the *Ode on a Grecian Urn.*

Thus despite the laudatory and even ecstatic tone of the rest of the poem, the Grecian urn is finally a "*cold* pastoral" (italics added), and its message I think must contain not only "Beauty is truth, truth beauty," but also the humbling "that is all / Ye know on earth, and all ye need to know" (ll. 49–50). Clearly all the urn can present of knowledge is this eternal truth. However much we yearn for surety, the price to be paid in human truth is great. Its paradoxes tease us out of thought; they arrest us, preventing us from melting into the artistic dream, from merging with it, from becoming the passionate revelers that it records. As Norman Bryson states, "art begins where an artificial barrier between the eye and the world is erected: the world we know is reduced, robbed of various parameters of its being, and in the interval between world and reproduction, art resides" (Bryson, p. xv).

Though the urn's failure comes of its failed narrativity, process, and closure, Keats has shown that the temporal arts can produce the same enthralled stasis. The *Ode to a Nightingale* is thus a companion piece to the *Ode on a Grecian Urn*.[23] The speaker's experience of the nightingale's song casts "a drowsy numbness" on his senses, like that of all enthralled contemplators, and he wishes for some means to

> leave the world unseen,
> And with thee fade away into the forest dim:
>
> Fade far away, dissolve, and quite forget
> What thou among the leaves hast never known,
> The weariness, the fever, and the fret
> Here, where men sit and hear each other groan.
>
> (ll. 19–24)

The groaning, suffering world he wishes to escape is the world of mortality and mutability, "Where Beauty cannot keep her lustrous eyes, / Or new Love pine at them beyond tomorrow" (ll. 29–30). Here Keats creates an anti-world to the aesthetic realm of *Psyche*. "The two sculptural frieze-figures—Beauty, lustrous-eyed, and Love pining in adoration—would remind us of Psyche and Cupid, except for the authorial comment about the impermanence of their bloom and constancy" (Vendler, pp. 88–89). They are the mortal counterparts of the gods, as the suspicious pleasure of indolence is of the divine offspring of Psyche.

The yearning speaker transcends mortality not through the silence of the pictorial urn or the poise of mythological love, but on "the viewless wings of Poesy." He thus trades the mute poem for the blind picture, and like Madeline, seeks vision by the sealing of his earthly eyes. As a result, he ascends into an "embalmed darkness," a phrase suggesting

death. His first thought upon achieving such poetic and musical transcendence, in fact, is of death:

> Now more than ever seems it rich to die,
>     To cease upon the midnight with no pain,
>         While thou art pouring forth thy soul abroad
>             In such an ecstasy!

But should he do so, the song would be unheard, and though the nightingale and its song are eternal, his touch with them depends upon his own mortality. Like the little silent town of the *Ode on a Grecian Urn* or the unworshipped Psyche before the poet takes her into the shrine of his mind, the nightingale's song would be unwitnessed if the speaker were to die, and he, of course, would be beyond experience, even the secondhand experience of another's ecstasy.

The speaker emerges from this fantasy not knowing whether it was "a vision or a waking dream" or whether he is now awake or sleeping. Was the flight with the nightingale the transcendent experience to which the descent contrasts? Or was it a mere dream compared to the reality of his descent—the realization and insight that it has fostered? As always in Keats (and everywhere insofar as value is at issue), it is the contrast that creates the value—the contrast between flight and descent, between blindness and sight, between poesy and life, between dream vision and reality. What Keats does in his final lines is to ambiguate the reality claim of either half of the dichotomies. Thus, whereas the Nightingale's flight and eternal song begin as infinitely desirable and infinitely valuable compared to the speaker's heartache and numbness in his separateness from the bird, they fade into a mere nothingness as he is left to his "sole self," and he remains in a visionary state of waking. The desire for pure artistic transcendence is misguided, for it would obliterate the very response that makes art art.

Keats is again showing the pattern of enticing romance that he spelled out in *The Eve of St. Agnes,* where the desire for pure vision closes the bud or turns the viewer to deathly stone. Whereas this idea is worked out in terms of the contrast between the spatial and temporal arts in *The Eve of St. Agnes,* the *Ode to Psyche,* and the *Ode on a Grecian Urn,* Keats shows that even poesy and song have this danger in them, that they can turn the hearer to a "sod" if they take him out of himself. Unless he can sing and see and dream, he will be like the enthralled Madeline, whose heart pained her with unheard eloquence, "As though a tongueless nightingale should swell / Her throat in vain, and die, heart-stifled in her dell."

I take the *Ode on Melancholy* as the climactic statement of this ide-

ology of romance contrast, of sensory repleteness as opposed to the renunciation of sight or sound, and of transcendence through the merging of physical and spiritual.[24] In *Melancholy,* instead of trying to forget "The weariness, the fever, and the fret / Here, where men sit and hear each other groan," the speaker urges us to embrace melancholy in its proper habitat—bliss. Only in this way will we ever experience or express true melancholy, for it exists only by virtue of its opposite.

> She dwells with Beauty—Beauty that must die;
>   And Joy, whose hand is ever at his lips
> Bidding adieu; and aching Pleasure nigh,
>   Turning to Poison while the bee-mouth sips:
> Aye, in the very temple of Delight
>   Veil'd Melancholy has her sovran shrine.
>
> (ll. 21–26)

In presenting this idea, Keats prohibits a series of stock gothic-romantic symbols of melancholy leading to Psyche: "Nor let the beetle, or the death-moth be / Your mournful Psyche" (ll. 6–7). Mournful Psyche should instead be the Soul losing Love the moment he is revealed to her, or Madeline and Porphyro fleeing like phantoms from their waking dream.

Whereas in those renderings the passage from bliss to melancholy is a temporal sequence, a function of the narrative plot, in *Melancholy* the opposites are simultaneously present. Moreover, one does not seek pleasure and inadvertently experience woe, but quite the reverse: one goes to pleasure to find an outward manifestation of a present woe. Whereas Psyche must rise with Cupid and descend into the underworld before she can achieve immortality, the speaker here condenses this romance pattern of rise, descent, and return into a single, mortal moment. It is a moment with all the physical sensuousness of Madeline and Porphyro's, for Melancholy is "seen of none save him whose strenuous tongue / Can burst Joy's grape against his palate fine" (ll. 27–28). The condensation of narrative sequence into simultaneity is Keats's formula for mortal vision, for *being* the nightingale or the urn or the Psyche of *Ode to Psyche,* and not merely watching them. Whatever stasis is achieved through this strategy is both its triumph and its own punishment, for the temporariness of atemporality is its very essence.

The image of sleepwatching returns in all its potency in *The Fall of Hyperion: A Dream,* where the speaker describes Moneta—Mnemosyne, memory, the mother of the Muses:

> But for her eyes I should have fled away;
> They held me back with a benignant light,

Soft, mitigated by divinest lids
Half-clos'd, and visionless entire they seem'd
Of all external things; they saw me not,
But in blank splendour beam'd, like the mild moon,
Who comforts those she sees not, who knows not
What eyes are upward cast.

(I, 240–47)

As Ian Jack points out, "We are here presented with another—incomparably greater—portrayal of Endymion gazing at Diana in her clouded heaven. . . . here it has become so moving and so pregnant with meaning that we are tempted to call the passage religious" (Jack, p. 231). The speaker has indeed become the religious worshipper, but not one achieving ecstatic transport or static enthrallment from gazing upon the unseeing other. In the terrifying presence of the goddess, the unseeing eyes provide some desperate comfort.

The goddess is Memory, and as such she crystalizes an aspect of the romance-painting-stasis complex that we have been following throughout Keats's compositions of 1819: the power and danger of art's superimposing one mental state upon another. That, in a sense, is what art is, and it is also the source of the ambiguity art creates between dreaming and waking. It is what the stained-glass window in *The Eve of St. Agnes* represents, casting the heraldry and lush fruits of old romance upon the virgin purity of Madeline. This power to superimpose is what raises stained glass above the inert painted and sculpted images that precede it in that poem. Memory, the sense of temporal discrepancy and at the same time rich superimposition, creates the contrastive value explored in *The Eve of St. Agnes* and the great odes.

This character of memory is apparent even in one of Keats's early poems, *In a Drear-Nighted December* (written December 1817), where nature is contrasted to the human spirit specifically on the grounds of the effects of memory. In December, the tree does not remember its "green felicity" nor the brook the sun's summery gaze.

Ah! would't were so with many
    A gentle girl and boy!
But were there ever any
    Writh'd not of passèd joy?
To know the change and feel it,
When there is none to heal it
Nor numbèd sense to steal it,
Was never said in rhyme.

(ll. 17–24)

The pathos of human sensibility is the sense of loss, which comes through the superimposing of past onto present. Poetry inevitably deals with this sense, or with the comfort that attempts to heal the hurt or the anaesthesia that tries to numb it. What it can never express is the unmitigated absence of this pain, for that would take it beyond the realm of the human. Moreover, as the source of all art, memory, in the person of Moneta, is not only expressed in poetry but occasioned by it. Poetry mimics memory in casting one mental state over another and thus creating in us the sense of painful contrast. The enthralled watcher is the deluded soul hoping to be removed from the dual consciousness inflicted by art and memory. Instead, he must learn to melt his reality into the aesthetic dream with all the physicality and sensory acuteness that it demands. He will then be equal to the dream, will share in it with all the blissful pain that the duality entails.

The climactic "solution" of the *Ode on Melancholy* and the painful comfort of *Hyperion* give way to the peace of *To Autumn,* in which the poise of the iconographic scenes of the season contrasts with the chilling threat of *The Eve of St. Agnes*'s iconography of winter. In *Autumn* we are again turned briefly into sleepwatchers as we see a figure "on a half-reap'd furrow sound asleep, / Drowsed with the fume of poppies, while thy hook / Spares the next swath and all its twined flowers" (ll. 16–18). The meaning of this sleep is thus the respite it gives from the death the harvest symbolizes. It is another image of the poise between burgeoning life and chill death that autumn represents. Yet the tone of this poem in no way suggests the pathos that Renaissance and romantic poets so often found in autumn. It is as if Keats's working out of melancholy left him free to praise the poise, the static perfection of this time of year or state of mind, expressed through a series of vignettes—arrested images—of acts in autumn. Critics have repeatedly compared these images to paintings, and Keats himself wrote Joshua Reynolds in connection with this poem that the fall's stubble plains look "warm in the same way that some pictures look warm."[25] Somehow, the menace of pictorial stasis is no longer a problem, and our temporary charmed involvement in such scenes and such art is not threatening. The temporary atemporality of the season can be enjoyed on its own terms in a momentary relaxation from the paradoxes of ecstasy.

It is unnecessary to mention how fundamentally this complex of concerns grows out of Lessing. Recall Meisel's observation that the only writers on art taken seriously by nineteenth-century English painters were Lessing and Reynolds (Meisel, p. 18). In his 1819 poems Keats builds upon and enlivens Lessing's mechanical opposition between the

spatial and temporal arts. Not only could the alleged stasis of the visual arts stand as a symbol of a flawed relationship to art and to the beloved; not only could it warn of the enthrallment generated by formulaic romance (in which visual artworks function as symbols of captured identity and inhuman transcendence). But the very opposition between the temporal and spatial arts could itself be shown fallacious, as in the pairing of the *Grecian Urn* and *Nightingale* odes. Though Keats and other nineteenth-century artists were profoundly suspicious of painting and sculpture because of their atemporality, Keats was all too aware of the attraction of this inhuman stasis and of the vital impurity of all human experience. Neither visual nor auditory art should be approached as by an enthralled gazer, but instead as by an impassioned participant. In that way, the blankness of the sleeper's eyes, the opacity of the dream, will be mitigated. In that way, Keats hoped, art superimposes itself upon the mind, is enshrined in the temple of consciousness, and makes of life a visionary waking.

*She saw—no, not saw, but felt—through and through a pic-
ture: she bestowed upon it all the warmth and richness of a
woman's sympathy; . . . she viewed it, as it were, with [the
master's] own eyes, and hence her comprehension of any pic-
ture that interested her was perfect.*

<div align="right">

The Marble Faun

</div>

# 4 Virgins, Copyists, and the Gentle Reader: Hawthorne

Despite the dangers that Keats sees in stasis, the promise the visual arts
hold out to the romance is perfect atemporal communication, which is
equated with love. But of course, this promise inevitably fails as the mo-
ment of transport fades into history. Aesthetic vision thus models the
fall from an Edenic unity of subject and object into the isolation and
separateness of failed presence. The popular notion that paintings are
enclosed moments of vision set off from time and complete in them-
selves is over and over again undercut in romances, where paintings are
dragged into the contingency of history and interpretation. And yet the
worth of art for romance, paradoxically, lies precisely in its ability to
teach this lesson.

Nowhere is the symbolic value of the visual arts in romance more
clearly worked out than in Hawthorne's *Marble Faun*. This work—
deadly if read as a novel—functions powerfully instead as a kind of ro-
mance anatomy. It repeatedly warns against its reception as a novel and
dramatizes the difference between novel and romance through the sym-
bol of the visual arts. It is the reader, the text constantly insists, who
invests the romance with its magic, as the viewer does a statue or paint-
ing. Without this participation, the statue is a hunk of rock, the only
worthy painting is Dutch still life, and the romance disintegrates into a
mere pastiche of technical devices. Paradoxically, the romance is like a
picture in its violation of narrative realism, but precisely through this
violation the reader is able to enter and enliven the text, and hence to
make it real. The intricacy with which this theory is worked out makes

of a rather stultifying novel one of the great imaginative works of aesthetic theory.

In almost every respect, *The Marble Faun* anticipates the broad outlines of contemporary reader-response criticism. Reacting against Lessing, for whom the determinant of aesthetic representation was the temporality of an art's medium, Hawthorne demonstrates that the conditions of representation lie instead in the perception and concretization of the work. From this point of view, Lessing's distinction between spatial and temporal arts makes no sense, for reception inevitably involves temporal process. Reader-response criticism proceeded from a similar opposition to formalism,[1] and thus, *The Marble Faun* can reveal the importance of the interartistic comparison in explaining the passage from formalist to contextualist thinking.

In an unsystematic way, the rest of Hawthorne's oeuvre provides a useful catalogue of romance clichés depending on the visual arts, and these will establish the complexity of *The Marble Faun*'s achievement. In *Fanshawe,* the heroine Ellen turns from history to old romance to beguile the time of her guardian. When she faints, she turns as white as "cold marble," and fainting yet again at the crisis, she is restored with a kiss by her adoring, but doomed scholar-lover. Like Sleeping Beauty she is sleepwatched, loved as an unmoving object of vision; yet this idealizing love is foiled as Fanshawe consumes himself in study. Hawthorne here employs the type of the romance lover as outsider and observer who is shut off from participatory domesticity by his very sensitivity as an observer. Knowledge contemplates and protects purity but cannot participate in it. This theme of a lost Eden underlies every romance of Hawthorne's from the great novels to the most formulaic short stories, until in the metaromance of *The Marble Faun* Miriam exclaims: "The story of the fall of man! Is it not repeated in our romance of Monte Beni?"[2]

In an early work like *Fanshawe,* Hawthorne was obviously self-conscious about the anachronistic gesture of writing romances in the heyday of the novel. A latter-day Cervantes, one of his characters notes that "these are strange times . . . when a doctor of divinity and an undergraduate set forth, like a knight-errant and his squire, in search of a stray damsel" (Hawthorne, p. 53). Yet if Cervantes was parodying the romance with such figures and inaugurating a new relation between writing and reality in the novel, Hawthorne was making a concerted effort to reclaim ground for the romance and to establish its legitimacy as a mode of "truth-telling" by indirection, a truth-telling about our experience of art.

For art, the romance stresses, is separate from normal experience.

Hence the repeated symbolism of the magic circle around the self that makes the romance possible, and makes its moral stance so problematic. Hester's "A" in *The Scarlet Letter* is a work of art in the brilliance of its embroidery, which "had the effect of a spell, taking her out of the ordinary relations with humanity, and enclosing her in a sphere by herself" (Hawthorne, p. 115). Cut off from this communal warmth, she stands "statue-like" (p. 228), "a statue of ignominy" (p. 128) in her "marble quietude" (p. 218). Likewise, the socialist community of Brooke Farm becomes the model for *The Blithedale Romance* because it is "a little removed from the highway of ordinary travel, where the creatures of [the author's] brain may play their phantasmagorical antics without exposing them to too close a comparison with the actual events of real lives" (p. 439).

This community, like all such worlds cut off from life, becomes a pastoral cliché, and the moral danger of such artificiality is constantly set before us: "the snowy landscape . . . looked like a lifeless copy of the world in marble . . . How cold an Arcadia was this!" (Hawthorne, p. 460). As a world cut off, an artificial construction, it provokes self-consciousness. Thus, Miles Coverdale is torn between the participatory ideals of the social experiment and his irrepressible cynicism. He sees the farm as a theatre and himself as a Greek chorus. "Destiny it may be,—the most skillful of stage managers,—seldom chooses to arrange its scenes, and carry forward its drama, without securing the presence of at least one calm observer. It is his office to give applause when due, and sometimes an inevitable tear, to detect the final fitness of incident to character, and distil in his long-brooding thought the whole morality of the performance" (p. 496). As such "the calm observer" is analogous not only to a chorus, but to the perceiver of a visual artwork. Accordingly, when Coverdale learns the truth of the relations among the mysterious trio of Zenobia, Priscilla, and Hollingsworth, he receives his revelation by staring out of his window at the boarding house opposite, where these characters are framed in their window "like a full-length picture" (p. 530).

The more that characters become removed from Coverdale's sympathies, the more they come to resemble visual artworks. Zenobia, who even in her days on the farm possessed great natural beauty, looks strikingly lovely dressed in the fashions of the town at the end: "Even her characteristic flower . . . had undergone a cold and bright transfiguration; it was a flower exquisitely imitated in jeweller's work, and imparting the last touch that transformed Zenobia into a work of art" (Hawthorne, p. 535).

The pathos of the observer's role is dramatized in Coverdale, who is

victimized by the very depth of his own sensitivity: "that quality of the intellect and the heart which impelled me . . . to live in other lives, and to endeavor—by generous sympathies, by delicate intuitions, taking note of things too slight for record, and by bringing my human spirit into manifold accordance with the companions whom God assigned me—to learn the secret which was hidden even from themselves" (Hawthorne, p. 533). The results of this talent and predilection are isolation and loss.[3] For in the bad pun of Zenobia's "thinly veiled parable," one must either kiss the beloved with her veil on, or have her remove it and lose her for all time. Thus, if Richard Mulcaster was right that poets "cover a truth with a fabulous veele, and resemble with alteration" (quoted by Parker, p. 81), the invitation to lift that veil through an act of interpretation is fraught with danger. Like Theodore in Zenobia's fable or a Psyche unredeemed by trials, Coverdale *un*covers the mystery of Priscilla, the Veiled Lady, and is left "to pine forever and ever for another sight of the dim, mournful face, . . . to desire, and waste life in a feverish quest, and never meet it more" (Hawthorne, p. 506). His final revelation is of himself—that he loved Priscilla, who is now lost to him forever.

In the whimsical short story, "Snow Image," Hawthorne again takes up the relation between belief and scepticism, but this time not as the drama of the observer but of the created being. Here the snowgirl, animated by two children's naive faith, is melted by the sceptical blindness of their father.

The archetypal offender of this sort, of course, is science, and Hawthorne elaborates the romance thematics of viewing with regard to "exact observation" in "The Birthmark" and "Rappaccini's Daughter." The problem with such observation is that it contains no sympathy, no involvement on the part of the viewer. As the humanist-scholar remarks of Rappaccini, "I know that look of his! . . . a look as deep as Nature itself, but without Nature's warmth of love" (Hawthorne, p. 1052). As a result, it turns its products into perfect and hence lifeless works of art. The perfected youth, Giovanni, destined as the immortal husband of Rappaccini's immortal daughter Beatrice, is horrified at his separation from the normal course of nature. "Giovanni grew white as marble, and stood motionless before the mirror, staring at his own reflection there as at the likeness of something frightful" (p. 1061). His self-consciousness proceeds from his artificiality; both render him not a person but a simulation, a work of art. This conclusion is fully apparent in the image of Rappaccini blessing his two creations: "the pale man of science seemed to gaze with a triumphant expression at the beautiful youth and maiden, as might an artist who should spend his life in achieving a picture or a

group of statuary and finally be satisfied with his success. He paused; his bent form grew erect with conscious power; he spread out his hands over them in the attitude of a father imploring a blessing upon his children" (p. 1064). In the familiar gothic horror of the scientist as mock-Creator, the exact observer ultimately drains life from the objects of his attention.

This pattern is presented in comic-ironic form in "Feathertop," where an old witch creates a scarecrow so artificial that everyone is in awe of him. Completely fooled by what they take as the last word in fashion, the townspeople welcome him and the old merchant agrees to let this "work of art" (Hawthorne, p. 1104) marry his daughter Polly. But Polly faints and Feathertop is stunned when they see his true self reflected in the mirror. For "perhaps the only time since this so often empty and deceptive life of mortals began its course, an illusion had seen and fully recognized itself" (p. 1105). The fate of artificial creation is to discover itself a construction, which is to say, to discover itself. Self-consciousness, or narcissism, as Hawthorne's rather tired parable "Egotism" reveals, is the bosom serpent, to be overcome only by loving sympathy or participation in another's life.

The only proper creation is nature's, for nature's creations are by definition not artificial. The hero of *The House of the Seven Gables,* Holgrave, reveals the truth about people in his daguerreotypes because he "make[s] pictures out of sunshine" (Hawthorne, p. 297). Moreover, they have the integrity and authenticity of a holograph. In "The Great Stone Face," the ideal man accidentally graven in the stone of the mountain is finally actualized in the face of a virtuous common man. In "Drowne's Wooden Image" a mechanical craftsman makes one true work of art, inspired by a beautiful woman's face. Incapable of creating beauty out of his own imagination, he rises to genius by seeing nature's beauty in a real woman, who "first created the artist who afterwards created her image" (p. 1119). In story after story we are told that simplicity and virtue in life are the only subjects proper to art. Without them, life turns into a doomed artifice, and art loses any moral power.

As in Keats, the logic of the romance-painting connection makes life, not art, the ultimate source of value. For even if artists turn all their efforts to perfecting nature, as Owen Warland does in "The Artist of the Beautiful," their triumph lies not in the beautiful thing produced, but in their own self-knowledge. "When the artist rose high enough to achieve the beautiful, the symbol by which he made it perceptible to moral senses became of little value in his eyes while his spirit possessed itself in the enjoyment of the reality" (Hawthorne, p. 1150). This self-possession is accompanied by the loss of all other human connections in

the story, and parallels the fate of Fanshawe, Coverdale, and the other excluded observers. Yet still it is presented as an achievement, a victory in comprehension. It is a stage of the Fortunate Fall, the transformation of sin and knowledge into enlightenment and faith.

Hawthorne symbolizes self-possession repeatedly by splitting the self into observer and observed. The viewing of oneself in a mirror destroys artifice, as we have seen in "Rappaccini's Daughter" and "Feathertop." In *The Scarlet Letter* self-observation precedes confession for Dimmesdale and social integration for Pearl. Pearl plays with her image in a woodland pool while Hester and Dimmesdale repledge their love. On his return, he "seemed to stand apart, and eye his former self with scornful, pitying, but half-envious curiosity. That self was gone. Another man had returned out of the forest; a wiser one; with a knowledge of hidden mysteries which the simplicity of the former never could have reached" (Hawthorne, p. 216). We shall later see how important this division of the self into viewer and subject is for Hilda and the rest of the characters in *The Marble Faun,* and how decisive the model of pictorial perception is for symbolizing it.

The doubling of self-knowledge is, of course, part of the all-pervasive Edenic myth in Hawthorne's romances, and when the self takes its own impression, sees itself, time stands still. Ekphrasis is thus a central thematic element in Hawthorne's work. He uses all the standard clichés—"memory's picture-gallery" (Hawthorne, p. 119), for example, in *The Scarlet Letter*—and follows out the logic of this Wordsworthian notion even in his wording.

But the pictures of memory, fixed though they are, vary in their meaning with the accretions of experience. The same is true of works of art. The meaning of Hester's "A" shifts with time from "adulteress" to "able." And the sleeping lad in "David Swan" might be an heir to riches, a love object, or a murder victim, depending on the interpretation that his viewers give him. Yet, to do away with the meanings of the past, with history, is a fatuous dream. Those like Miriam in *The Marble Faun* and Holgrave in *The House of the Seven Gables* who want to escape the past can do so only by righting its wrongs in the present, by making history repeat itself with a difference in the full circle of justice. The reward for their pains may be love, the only state in which Eden returns and time vanishes. Thus, Phoebe and Holgrave "transfigured the earth, and made it Eden again, and themselves the first dwellers in it" (Hawthorne, p. 428).

The meaning of time in human experience and in art is perhaps the central preoccupation of Hawthorne's romances. He says in his preface to *The House of the Seven Gables* that a romance implies either the de-

viance from realist norms or merely "the attempt to connect a bygone time with the very present that is flitting away from us" (Hawthorne, p. 243). But in the course of his work, the difference between the two is obliterated. As with Keats, the superimposition of past onto present produces the very mistiness and "atmosphere" of romance, the look of familiar places lit by moonshine, "somewhere between the real world and fairy-land, where the Actual and the Imaginary may meet" (Hawthorne, p. 105). Time's influence is relentless; trying to escape by insisting on Eden, trying to escape experience, is inevitably foiled. But by working through the past and righting its effect in the present, transcendent love is at least conceivable.

The price that art pays for the layering of time-consciousness is the violation of novelistic realism, in particular the temporal-causal cohesiveness of plot and character. Hawthorne repeatedly admits to this weakness as an aesthetic trade-off. In *The House of the Seven Gables* he points to the picturesqueness of the romance atmosphere, and then notes, "the narrator, it may be, is woven of so humble a texture as to require this advantage" (Hawthorne, p. 243). And in *The Blithedale Romance* he regrets the American propensity for judging fictive characters against "actually living mortals; a necessity that generally renders the paint and pasteboard of their composition but too painfully discernible" (p. 439). The paradox that the multi-layered time of the romance interferes with its temporal, causal, and psychological contingency is examined at length in *The Marble Faun*.

Thus, in a fragmentary fashion, Hawthorne was marshalling the stock elements of the romance—the myth of Eden, the Sleeping Beauty archetype, the isolated observer, the cold observation of science and heartless art, the division of the self into watcher and watched, the relation between antirealism and memory, and finally, the mockery of past romances themselves vis-à-vis the artistic present. We have seen most of these in Keats's poetry already. Hawthorne's contribution lies in his exploration of this complex in romance fiction. *The Marble Faun* founds the pictorialism of romance fiction in its violation of narrative realism.

*The Marble Faun* is utterly pervaded by art. Every character is both an artist and a work of art—for example, Donatello, with his resemblance to Praxiteles's statue of a faun and with the "coincidence" that his name is also that of the "naive" quattrocento sculptor. The text relates his growth from archaic simplicity to self-reflexive complexity. In the latter state, he is sculpted by his friend Kenyon, who struggles to capture Donatello's transitional nature in clay. Frustrated, Kenyon mauls the material and achieves an image of Donatello's evil self, but rejects it as too much bound to a single moment. Finally, he resorts to marble and

manages to catch the transitory quality of Donatello's mind: "Donatello as the Faun but advancing towards a state of higher development." Hilda explains the successful likeness as "the chance result of the bust being just so far shaped out in the marble, as the process of moral growth had advanced in the original" (*MF,* p. 315), and Kenyon accordingly decides to leave the statue as it is. Donatello, insofar as he has opened himself up to experience, has become his own creator, both a work of art and its artist. Rather than the closed perfection of the ancient Edenic state, the modern sculpture and modern man are in constant evolution, incomplete, arrested at any given moment in an unending quest.

Moreover, it is the processual nature of Kenyon's statue, the narrator tells us, that gave rise to the very novel that we are reading. Like the first romance, the *Story of Daphnis and Chloe,* which was inspired by a painting, or Balzac's "Sarrazine," which explicates a painting and in turn is the occasion for a treatise on interpretation (Barthes's *S/Z*), *The Marble Faun* allegedly arose from the narrator's glimpse of Kenyon's statue of Donatello. "It was the contemplation of this imperfect portrait of Donatello that originally interested us in his history, and impelled us to elicit from Kenyon what he knew of his friend's adventures" (*The Marble Faun,* p. 316). And what fascinated the narrator about this "imperfect portrait" was not any artistic failing in it—although less interested viewers saw it as flawed—but rather its incompleteness, "the riddle . . . propounded there; the riddle of the soul's growth" (p. 316). An artwork that incorporates incompleteness within it gives rise to narrative and prompts an interpretation that extends the suggestive moment of the work to the temporal flow and, presumably, to the closure inherent in a narrative.

The impetus to change picture into narrative, we learn, is purely a function of the perceiver. The narrator claims that most viewers of Donatello's bust find it an unsuccessful, forgettable piece. It is only the rare viewer such as himself who seeks a factual or imaginative extension of the work into a story (*MF,* p. 8). And there is little wonder in the rarity of this habit of perception, for artists themselves are shown to have trouble reconciling narrative subjects with their visual representations. Miriam blames her frequent inability to tell what stories sculptures depict on the sculptor's own distress. "It is so difficult . . . to compress and define a character or story, and make it potent at a glance, within the narrow scope attainable by sculpture! Indeed I fancy it is still the ordinary habit with sculptors, first to finish their group of statuary . . . and then to choose the subject" (p. 100).

Even such a talented interpreter as Hilda tends to disjoin subjects

from their histories. Miriam, observing the sensitivity of Hilda's copy of Guido's *Beatrice,* wonders whether the copy does not indicate a sympathy between Hilda and the wretched Beatrice. But Hilda answers, "I really had quite forgotten Beatrice's history, and was thinking of her only as the picture seems to reveal her character" (*MF,* p. 51). Hilda's innocence lies in her "gifted simplicity of vision" (p. 277), the very faculty that makes her such a perfect copyist. It allows her to respond to paintings without turning them into narratives, and in fact to ignore whatever narrative connections their subjects possess. Innocence, like formalism, is a nonnarrative state, the text reminds us, where there exist no beginnings and ends, no consciousness of past or future, but only an eternal present. To turn a picture into a narrative, to interpret it in terms of the surrounding story of its characters or author or audience, is in effect to fall. Thus, Hilda becomes suddenly disappointed with Raphael's Virgins after witnessing Miriam's and Donatello's crime, because she cannot believe that the Virgin would reveal herself to an artist who could so passionately depict the Fornarina (p. 279). Her unwitting fall into experience forces her to interpret rather than copy, and that means to connect the moment of the artwork with the various temporal continuities in which it figures.

*The Marble Faun* dramatizes the oneness of interpretation and narrative extension by referring to art that commemorates the moment of lost innocence. The fountains of Donatello's castle and Panini's painting of Hilda suggest this conclusion in particular: the one a likeness of a nymph lost to her knight when he contaminated her with guilty blood; the other a depiction of the distressed and disillusioned Hilda entitled "Innocence, dying of a bloodstain." To understand the artwork one must hear the story behind it, and indeed Kenyon's experience at Donatello's castle and our experience of the novel as a whole consist in listening to a tremendous number of "legends." All of these extend backward relentlessly to a Golden Age or Edenic garden; all of them end in the commemorative moment of the work of art, when the innocent state was not only irretrievably lost but marked as lost and eternalized in art, paradoxically, as lost. As such, the story—all the stories—have a similar beginning and middle, but no proper conclusion—merely a termination. In effect, the termination of art is shown to be an opening for an unlimited number of conclusions formed by the work's reception and interpretation, which consist in the conjoining of the story and its artistic representation with the life experience of its perceiver.

In handling the theme of narrativity, Hawthorne includes two of the classic treatments of visual narrativity—the building and the painting with a repeated subject. The first is Donatello's castle itself, where

"through one of the doors . . . Kenyon beheld an almost interminable vista of apartments, opening one beyond the other, and reminding him of the hundred rooms in Blue Beard's castle, or the countless halls in some palace of the Arabian Nights" (*MF*, pp. 179–80). One could hardly ask for a clearer symbol of the infinite regress of narrativity, the story upon story upon story that we use to extend the fabulous, un-knowable finitude of our own existences.

The frescoes in Donatello's dining room likewise lack narrative cohe-sion, despite the repetition of the subject. The master of the castle sat, "appearing to follow with his eyes one of the figures, which was re-peated many times over in the groups upon the walls and ceiling. It formed the principal link of an allegory, by which (as is often the case in such pictorial design) the whole series of frescoes were bound together, but which it would be impossible, or at least, very wearisome, to un-ravel" (*MF*, p. 186). If a whole story or a moral unity exists in the frescoes, it is either utterly elusive or utterly boring. One cannot or will not follow the figure through all its appearances. Hence the meaning of the adventures—and ultimately of the figure—is incomplete, a moral blank and a narrative question mark. This fact, we are given to under-stand, is typical of pictorial allegories. No matter what unity is provided by their repeated subjects they fail to be construed as wholes, but only as the fragments that they are, and as the intentional gesture of the artist toward narrative and symbolic wholeness. In any pictorial narrative, the viewer's participation is a necessary component of determinate mean-ing, just as in the transformation of an ekphrastic painting into a nar-rative. But in the fallen world, this participation is never completely suc-cessful, and the picture-narrative opposition is the symbol of this failed receptivity.

In expressing boredom with narrative painting, the narrator is echo-ing the opinion of those critics of the 1750s who insisted on an art of "absorption." Friedrich Melchior Grimm, for example, writes, "I frankly admit that I have never seen a gallery or ceiling nor read an epic poem without a certain weariness and without feeling a diminution of that vivacity with which we receive impressions of beauty" (quoted in Fried, p. 88). Michael Fried comments, "the new emphasis on unity and in-stantaneousness was by its very nature an emphasis on the *tableau*, the portable and self-sufficient picture that could be taken in at a glance, as opposed to the 'environmental,' architecture-dependent, often episodic or allegorical project that could not" (ibid.). Such thinking called for an "absolutely perspicuous mode of pictorial unity" (pp. 75–76) in which everything in the painting was instantaneously intelligible to the viewer. This kind of pictorial unity would accomplish a perfect communication

between painting and beholder, an atemporal flash of intelligibility whose object was to enthrall. One might term it the romance of the image, an effect fundamentally opposed to the temporally unfolding narrative. As we have seen in Keats, romance is both enamored and suspicious of this attitude to the image, and constantly complicates the perspicuousness of the picture through story.

It is just as suspicious of its own cohesiveness as a narrative. Near the end of *The Marble Faun* Hawthorne insists on the same lack of cohesion in his own narrative, and does so by reference to painting. The narrator at first refuses to recount the circumstances of Hilda's disappearance, and when he finally does so in the perfunctory conclusion, the significance of these temporal and causal explanations does indeed seem minimal. The narrator thus was right to have cautioned us that "it is better, perhaps to fancy that she had been snatched away to a land of picture: that she had been straying with Claude in the golden light which he used to shed over his landscapes, but which he could never have beheld with his waking eyes till he awoke in the better clime. We will imagine that . . . Hilda had been permitted, for a season, to converse with the great, departed masters of the pencil, and behold the diviner works which they have painted in heavenly colors" (*MF,* pp. 375–76). The breaks in the narrative are to be experienced as fantastic absences, as if what is not known in a causal-temporal sequence belongs to a totally different order of existence best symbolized by the hiatus of a picture, depicting as it does a moment suspended from the normal continuities of realist experience.

Thus, in *The Marble Faun,* the world of picture is both a fantasy paradise—the place where good painters and viewers go!—and a land of super-realism—a land seen with eyes that have awoken in a better clime, transported from the pale northern light to the glorious radiance of Italy. Accordingly the narrator calls Italy "the Pictorial Land" (*MF,* p. 307). Hawthorne plays in his preface on the necessity of Rome to romance, because of its saturation in the past. There can be no romance "where there is no shadow, no antiquity, no mystery, no picturesque and glooming wrong" (p. xi). Experience torn out of its here-and-now is pictorial, and likewise romantic. The suspension of the narrative line, the isolation of the moment from quotidian experience into the realm of history or memory's "picture gallery," is what admits the antirealism of romance, and this suspension for Hawthorne is the (failed) ideal of pictorial art.

Moreover, Hawthorne's narrator apparently expects us to assent to this artful suspension. He invokes our hypostatized identity as the "gentle reader" and trusts that we "would not thank [him] for one of

those minute elucidations, which are so tedious, and, after all, so unsatisfactory, in clearing up the romantic mysteries of a story" (*MF*, p. 377). Like Donatello's frescoes, which suggest but do not fulfill the promise of narrative continuity, any narrative wholeness that could be constructed out of the fragments Hawthorne presents would be either tedious or unsatisfactory. A romance, like a narrative picture, frustrates the urge for closure and cohesion. And switching to the metaphor of the tapestry, the narrator says that we are too wise to look at the wrong side of the work when the right side "cunningly arranged with a view to the harmonious exhibition of its colors" (ibid.) has been presented. The right side is self-consciously and programmatically artful, concerned with aesthetic "effect" and not with the technical contingencies of plot construction.

If the artfulness is successful, the narrator continues, "this pattern of kindly readers will accept it at its worth, without tearing its web apart, with the idle purpose of discovering how the threads have been knit together" (ibid.). What an extraordinary move on Hawthorne's part to make the "gentle reader" part of his design: "this pattern of kindly readers." Part of the romance web, then, is the very perceiver, whose creation by the text and whose assent to be so created are a function, it turns out, of a scepticism about the coherence of all experience. As the narrator states, "the sagacity by which he is distinguished will long ago have taught him that any narrative of human action and adventure—whether we call it history or romance—is certain to be a fragile handiwork more easily rent than mended. The actual experience of even the most ordinary life is full of events that never explain themselves, either as regards their origin or their tendency" (*MF*, pp. 377–78).

Every narrative is artificial—whether art or history or life. Every event in life—or at least some events in every life—are like pictures in being cut off from their origins and tendencies, their causes and effects, their past and future. In perhaps the most archetypal move of romance, Hawthorne here embeds a realist claim in the seeming source of romance's antirealism: its violation of the cohesion of plot and character. Insofar as the romance resembles a picture it mimics the indeterminacy of all narrative.

Thus, paradoxically, pictures provide a new realist standard: the very temporal suspension that Lessing judged the downfall of the visual arts as icons of actions. The breach between realism and narrativity created in the Renaissance, when painting achieved realism only by eschewing narrativity, is mended by a wholly new interpretation of what narrative is. Here narrative becomes a patchwork, a sequence that is at the same time, and more significantly, the spaces between its elements. Its whole-

ness resides utterly in the perceiver's will to complete it, and that will is the very tendency to turn picture into narrative that the work trains the reader to perform. Without that reader, the work of narrative fiction or fact is as fragmentary as a pictorial narrative or any single painting, sculpture, or tapestry. It is the romance and not the realist literary work that keeps this fact before us.

Just to show how the process comes about, when Hilda does return to the narrative from her unaccountable absence in the land of picture, she enters by a stagelike balcony, framed like a painting and separated from the wild carnival scene around her.[4] She looks uncomprehendingly at the tumult below, and others near her on the balcony question her intrusion. She and they first stare at each other, but "immediately, [Hilda] seemed to become a portion of the scene" (*MF,* p. 376). Attracted by her beauty and wonder, the crowd throws flowers and candy to her, and she "looked through the grotesque and gorgeous show, the chaos of mad jollity, in quest of some object by which she might assure herself that the whole spectacle was not an illusion" (p. 377). At this point, she spots Kenyon, throws a rosebud at him, and they are united. From a picture to a stage, from an object observed and loved by an audience to an observer and lover herself, Hilda makes the transition from pictorial suspension to narrativity. The mutual commerce of perceiver and perceived is the key to this process, as to every successful—and therefore fantastic—story whole.

But having laid bare the artificiality of narrative and its dependence on the energy and interest of the perceiver, Hawthorne goes on to problematize the very process of sympathetic perception. Just as the narrator singles himself out as a uniquely responsive viewer of Donatello's bust, one who extended it into a history, so Hawthorne—however archly—addresses his own romance to an ideal reader.

In a parody of the blandishments with which authors try to mold their audiences to their own design, making them a "pattern of kindly readers," he addresses the fleeting figure of the "gentle reader": "that one congenial friend—more comprehensive of [the author's] purpose, more appreciative of his success, more indulgent of his shortcomings, and, in all respects, closer and kinder than a brother—that all-sympathetic critic, in short, whom an author never meets, but to whom he implicitly makes his appeal whenever he is conscious of having done his best" (*MF,* p. ix). Having never met this person, the author still finds no reason to doubt his existence, except for the fact that he has not written a novel for such a long time that this reader may perhaps in the meanwhile have died. "In these many years, since he last heard from me, may he not have deemed his earthly task accomplished, and have with-

drawn to the paradise of gentle readers, wherever it might be, to the enjoyments of which his kindly charity on my behalf must surely have entitled him? . . . If I find him at all, it will probably be under some mossy gravestone, inscribed with a half-obliterated name which I shall never recognize" (p. x).

Fatuous as this introduction appears—sharing much with the preface to *The Scarlet Letter* in this respect—its tone is bivalent, and it is an essential part of this romance in which reception is so primary a theme. Every author writes to an ideal other. That other, whose whole existence for the author is summed up in his sympathy, is not only unknown to him but may have ceased to exist. Whether alive or dead, whether ever alive or not, the gentle reader is a necessary fiction on the writer's part, and surely one of life's more fantastic fictions.

In the first place, like the four main characters and the narrator himself, the ideal reader will have a history and will change. Most trivially, he will simply change his mind, as the narrator does in the space of a single page, describing the Trevi Fountain. First he notes "the absurd design of the fountain, where some sculptor of Bernini's school had gone absolutely mad in marble." He expatiates on this response for a while, but then rather surprisingly concedes, "after all, it was as magnificent a piece of work as ever human skill contrived" (*MF*, p. 116). The narrator experiences a similar conversion with regard to St. Peter's, which at first looks to him like a blown-up jewel box, perfect, but too big to be seen in a single glance. One is thus forced to see it part by part: "it is only by this fragmentary process that you get an idea of the cathedral . . . [however, eventually] you discover that the cathedral has gradually extended itself over the whole compass of your idea" (p. 289).

In the course of such descriptions of artworks and of his reactions to them, the narrator seems to come to terms with them, to be molded into an ideal perceiver. The implication here is that the perception of even as static an art as architecture involves temporality. The narrator's description of his experience with St. Peter's is suspiciously similar to the fusing of fragments that he claims the reader of a literary narrative performs. The ideal reader is not born, but made by the work that he perceives, and he is made over time through repeated perceptions. Moreover, the perfect pattern that he is can also fall apart as he changes further, so that the fiction of the gentle reader has the durability of a will-o-the-wisp. One could argue that the adventure of Hilda, if not of all the main characters, is a symbolic rendering of the perceiver's continuing attunement to art.

This claim might sound peculiar when applied to Hilda, since she is set up from the beginning as an ideal perceiver who seemingly loses her

perceptual perfection. Yet Hawthorne's fatuous description of the gentle reader should not be forgotten, and in its light Hilda's initial sensitivity takes on a rather unsatisfactory value. She comes to us as the perfect virgin, indeed the worshipper of the ideality of the virgin state and of innocence, as symbolized by her tending of the Virgin's fire in the dove-cote. Perfect as her aesthetic response is, it removes her talent utterly from the realm of creativity and leaves her nothing to do but copy.[5]

Hilda had ceased to consider herself as an original artist . . . she had the gift of discerning and worshipping excellence in a most unusual measure . . . She saw—no, not saw, but felt—through and through a picture: she bestowed upon it all the warmth and richness of a woman's sympathy; not by any intel-lectual effort, but by this strength of heart, and this guiding light of sympathy, she went straight to the central point, in which the master had conceived his work. Thus, she viewed it, as it were, with his own eyes, and hence her com-prehension of any picture that interested her was perfect.

(*MF,* p. 43)

This description is as close an approximation of the preface's gentle reader as one could wish. But the narrator does not stop here. He gushes, "Her copies were indeed marvelous . . . [having] that evanes-cent and ethereal life—that flitting fragrance, as it were, of the origi-nals—which it is as difficult to catch and retain as it would be for a sculptor to get the very movement and varying color of a living man into his marble bust" (*MF,* p. 45). The only way to achieve the latter, we recall, is to leave the work as incomplete as the subject, as Kenyon does with Donatello's bust. This incompleteness provides the stimulus for the narrator to search out the story behind it and the gentle reader to consolidate the narrative that results. Yet Hilda takes the old masters' works as utterly complete unto themselves, fails to mine their narrative potential, as with the Beatrice example, and can do nothing better than repeat them in perfect, closed copies.

Borges, of course, would find in Hilda, as in his rewriter of *Don Quixote,* one of the world's great creative geniuses. But Hawthorne be-longs to the nineteenth century. Just as with Donatello's replica of the ancient faun, he presents Hilda's perfect copies as a disservice to art. They halt the interpretive unfolding of the work in terms of the lives of the interpreters and of changing history and times.[6] Hilda herself is too static in this way, arrested in her tower, valuing virginity not for its fra-gility and transitoriness but as an end in itself. As Kenyon muses, "It is strange, with all her delicacy and fragility, the impression she makes of being utterly sufficient to herself" (*MF,* p. 97). To be complete in this way is to be outside history, time, and love. To treat an artwork as thus

complete is to relegate its meaning to mere repetition. And to value this state is to be a "worshipper" and an idolator. The only thing that saves Hilda finally is the "faith of her fathers," as she refers to the New England puritanism that she has inherited. This faith, and in particular, its attitude toward interpretation and art, provide the final relativization of the gentle reader's status.

In tying the painting-literature relation to religion in this way, Hawthorne was sensing a thematics that critics only very recently have noticed.[7] The perfect repetition of Hilda's copying is shown to be idolatry, the worship of the face of symbols rather than the power or idea that lies behind them. Hawthorne establishes this claim through the general depiction of Rome as the ancient ideal submerged in the murky sin of Catholicism. What the various artists, but most especially Kenyon, try to achieve is a neoclassicist revival of that "fundamentalist" art so clearly opposed to the institutional art of the Church. Thus, Miriam is pursued by a sin not her own, in the figure of a monk before whom she kneels not in prayer but in thralldom (*MF*, p. 86). Hilda likewise sees worshippers kneeling before statues in St. Peter's and kneels briefly herself, before her upbringing shames her into standing. In the great crisis of the book she does kneel before a priest in confession, but dangerously similar as this act is to Catholic worship, Hilda escapes thralldom because of her refusal to accept the institutional meaning of the act. For her, the priest was a person like any other to whom she could tell her terrible secret without fear of consequences. But of course, it is only within the static ideology of Catholicism that such a narration could have no effect. Outside the faith, storytelling produces effects, and Hilda in suffering them enters the interpretive history of the deed she has witnessed.

As long as Hilda refuses to tell what she has seen, she is immobilized. And Hawthorne does not fail to explain this state by analogy to the visual arts. Hilda registers the murder as stone does the sculptor's chisel. "Poor Hilda . . . saw the whole quick passage of a deed, which took but that little time to grave itself in the eternal adamant" (*MF*, p. 140). Afterward, everything is shaped by the memory of this experience, and Hilda finds herself a perfect copy of Guido's *Beatrice* in look, as she sees both herself and the portrait reflected in a mirror (p. 167). Charles Dickens was also struck by the portrait's look, "an expression that to his eye still echoes the terror and helpless desolation of Rome's best-known victim of a monstrous parental voracity" (Meisel, p. 310). The sin of the fathers enacted on Hilda is the legacy of vision, her sight of the fateful crime.

Just as Hilda sees herself in Beatrice's picture and sees both reflected

in a mirror, fate presents Miriam with a "deadly iteration with which she was doomed to behold the image of her crime reflected back upon her in a thousand ways, and converting the great, calm face of Nature . . . into a manifold reminiscence of that one dead visage" (*MF*, p. 155). This deed, like the Fall which it symbolizes, produces nothing but repetition—perfect copies—for all that experience it. It is this "deadly iteration" that Hilda's confessional narrative interrupts and changes into life-giving justice and love.

The reason for the success of the confession, the book suggests, is the opportunity it provides Hilda to stand outside herself. The developmental value of such a state is obvious, given what has been said about Hilda's prior self-sufficiency. Hilda yearns for this doubling of herself (cf. *The Scarlet Letter*) after seeing a painting of Petronilla in St. Peter's "representing a maiden's body in the jaws of the sepulchre, and her lover weeping over it; while her beatified spirit looks down upon the scene, in the society of the Saviour and a throng of saints. Hilda wondered if it were not possible, by some miracle of faith, so to rise above her present despondency that she might look down upon what she was, just as Petronilla in the picture looked at her own corpse" (*MF*, p. 292). To look down on what one was is not to copy any longer but to become reflexive, to divide the present from the past with a sense of difference. Hawthorne presents this idea through a painting, and symbolizes it by the act of narration—not as iteration but as interpretation.

But Hilda's troubles had altered her attitude toward art even before the climactic confession in St. Peter's. Her taste for the old masters had dulled, so that this "poor worshipper became almost an infidel" (*MF*, p. 278). "Hilda had lavished her whole heart upon [pictorial art], and found (just as if she had lavished it upon a human idol) that the greater part was thrown away" (p. 280). As a direct result, her ability as a copyist declines. As soon as she gives up her thralldom to art, her response ceases to be repetition.

But what is her new response? The book gives us to understand that it consists in reading herself into the work, which is otherwise a moral blank. Just as the monk who haunted Miriam's steps could serve as a pictorial model for either a saint or an assassin (*MF*, p. 12), or Miriam's dummy could be taken as a heroine of romance or a rustic maid (p. 30), the work of art is an indeterminate whole that gains meaning through the perceiver's needs and desires. Thus, Donatello trembles at the fearsome look of God and the saints depicted in a stained-glass window, whereas Kenyon responds to it with delight as a "symbol of the glories of the better world, where a celestial radiance will be inherent in all

things and persons, and render each continually transparent to the sight of all" (p. 252). Donatello answers that "each must interpret for himself" (p. 253).

Interpretation is necessary when signs are not transparent, but instead ambiguous. Language is so, formed as it is by "the sophistication of the human intellect," in contrast to Donatello's cry which "might have been the original voice and utterance of the natural man" (*MF*, p. 204).[8] The yearning for the primordial transparency of signs leads back to nature. Thus, Kenyon is moved to speak the denial of speech as he takes in the view from Donatello's tower: "Nay; I cannot preach . . . with a page of heaven and a page of earth spread wide open before us! Only begin to read it, and you will find it interpreting itself without the aid of words. It is a great mistake to try to put our best thoughts into human language. When we ascend into the higher regions of emotion and spiritual enjoyment, they are only expressible by such grand hieroglyphics as these around us" (pp. 212–13). Hieroglyphics are supposedly iconic signs, like painting or sculpture in the traditional account, and nature's hieroglyphics interpret themselves, at least to the Protestant eye of Kenyon.

For Kenyon, nature signifies unambiguously God's providence toward humankind. The proper place to worship God is not in a building like St. Peter's which defies the unitary effect that worship requires—direct communion—but in a place like the Pantheon. This building, significantly, was an ancient place of worship, and so carries with it the "clouds of glory" Hawthorne finds in the classical world. "The world has nothing else like the Pantheon . . . the gray dome above, with its opening to the sky, as if heaven were looking down into the interior of this place of worship, left unimpeded for prayers to ascend the more freely" (*MF*, p. 379). Kenyon calls the aperture "that great Eye gazing heavenward," and tells Hilda that the only place for them to kneel is on the mossy pavement beneath it, which reminds him of an English churchyard. "If we pray at a saint's shrine, we shall give utterance to earthly wishes; but if we pray face to face with the Deity, we shall feel it impious to petition for aught that is narrow and selfish" (p. 380).

The Pantheon becomes an image of the transcendentalists' eye of heaven, and Hawthorne's dependence on their ideology is only too obvious. But he goes on to implicate the visual arts in transcendentalist vision. Starting from Emerson and, as we shall see, Lessing, along with Protestant dogma and his own experience with the visual arts, Hawthorne seems drawn to a peculiarly modern indeterminacy in which vision offers both the promise of perfect presence and its undoing. Iconic semiosis is the only hope for reaching God, for stopping time,

for completion, but it is constantly—and humanly—drawn into the endless unfolding of narration.

Interestingly, the two buildings that Hawthorne uses to render "symbolic" (mediated) semiosis and iconic semiosis—respectively, St. Peter's and the Pantheon—were both painted by the prominent Italian artist, Giovanni Paolo Pannini (figs. 13, 14). In fact Pannini painted and drew them in series controlled by light and viewing angle. He also depicted virtually every Roman scene described in *The Marble Faun* in two collossal works of 1757, now in the Metropolitan Museum: *Ancient Rome* and its pendant *Modern Rome* (figs. 15, 16). These represent interiors in which the walls are covered with paintings of the glories of Roman architecture and sculpture: the Coliseum, Trajan's Column, the Farnese *Hercules,* the *Laocoön,* and, significantly, the Pantheon, in *Ancient Rome;* Michelangelo's *Moses,* his *David,* the fountains of the Piazza Navona, and, correspondingly, St. Peter's, in *Modern Rome.* Pannini's two works thus establish the ideological division in sculpture and architecture on which *The Marble Faun* is based. They contrast the ancient world to the modern, the classical to the Catholic, and the Pantheon to St. Peter's. They even inspire the opposing thematic foci in the novel through the artworks central to each canvas. In *Ancient Rome* the figures look at the *Aldobrandini Wedding,* whereas the center of *Modern Rome* is the *Moses.* *The Marble Faun* is resolved in a wedding, like all normative romance, whereas the characters associated with Mosaic law and the Catholic world of Renaissance Italy—Miriam and Donatello—are the dark side of the book, fated to misery or death.

Finally, the semantic structure of Pannini's two canvases is fundamentally akin to that of *The Marble Faun.* In each Pannini work, ancient or Renaissance sculpture and architecture are reproduced in paintings, obviously of a later date, that are being viewed by artists and other watchers. These paintings of artworks are in turn assembled and depicted in yet other paintings—Pannini's two canvases. This nesting of artwork in artwork in artwork is the process of creative reception that Hawthorne advocates through Hilda. Moreover, the aesthetic geography of Rome that results from the arrangements of paintings on the studio walls is analogous to the narrative geography in *The Marble Faun,* where those ancient and modern landmarks become the background to the events of the story. The superimposition of past onto present, the constant remaking of culture, is history seen as the act of interpretation.

To signal this thematic cross-pollination, Hawthorne creates a character called "Panini" in his romance. A painter, he sees Hilda standing miserably before da Vinci's picture of the mad Joanna of Aragon, who

*Fig. 13.* Giovanni Paolo Pannini, *Interior of St. Peter's.* Boston Atheneum.

reminds her of Miriam. Panini paints Hilda in this attitude "gazing with sad and earnest horror at a blood spot . . . on her white robe" (*MF,* p. 273). He calls it "Innocence, dying of a bloodstain," but the dealer who buys it from him interprets it differently. "No, no, my dear Panini. The picture being now my property, I shall call it 'The Signorina's Vengeance.' She has stabbed her lover overnight, and is repenting it betimes the next morning" (p. 274).

The meaning of the episode is pointed for us by the narrator, who claims that the dealer's response should not be laid to an evil nature, but to a lack of sensitivity. But what it serves to illustrate as well is the all-pervasive ambiguity of the visual arts. Though we might feel the dealer to have been "mistaken," the text implies that the ambiguity of art is finally a good thing. Hilda's ultimate position on artistic perception is just this—that art must be open so that the perceiver can add himself or herself to it. "Nobody, I think, ought to read poetry, or look at pictures or statues, who cannot find a great deal more in them than the poet or artist has actually expressed. Their highest merit is suggestiveness" (*MF,* p. 314). Hilda has thus moved as far as possible from the perfect copyist

*Fig. 14.* Giovanni Paolo Pannini, *Interior of the Pantheon*. National Gallery of Art, Washington; Samuel H. Kress Collection.

*Fig. 15.* Giovanni Paolo Pannini, *Ancient Rome.* Metropolitan Museum of Art, New York; Gwynne Andrews Fund, 1952.

that she once was. At this point, the artist's intentionality is virtually irrelevant to the problem of interpretation. Art merely serves as an occasion for the hermeneutic expression of the perceiver. Thus, the author's gentle reader is not the one twin who can read his every thought, but ultimately everyone. The greatest virtue of art is its adaptability and openness to the diversity of human experience.[9]

Art that closes itself to the reader's individuality and imposes a fixed meaning is a kind of enchantment, and shares in this respect the snares of the beautiful woman. This connection offers another explanation of Hilda's initial dedication to copying the great masters rather than creating her own art. The narrator charges us to admire her for "choosing to be the handmaid of those old magicians, instead of a minor enchantress within a circle of her own" (*MF,* p. 47). In contrast, Miriam, like the magician painters, is repeatedly said to have bewitched Donatello, or made him her thrall, and the narrator seldom fails to point out the dangers of such bewitchment. Gazing at Miriam's self-portrait, "you saw

*Fig. 16.* Giovanni Paolo Pannini, *Modern Rome*. Metropolitan Museum of Art, New York; Gwynne Andrews Fund, 1952.

what Rachel might have been, when Jacob deemed her worth the wooing seven years and seven more; or perchance she might ripen to be what Judith was, when she vanquished Holofernes with her beauty, and slew him for too much adoring it" (p. 12). Miriam's sketches are full of beautiful women who are responsible for the undoing of the men they entrap. Women and art, the text implies, should set their beholders free rather than enthrall them.

And yet, perfect freedom, like complete entrapment, is ultimately undesirable. Entrapment leads to mere copying, infinite repetition, and the isolation of the work from the continuities of human history and interpretive narrative. Perfect freedom, on the other hand, would be interpretive chaos, and would, surprisingly, amount to the same thing. With no limits on interpretation every act of perception would be unique and unbound to the history of the text. Though the desire for freedom makes everyone yearn for such a state, for such an Eden of untrammelled sense making, the text repeatedly warns against it. We cannot es-

cape history, though we actively create that history out of the detritus and fragments that surround us.

The text thus concentrates on the meaning of artistic permanence. When Hilda regrets that even mediocre statues last longer than the greatest paintings, Miriam reminds her of the "unspeakable boon" that comes of the transitoriness of things, the thought that "this, too, will pass away" (*MF*, p. 122). But when Miriam expresses a similar idea to Kenyon, he answers that what she says "goes against my whole art . . . it is good to work with all time before our view" (p. 96). Obviously, sculpture is the vehicle for such concerns—certainly Lessing presented it so—since its material is as close to permanent as possible. But sculptural permanence acquires a whole array of negative connotations as the novel proceeds. The monk is termed "stone dead" after his fall from the cliff, and Hilda warns Kenyon, the self-proclaimed "man of marble," against stony coldness: "It is because you are a sculptor that you think nothing can be finely wrought except it be cold and hard, like the marble in which your ideas take shape" (p. 84). When Miriam complains of Hilda's lack of pity, Kenyon explains her behavior as if she were an ancient sculpture that must preserve its "severity" and "white shining purity" (p. 238).

In an echo of Shelley's *Ozymandias*, the narrator bemoans the persistence of portrait busts beyond the time when their subjects—specific individuals—have any importance to the perceiver (*MF*, p. 95). And similarly, those who build timeproof houses to pass from generation to generation "incur, or their children do, a misfortune analogous to that of the Sibyl, when she obtained the grievous boon of immortality" (p. 250). As with T. S. Eliot's Sibyl in *The Waste Land*, Hawthorne symbolizes one form of historical malaise as the perpetuation of art into a time when what it signifies is no longer of any importance.

Hence, characters frequently find works of art becoming mere chunks of stone when their interest in them wanes. Empty husks of meaning crowd each other in Hawthorne's Rome, at times providing an uncanny preview of Eliot's "heap of broken images." The permanence of stone—ostensibly its strength—serves more often to reveal the inevitable decay of meaning in sculpture and all art. Permanence is dead, cold, providing a "grievous boon" rather than the "unspeakable boon" of transitoriness.

The effect of these "ponderous remembrances" from the past is to obliterate the here and now. Rome's stony ruins oppress and displace the present, creating

a perception of such might and density in a by-gone life, . . . that the present moment is pressed down or crowded out, and our individual affairs and inter-

ests are but half as real here as elsewhere. Viewed through this medium our narrative—into which are woven some airy and unsubstantial threads, intermixed with others, twisted out of the commonest stuff of human existence—may seem not widely different from the texture of all our lives. Side by side with the massiveness of the Roman past, all matters that we handle or dream of nowadays look evanescent and visionary alike.

<div align="right">(<em>MF</em>, p. 2)</div>

This passage comes at the very start, warning that the stony permanence of Rome's past not only effaces the present, but in doing so obliterates the difference between romance and life. At the same time, the narrator has said that such a context is the only soil in which a romance can flourish. Seemingly, only when the past is so obtrusive as to call into question the reality of lived experience can romance gain an imaginative foothold. Yet the risk romance runs is to have that very present, which is its primary goal, rejected as a value. With all that weight of the past before us, is it not petty to value the evanescent moment? This is the question that Kenyon poses at the final moment of his crisis. But even before that he must find some way to modify the coldness of the stony eternity around him.

Kenyon, as a sculptor, in fact sees his job as making the stone warm and the boon of transitoriness speakable. In his very first appearance in the book, he argues a position straight out of Lessing's *Laokoön*. "Flitting movements, imminent emergencies, imperceptible intervals between two breaths, ought not to be incrusted with the eternal repose of marble; in any sculptural subject, there should be a moral standstill, since there must of necessity be a physical one" (*MF*, p. 10). We have already seen how Kenyon modifies this static view of art through his many attempts to portray Donatello, finally culminating in the matching of unfinished artifact to developing nature. Not immortal poise but mortal incompletion and hence promise are the stuff of artistic truth as he comes to see it.

Kenyon, more than any of the others, has had an inkling of this solution right from the start. After his parroting of Lessing, when Hilda complains that Praxiteles's *Faun* has become nothing more than a chunk of stone to her after so much viewing, he states, "It is the spectator's mood that transfigures the Transfiguration itself. I defy any painter to move and elevate me without my own consent and assistance" (*MF*, p. 10). Kenyon already knows that artistic meaning is a function of the receiver, and hence is open to history—both collective and personal.

The narrator suggests this conclusion by repeatedly blending the temporal and spatial arts in just the way that Lessing had criticized. "Only a sculptor of the finest imagination, the most delicate taste, the

sweetest feeling, and the rarest artistic skill—in a word, a sculptor and a poet too—could have first dreamed of a Faun in this guise, and then have succeeded in imprisoning the sportive and frisky thing in marble" (*MF*, p. 5). He praises a "poet-painter [perhaps Blake?] whose song has the vividness of picture, and whose canvas is peopled with angels, fairies, and water spirits, done to the ethereal life because he saw them face to face in his poetic mood" (p. 107). Kenyon himself tends to split the material side of sculpture from its meaning, which he terms "poetic." "A sculptor . . . should be even more indispensably a poet than those who deal in measured verse and rhyme. His material and instrument, which serves him in the stead of shifting and transitory language, is a pure, white, undecaying substance. It insures immortality to whatever is wrought in it and makes it a religious obligation to commit no idea to its mighty guardianship, save such as may repay the marble for its faithful care, its incorruptible fidelity, by warming it with an ethereal life" (p. 109). The idea gives warmth and life to the immortal stone, and in this way poetry and sculpture merge. As a consequence, to insist, as Lessing does, that the allegorical is the realm of poetry and not of the visual arts is to condemn the latter to an eternal coldness.

Not surprisingly, this merging of the arts is precisely what Hawthorne uses to describe the meaning of Hilda's and Kenyon's love. "The whole tribe of mythical creatures," Kenyon marvels, "yet live in the moonlit secluson of a young girl's fancy . . . What bliss, if a man of marble, like myself, could stray there, too!" (*MF*, p. 82). In order to do so, Kenyon must struggle through his own fall, the temporary loss of Hilda, feel "the immortal agon of Laocoön" (pp. 110, 324), and see his statue of Cleopatra—perfect in its repose and yet wild with "latent energy and fierceness" (p. 101)—become a mere lump of stone to his deadened heart.

His lesson comes in two stages, both involving the intermediary of art, and both presenting the meaning of life in terms of the interplay between transitoriness and permanence. When Hilda fails to meet Kenyon at the Vatican, his only solace comes with viewing the Laocoön. Here he reiterates Lessing's famous interpretation in terms of the "pregnant moment," but abstracts from it what for Lessing would be a literary allegory, prompted by the here and now of his own mental state. The Laocoön

in its immortal agony impressed Kenyon as a type of the long, fierce struggle of man, involved in the knotted entanglements of Error and Evil, those two snakes, which, if no divine help intervene, will be sure to strangle him and his children in the end. What he most admired is the strange calmness diffused

through this bitter strife. . . . Thus, in the Laocoön, the horror of a moment grew to be the fate of interminable ages. Kenyon looked upon the group as the one triumph of sculpture, creating the repose, which is essential to it, in the very acme of turbulent effort.

<div align="right">(<em>MF,</em> p. 324)</div>

The narrator, now switching from the simple reporting of Kenyon's response, draws back to reveal Kenyon's subjectivity: "but, in truth, it was his mood of unwonted despondency that made him so sensitive to the terrible magnificence, as well as to the sad moral, of this work" (ibid.).

Though the Laocoön does not reveal the whole truth of things, and though Kenyon does not wholly understand his own response to it, nonetheless he must pass through the experience of its terrible magnificence and sad moral in order to achieve Hilda's love. For this experience is a version of the crime that humanizes Hilda as well, and by perceiving the Laocoön, Kenyon becomes a symbolic witness of the suffering of Miriam and Donatello. No sooner does Donatello commit the murder than Miriam realizes that "the deed knots us together for time and eternity, like the coil of a serpent!" (<em>MF,</em> p. 142). And though she quickly offers a more hopeful metaphor—"One wretched and worthless life has been sacrificed to cement two other lives for evermore" (p. 143), the text condemns this metaphor too. We learn that the "gigantic hovels" of Rome have been made from antique ruins, "and their walls were cemented with mortar of inestimable cost, being made of precious antique statues, burnt long ago for this petty purpose" (p. 88). The monk's death means either the toils of sin or the destruction of antique value. One way or another it is negative, symbolizing the eternal presence of evil and the eternal frustration of human achievement and hope.

The next step for Kenyon, however, is to revolt against this lesson. He stands looking down on Rome and feels the all-consuming power of time. "Your own life is as nothing, when compared with that immeasurable distance," the past. But this thought soon gives way to another: "even while you taunt yourself with this sad lesson, your heart cries out obstreperously for its small share of earthly happiness, and will not be appeased by the myriads of dead hopes that lie crushed into the soil of Rome. How wonderful that this our narrow foothold of the Present should hold its own so constantly, and, while every moment changing, should still be like a rock betwixt the encountering tides of the long Past and the infinite To-come! Man of marble though he was, the sculptor grieved for the irrevocable" (<em>MF,</em> p. 341).

Life, Kenyon comes to realize, is lived as a willed fiction, a romance preciously maintained in the face of time and history. It is an intentional idyll, and therefore most fragile because built on paradox. Its supreme

<div align="right"><em>Virgins, Copyists, and the Gentle Reader</em>   117</div>

value is the present; yet the present cannot be valuable without consciousness of the whole force of past and future. It creates an Eden because humankind has been expelled from Eden. Like Donatello's family wine, it is "sunshine," because it does not travel. It stops time as if in marble, only because time is irrevocable. Thus, when Miriam and Donatello meet under the benediction of Pope Julius's statue, they become like statues before the crowd: "there they stood, the beautiful man, the beautiful woman, united forever, as they felt, in the presence of these thousand eye-witnesses, who gazed so curiously at the unintelligible scene" (*MF,* p. 268). The "statue," utterly open to construal by its witnesses, is nevertheless meaningful because of its present value, its immediate adequacy to the doomed love that it represents. In such moments, sculpture is both transparent and utterly opaque, both self-identical and shifting according to the mind of the viewer.

Having himself experienced this paradoxical wisdom, Kenyon is all the more wretched, since he cannot actualize his own romance with Hilda: "Once Kenyon had seemed to cut his life in marble; now he vaguely clutched at it, and found it vapor" (*MF,* p. 344). In his search for Hilda, however, he unearths an antique statue, a marble woman, and soon after Hilda returns from the land of picture, as we have seen. She descends from her tower, going from marble severity to the warmth of hearth and home in a move precisely the opposite of Donatello's, who has to struggle upward in his tower toward the light. Thus, Hilda and Kenyon in their marriage and Donatello and Miriam in their surrender to justice enter history from the suspension of romance.

It is the paradox within this suspension that generates story, and in this respect Hawthorne is a faithful follower of Keats. His whole book is, in a sense, an exploration of ekphrasis as a symbol of human time-consciousness. The most obvious echoing of Keats is the chapter entitled "The Sylvan Dance," a play on Keats's "sylvan historian," the Grecian urn. The spontaneous dance of the main characters, which draws in strangers of all classes, is a symbol of perfect presence. "Each varying movement had a grace which might have been worth putting into marble . . . but vanished with the moment that gave it birth, and was effaced from memory by another" (*MF,* pp. 66–67).

But the dance inevitably does suggest artworks to the narrator. "As they followed one another in a wild ring of mirth, it seemed the realization of one of those bas-reliefs . . . twined around the circle of an antique vase; or it was like the sculptured scene on the front and sides of a sarcophagus" (*MF,* pp. 69–70). Here are the opening images of *Ode on a Grecian Urn* and *The Eve of St. Agnes.* But unlike them, this is a case of arrested motion that suggests a "close," and not a happy one. "Always

some tragic incident is shadowed forth or thrust sidelong into the spectacle; and when once it has caught your eye you can look no more at the festal portions of the scene, except with reference to this one slightly suggested doom and sorrow" (p. 70). As in the *Ode on Melancholy*, the joy and beauty of the dance can be experienced only in the awareness of impending doom, a doom that unfolds in time and is told in narrative.

The agent of doom is the monk, whose moral, like everything in the book, is a matter for the observer to construe. He is not only an object of our attention, but also an observer. He watches Miriam doggedly, even from his coffin, and so prevents her from escaping the past as she so wishes. The monk is merely the most obvious case of the all-pervasive observation that characterizes the book (see Dryden, p. 29). Hilda witnesses the murder. Miriam paints herself as the observer of others' happiness. Characters take in views from cliffs, towers, and other vantage points, and paint each other in such attitudes. Hilda, we recall, is painted observing da Vinci's painting and earlier in the act of copying great masters' works on her own canvas. The monk not only peers after Miriam but ends up within her paintings, and "left his features, or some shadow or reminiscence of them, in many of her sketches" (*MF*, p. 22). Watchers are watched; subjects become objects; and observation is embedded in observation, like a set of Chinese boxes. The very Pantheon is described as a great eye looking toward Heaven. This is a book of nature-watchers, death-watchers, people-watchers, and art-watchers. And though in the case of the Pantheon, perhaps, vision creates a self-contained moment, in all the other instances observation implies the entoilment of the moment in history.

The book explodes what Michael Fried terms "the supreme fiction of the beholder's nonexistence" (Fried, p. 108), that absorptive assumption meant to guarantee perfect, noncontingent communication. For Miriam's desire to escape her past is foiled specifically by the presence of unwanted observers: the monk, who follows her, and Hilda, who unwittingly observes her crime. The audience guarantees not only the renewal of meaning in time but also the perpetration of change. It produces the interpretive difference—"ungentle reader" that it is—that makes the work both a living and a decaying thing.

When we are told in the novel's last line that Miriam's "crime lay merely in a glance" (*MF*, p. 388), we are being shown the responsibility and also the violence of the observer's role. We try to kill off the thing that watches us, even if it is no more than the self-consciousness that experience creates in us. As observers, we kill off the original observer of art, the author, whose romance with his work, his sense that he has given it a meaning that he knows, we undermine by drawing it into the

toils of our life's meanings. Glances are never innocent, though there is nothing seemingly more static, momentary, and "inconsequential" than a look. The fact that art never goes on in a vacuum between work and artist but always includes an observer is what makes it a moral fact and an essential part of the ongoing narrative of history.

Though *The Marble Faun* covers much ground, one would be justified in saying, I think, that it is in large part a revision of Lessing, neoclassicism in general, and the Renaissance severance of realism from narrativity. Hawthorne shows the oversimplification of these views by attacking their formalism—the equation of the essence of visual art with its material and the assumption of perfect, noncontextual communication. Material is semantically inert, he insists over and over again. Like an anticipation of Prague structuralism or phenomenology, he equates the aesthetic object with the perceiver's construct, which like its agent is open to change. He connects the timelessness of material, on the other hand, with the yearning for semiotic immediacy—for presence—with all the paradoxes that "semiotic immediacy" carries. The literary genre most concerned with these paradoxes, Hawthorne shows, is the romance. And therefore, the romance is that genre of literature most consciously obsessed with its relation to the visual arts. A host of nineteenth-century writers used painting, sculpture, architecture, tapestry, or stained glass within their romances, but no other elevated the romance–visual arts connection to the central theme of his or her fiction. This is the brilliant achievement of *The Marble Faun*.

# 5 A Renaissance-Modernist Dalliance: Joyce and Picasso

Modernism introduced profound changes into the visual arts. At no time since the quattrocento had pictorial art broken so decisively from its past that modernity and revolt themselves became central to the meaning of a movement. Writers confronted with the breathtaking iconoclasm of cubism and abstractionism learned a corresponding disrespect for the givens of their art—the temporality of its subject and medium, the conventional unity of its point of view, and its battery of realist norms. The technical experimentation of imagism and vorticism and all the fiction associated with "spatial form" can be seen to be under the influence of the visual arts, as can the more extreme ventures into literary cubism of Gertrude Stein, Wallace Stevens, Guillaume Apollinaire, and E. E. Cummings. This is the path of interartistic influence that one would expect to see traversed: writers asserting their independence from Stephen Dedalus's nightmare of history by turning their works into the concrete objects dictated by the avant-garde painter.

However, though the twentieth century began with a Kuhnian paradigm shift in painting, the competition between the older and newer models did not eventuate in a clear victory for either side. Unlike such moments in scientific history where one paradigm directly supplants another, the avant-garde model was instead superimposed upon the Renaissance norm, and carried with it not only its own meaning and power but the marker of newness and success. Likewise, the older norm did not disappear but remained available to indicate the passé or to be reinterpreted in light of the new. The coming of the new artistic para-

121

digm was hence more the overlaying of a palimpsest than the replacement of one model by another. As such, it was a perfect occasion for parody and irony, for the viewing of one system through the eyes of another, and for the relativizing of any claims to unique truth on the part of either.

The attitude of modernist writers to artistic history had more to do with their choice of painterly model than one would expect. Some experimentalists believed that they were making a clean break with the past—indeed, this idea is a topos of early modernism—and they built their work specifically on the new systems of cubism and abstractionism. Imagist, vorticist, and futurist literary manifestos amply illustrate this intention. But artists unwilling to break so violently with the past, particularly narrative writers, sometimes saw their art as a compromise between the two models of painting; hence, they gave new meaning to the older norm while preserving it. Nowhere can this tendency be seen more clearly, I think, than in the "Nausicaa" chapter of *Ulysses,* a richly ironic and parodic tantalizing of one pictorial model by the other. In the encounter between them, Joyce explores in yet another context the notions of time, artistic history, and intersubjectivity so crucial to *Ulysses* as a whole, and at the same time, adapts the romance-painting relation to the radically altered state of visual art.

As we have seen, the Renaissance provided the assumptions for what we now take as pictorial realism: a two-dimensional plane meant as the equivalent of a moment of vision, with the perceiver's position vis-à-vis the represented scene organizing the relative size, prominence, and placement of the elements within it. Through perspectival foreshortening and chiaroscuro, a painter could imitate depth and volume on a flat surface, as if a momentary view of reality could be frozen in paint for all time. The perceptual realism of such painting (compared to medieval or modernist art), and simultaneously its temporal abnormality in apparently stopping time, make the Renaissance norm paradoxical in its mimesis: it is bound both to contingent reality and to the realm of eternal truth. This paradox is embodied in the literary topos of ekphrasis, in which a poem declares its aspiration to the eternal poise of the visual arts, and at the same time, as a temporal artwork, demonstrates its inability to achieve it.

In the experiments of cubism and abstractionism, these assumptions are deliberately flouted. Cubist paintings include multiple views of the same object that could not all be seen in a single moment of perception. Abstract art usually ignores perspectival illusionism, chiaroscuro, and the project of adequating the picture plane to the three-dimensional

Pennsylvania
Book Center
8o-2-7600     Thank You

*o13.95
*o06.95
*o20.90  ST
*o01.45  TX

*o22.35

world; or else it marshals these techniques to mock the mimesis they usually serve. The "scenes" of a suprematist or high abstract-expressionist work are not an imitation of what a viewer at any given moment might see. In twentieth-century art, process and self-reference invade every aspect of painting, so that the fixing of time, viewer, and represented object becomes a curiosity of the past.

The Renaissance norms also implied a model of pictorial communication. Alberti urged painters to include inside the work a perceiver whose facial expression and gestures would instruct the actual viewer in how to respond to the represented scene. In echoing the painted response, the viewer would complete a communicative circuit between intention and affect. We saw in chapter 2 that this communicational model was often questioned in post-Renaissance art, as in the splitting of formal and erotic responses in Dürer's woodcut, or in the "sleep-watch" and other "absorptive" topoi in which the subject appears to have no awareness of its perceiver. The perennial association of opposed gender roles for the gazer and his object presented moral problems about exactly what communication was acceptable in painting, and prompted the parallelism between the act of pictorial perception and the whole spectrum of romance attitudes, from voyeurism to worship.

In early modernism, the Albertian ideal of pure communication was both obliterated and reaffirmed. In cubism, futurism, and abstraction there are few "pictures of the perceiver" inside the work to model a proper emotional or moral response. In fact, emotional, historical, and dramatic content was largely eliminated, so that the perceiver, in a strange parallel with Dürer's draughtsman, is limited to a formal response. But this response was the product of the work's educating the viewer in the arbitrariness of the laws of perspective, chiaroscuro, and the rest of the Renaissance norms. A rather intense technical communication was the aim of these thematic restrictions. As a result, the erotic and formal possibilities of picture-gazing were split anew. In *Les Demoiselles d'Avignon,* prostitutes exhibit themselves in the interests of cubist experiment, and Duchamp's *Bride Stripped Bare by Her Bachelors, Even* not only bares the givens of sculpture with its abstract mechanisms embedded in glass, but bares the perception of art to its erotic minimum, the title.

James Joyce seems to have been keenly aware of the problems in the visual arts arising from the modernist revolution, and especially their implications for the literary romance. Thus, when he set out to parody the romance in the "Nausicaa" chapter of *Ulysses,* he also parodied the conflicting pictorial norms of his day. His scheme for *Ulysses* designates painting the "art" of "Nausicaa." It is not only that certain arrested mo-

ments are marked with the exclamation "Tableau," or that the heroine Gerty MacDowell likens the sea to chalk painting on pavement. These and the few other pictorial references in the chapter hardly warrant its dedication to the art of painting. Rather, the entire structure of the chapter evokes the situation of pictorial perception, and explores this situation in light of the modernist shift in norms.

Joyce's library in Trieste contained Lessing's *Laokoön* as well as a full range of romances, from *The Arabian Nights* to *The Golden Ass* to Keats to Paul de Kock.[1] Nevertheless, the romance-painting connection has not been discussed in relation to Joyce, and in fact there is relatively little critical discussion of the "Nausicaa" chapter's use of painting in general. In part, this neglect is caused by Joyce's passion for the art of music, which has made his relative lack of references to the visual arts noticeable by contrast. In part, Joyce's faulty vision has suggested that he had so much difficulty seeing paintings that they were not a significant influence upon him.

One of Joyce's closest friends, and the only person with whom he discussed *Ulysses* in detail, was the artist Frank Budgen. In *James Joyce and the Making of Ulysses*, Budgen reproduces several of his own illustrations for *Ulysses*, one of which shows Bloom and the exhibitionist Gerty on the strand.[2] Budgen calls "Nausicaa" "the one pictorial episode in *Ulysses*," and continues:

It must be regarded as something of a wonder that the seen thing should play the great part it does play in the writing of a man whose sight was never strong. But the many things in *Ulysses* vividly seen are generally closeups. They are vehemently drawn, sometimes photographed as with a stereoscopic camera, but not painted. Space, air and a diminishing force of sight towards the periphery of the field of vision are lacking. If there is a parallel in the art of painting for Joyce's swift, instantaneous shots of life it is in the art of Matisse or . . . the draughtsman, Rodin, watching, ready pencil in hand, the model doing whatever it pleased in his studio.

(Budgen, p. 211)

This enthusiastic but rather impressionistic treatment of Joyce's use of painting leads to the conclusion that "*Nausikaa* is essentially pictorial, not because of any pictorial descriptions (there are very few), but because we are always made to feel conscious of the ambient of air around Bloom, Gerty, and her friends" (p. 213).

Another approach to Joyce and the visual arts is the comparison of his work to cubism. When Jane Heap and Margaret Anderson were tried for obscenity for publishing chapters of *Ulysses* in the *Little Review*,

the attorney John Quinn's final defense was that "Nausicaa" was analogous to cubist painting.[3] This analogy, like the assumption that Joyce's poor vision caused him to have little interest in the visual arts, has become a critical commonplace. Though Joyce's disjunctions and abrupt juxtapositions do suggest cubism, and though the intersection of multiple viewpoints links cubism and Joyce in the overall project of modernism, I hope to show that "Nausicaa" is, in a sense, a metacubist work, in that it juxtaposes the Renaissance pictorial system to the modern one, and examines both in the light of the romance of communication. We might thus think of Fritz Janschka's illustration to "Nausicaa" (fig. 17) as a modern counterpart to Dürer's woodcut discussed earlier.

The plot of "Nausicaa" is an interchange between an observer and a subject, the traditional components of the Albertian model, but Joyce shows that the two roles are interchangeable. Bloom watches Gerty seated on the beach; Gerty watches Bloom watching her. Excited by his gaze, she displays herself to him, thus becoming a "speaking subject," and he in turn is excited to a masturbatory orgasm. Each creates the other by creating the other's response, inducing him or her to display and to desire. Gerty, totally engrossed in her role as Bloom's voyeuristic object, imagines herself in the third person and composes Bloom's response to that objectified self as we listen in on her thoughts: "her face was suffused with a divine, an entrancing blush from straining back and he could see her other things too . . . and she let him and she saw that he saw . . . he couldn't resist the sight of the wondrous revealment half offered . . . and he kept on looking, looking."[4] Each character projects a fantasy of the other in the course of this subject-object interplay—Gerty through the fallen romance clichés of ladies' journals,[5] Bloom through the primordial symbolism of femininity and the homely wisdom of his own experience. In both cases, the visions fail to coincide with the self-images of the two characters, although for the reader they each contain a certain truth.

Gerty and Bloom here demonstrate the problem of intersubjectivity through the myth of vision common to erotic painting and the romance—the temporary appropriation of another solely by looking. As we peep into Gerty's narration we hear her fantasizing: "The eyes that were fastened upon her set her pulses tingling. She looked at him a moment, meeting his glance, and a light broke in upon her. Whitehot passion was in that face, passion silent as in the grave, and it had made her his" (Joyce, p. 365).

This visual appropriation is aided by Gerty's setting. Rococo paintings, though still functioning within the general givens of the Renais-

sance system, tried to eliminate the distance between viewer and subject by enveloping figures in clouds, films, mists, and drapery. As Bryson argues, "for its erotic content to be fully yielded up, the body must be presented to the viewer as though uniquely made to gratify and to be consumed in the moment of the glance. . . . [It] cannot any longer reside in a reproduced spatiality of the world, but must be transported to another space that is as close as possible to that inhabited by the viewer" (Bryson, p. 92). Appropriately then, as Gerty and Bloom's encounter starts to heat, her companions depart and she is left alone surrounded by the sandy dunes of the strand, a fitting rococo setting.

Through the impassioned language and the setting of visual possession, we are made to see Gerty's romance clichés as both ridiculous and pathetic. They constitute, after all, what Joyce described to Budgen as "a namby-pamby jammy marmalady drawersy (alto là!) style with effects of incense, mariolatry, masturbation, stewed cockles, painter's palette, chitchat, circumlocutions, etc etc." (Ellmann, 1959, p. 489). Though Bloom says that "still it was a kind of language between us" (Joyce, p. 372), the imperfection of this language is obvious—suggested in the Homeric source for the chapter which involves unrequited love, in the faulty parallel between the Virgin Mary and Gerty who favors "electric blue," in the "perspectival" distance that separates them, and in masturbation itself, a satisfaction of desire that can bear no fruit. Moreover, Gerty limps; like a painting she is imperfect in her motion.

Joyce, whose genius lies in his ability to sum up past culture through artistic techniques that supersede it, applies the traditional model of pictorial communication to the problems of alienation and failed intersubjectivity that lie at the heart of *Ulysses*. At the same time, he adopts the cubist model of painting with its polyperspectivalism and its *durée*, as when he juxtaposes the traditional stopped action of the "Tableau" moments to the repeated references to Gerty's period and to the moon.

Joyce's particular handling of the painting-literature analogy here is worth comment, for more obviously cubist writers such as Gertrude Stein and E.E. Cummings went about the connection quite differently. For them, if painting was traditionally atemporal and became in cubism an art of *durée*, literature was traditionally temporal but became in their experiments an art of stasis or suspension from time. Thus, ekphrasis shifted from a doomed literary longing to a literal goal. With such writers, literature mimicked painting, in that each art overturned its traditional temporal norms, although at any given time the temporal norms of the two arts remained directly opposite.[6]

In "Nausicaa," however, the analogy is not obverse but direct. Al-

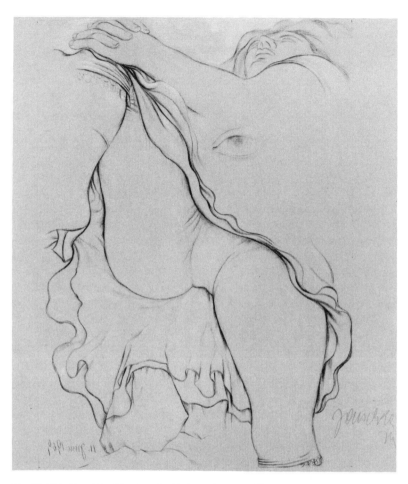

*Fig. 17.* Fritz Janschka, *Nausicaa,* in *Werkstatt-Monographie.*

berti, as we have seen, understood pictorial perception as a suspended moment in which the modeled perceiver and the actual perceiver shared responses, that is, in which perfect communication—and by rococo extension, love—was possible. Though many painters problematized this assumption, they did so only because the assumption was normative in the Renaissance model. Joyce's Gerty, I think, stands for this outmoded model. As we have seen, she imagines herself in the third person as an object presented to Bloom's view and purposely arranges herself both to attract that view and to determine the response to it. She is a speaking

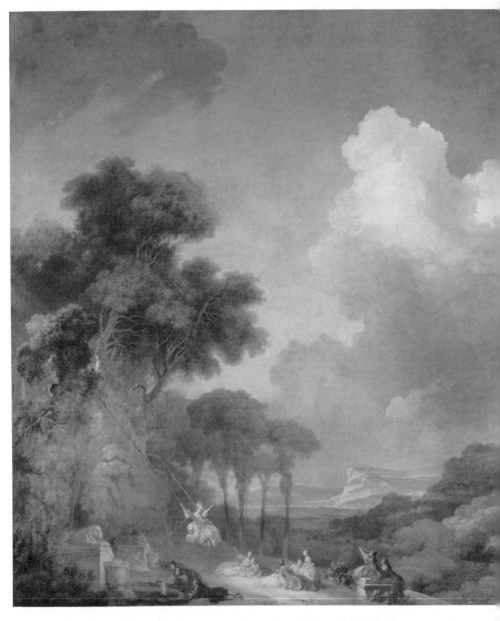

*Fig. 18.* Jean-Honoré Fragonard, *The Swing.* National Gallery of Art, Washington; Samuel H. Kress Collection.

subject, an "artful," "designing" woman, like the one in Fragonard's *Swing* (fig. 18), except that unlike that rococo wanton and unlike Diderot's Susannah, too, she reveals herself to both her observer, Bloom, and to her audience, us. But Gerty's dream of love is doomed to fail because the artificiality of her means and the Edenic innocence of her end are so incompatible. In a parody of the Albertian yearning for perfect communication through geometry and optics, Gerty combines cloying sentimentality with a disconcerting expertise in feminine technology—clothes, hair, and nail care. There is even a pun on the "drawers" she reveals to Bloom: underwear, sources of attraction to draw Bloom in, and masters of the art of drawing. Gerty is like an anachronistic Renaissance artist learning sophisticated approaches to perspective and light-modeling in order to bring about spontaneous, overdetermined vision. She vainly clings to the precepts of ladies' journals and the language of sentimental romance in the hope of creating love at first sight, instantaneous and pure communication.

In contrast, Bloom becomes a temporary embodiment of the modernist pictorial model with its reintroduction of *durée* and its seeming callousness about the perceiver. As we shall presently see, Bloom finds himself an enemy of stopped action, a proponent of temporal flow, and a kindly dismisser of Gerty's romance sentimentality. He comes to see ekphrasis and the freezing of time as traps inimical to both love and successful communication. Thus, the temporal modes of painting and literature are directly analogous for Joyce in both the Renaissance and modernist models. Joyce aligns the stopped time of Renaissance painting with the suspended time of old-style romance, and the temporal *durée* of modernist pictures with the recuperative temporal flow of *Ulysses* as a whole.

The conflict between these two notions of time is central to the "Nausicaa" chapter. Bloom discovers that his watch has stopped at what he assumes to have been the moment of Molly's adultery with Blazes Boylan. This melodramatic "arrested moment" comes to his attention when one of Gerty's girlfriends interrupts his masturbation to inquire about the time; she returns with the news that "his waterworks were out of order" (Joyce, p. 361). In a parody of Keats's urn, stopped time and stopped sex are equated. "Keats's image of a fruitful consummation in the great celebraton of the reunited lovers in Book III [of *Endymion*] is a Dance of the Seasons, a transformation of the linear procession of times into a round" (Parker, p. 181). The "dance of the hours" in "Nausicaa," however, is the occasion of Molly and Boylan's first meeting, an instant that threatens the love of Bloom and Molly. The irrevocability of time's

passing and the impossibility of stopping it are the dark side of the ekphrastic theme. Gerty pictures herself with misted eyes as she thinks of the years "slipping by her, one by one" (Joyce, p. 364), with no marriage yet in sight. But the absurdity and sentimentality of the desire to stop time are apparent when Baby Boardman's sudden spit-up is termed a "slight contretemps" (p. 363).

Victimized by the ekphrastic moment, Bloom fashions a myth of time as period and *durée,* imagining the entire universe run by a magnetism that synchronizes sexual attraction, the moon and the tides, and women's menstrual cycles. "How many women in Dublin have it today? Martha, she. Something in the air. That's the moon. But then why don't all women menstruate at the same time with same moon, I mean? Depends on the time they were born, I suppose. Or all start scratch then get out of step" (Joyce, p. 368). Just as Gerty's friends undercut Bloom's stance as mysterious stranger, his whimsical ideas are treated with considerable humor, for the falling out of step with natural time is inevitable. It serves as one of the primary metaphors in "Nausicaa" for the failure of love and understanding, as the chapter ends with the "cuckold" clock striking three times three.

Still, the polyperspectivalism that accompanies this falling out of step with time is itself a modernist value, a case of the parallax vision needed to set Bloom on a course homeward. If sentimentality tries to stop time, Bloom's sophistication and even toughness can renew and enlarge it. Turning from his visual possession of Gerty, Bloom remembers his courtship of Molly and wishes that he "had a full length oil-painting of her then. June that was too I wooed. The year returns. History repeats itself. Ye crags and peaks I'm with you once again. Life, love, voyage round your own little world. And now? Sad about her lame of course but must be on your guard not to feel too much pity" (Joyce, pp. 376–77). Bloom, ever suspicious of the sentimental lure of romance, holds back his sympathy from the lame Gerty, and voyages on—to the hospital where Mrs. Purefoy is giving birth, to his encounter with the filial Stephen, and to his home and Molly. Romance tries to stop time; love tries to renew it. And Joyce dramatizes the relation between time, communication, and love through the meeting of the two pictorial models.

Though the inadequacies of the Albertian model for the fulfillment of communicative desire are all too obvious, Joyce leaves vision, voyeurism, desire, romance, and mutual subject-object creation a complex so full of historical and contemporary salience that no one—not even the most avant-garde—could fail to acknowledge its importance. The chapter in many respects reads like a fictional grammatology, a critique

of modes of closure and the interpretive security of the past. Yet, when we consider that Bloom in some sense does end up completing the romance journey back to his starting point, and that the eternal present of the *Odyssey* and all art is as important to the book as their elaborate deconstruction, the tendency to dismiss Gerty as a dupe of advertising and cheap fiction disappears. She and the norms she depends on are part of a perennial romance ideology in which pictures speak directly to the heart.

It was perhaps the competition among pictorial models in the early twentieth century that allowed the literary significance of painting to surface so directly, and it was Joyce's brilliance that crystalized it as a parody in the "Nausicaa" episode. The metahistorical significance of the clash of models allowed Joyce to follow the themes of unrequited love and imperfect communication to the sphere of artistic history. There he could imagine how two pictorial models would see each other: the lame Albertian heroine yearning for the modernist hero to claim her as his own; the avant-garde wanderer rejecting her as a pathetic, unsatisfying substitute for a communicative closure that his homelessness does not allow. Joyce manages to mitigate both these views by humorously preserving and personifying them in the historical palimpsest of *Ulysses*.

Joyce's parody is an adaptation of romance to the modernist revolution in painting. But visual artists also felt a need to reassess the terms under which their art consorted with the romance. Probably no more sustained visual inquiry into the connection exists than Picasso's oeuvre—hundreds of drawings, prints, and paintings concerned with communication, intersubjectivity, desire, and love. Indeed, Picasso was an anatomist of romance-painting relations, very much in the manner of the literary artists we have considered. In particular, Picasso made frequent use of the sleepwatch motif throughout his career, beginning with a blue period self-portrait[7] and continuing up to his last works. Preoccupied as he seems to have been with this image of vision and communication, however, he omitted it completely from his great experiment with cubism, in which the fixity of the perceiver, the momentariness of perception, and the psychological interest of the subject were all suspended. Cubism neglected the romance possibilities of pictorial perception, and Picasso later dramatized this fact in his *Vollard Suite*. For as soon as his involvement with cubism dissipated, he returned to the sleepwatcher theme, showing artist-monsters gazing in rapt devotion before sleeping nudes and vice versa (fig. 19). The sleepwatch in such

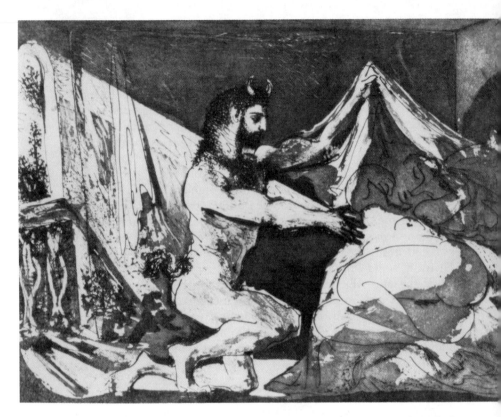

*Fig. 19.* Pablo Picasso, *Satyr and Sleeping Woman.* Aquatint, 1936, no. 27 in the Vollard Suite. Copyright © ARS, New York/S.P.A.D.E.M. 1987.

works represents the pause before violation less often than the arrest at the inviolability of the dreamer and the incommunicability of thought and desire.

Leo Steinberg shows Picasso ringing a multitude of changes on this theme. Each expresses a kind of awe at the dynamics of the Albertian model—the astonishing odds against a subject's speaking its meaning, against an observer's effectively pointing that meaning, a viewer's construing that meaning, an artist's making that meaning. The autobiographical thrust of these works (they are usually self-portraits or depictions of paradigmatic artists) completes the communicative circuit. As with the mutual making of Gerty and Bloom, the viewer is also the creator, and in each role is equally helpless to penetrate the depths of the represented subject. In some cases the subject and the viewer even change places. In a schematic sleepwatching scene of 1946, *Satyr and Sleeping Woman* (fig. 20), Steinberg notes such a switch: the woman may be dreaming the satyr, or "on the other hand, she may herself be the projection of the satyr's lust. Lusting with imagination, he could

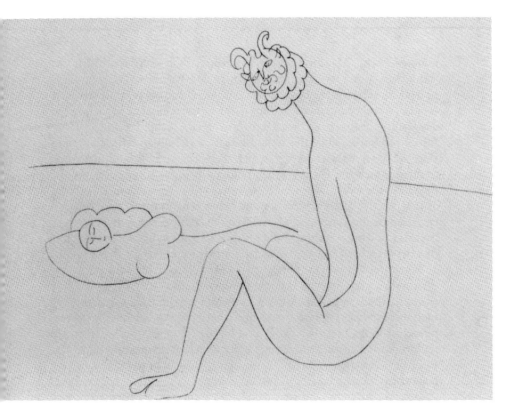

*Fig. 20.* Pablo Picasso, *Satyr and Sleeping Woman*. Pencil drawing, 1946. Zervos, *Dessins,* p. 187.

even project her particular kind, who would dream just such a satyr as he. Perhaps in the drawing they engender each other? Then each is the other's created fantasy; then desire and dream alike anticipate art in the operation of image-making" (Steinberg, p. 114).

Even in works that are not sleepwatches, Picasso analyses the relations between vision, voyeurism, creativity, and love. In the *Vollard Suite* the majority of the hundred sheets represent scenes of viewing. The commonest is that of an artist and a model who observe a work of art. Often the artist embraces or fondles the model while they both look directly at a sculpture of her. The connection between love, sexuality, art, and vision is emphatically drawn, particularly in the part of the *Vollard Suite* called the "Sculptor's Studio."

Completed in two condensed bursts of creativity (March to May 5, 1933 and January to March 1934), these works explore seemingly every combination and possibility within the romance-art connection. Sometimes there is a perfect circuit of communication among sculptor, model, and work, with eyes interconnected and eros and aesthesis bound. In

number 39 (fig. 21), for example, the heads of the sculptor, model, and statue are all tied to each other by encircling garlands. The woman is both the model for the bust and its enthralled audience, while the man is both its maker and its viewer, his hands at the same time modeling the work and caressing it, so that the roles of creator, beholder, and lover are fused. Moreover, since the sculptor and model observe the bust, and since we observe the etching in which they do so, we become analogous to them as viewers. The act of beholding is by implication a discovery of the self in the work, as it is for the model, and a creation and act of love, as it is for the sculptor. Viewer and work are intimately connected—encircled by the same garland—so that the etching, through its connection to the work within it, establishes a special kind of intertextuality: that between itself and us, whom it has made into a text for the occasion.

Sometimes artworks, rather than faithfully copying and returning the model's gaze, instead become voyeurs. In number 61 (fig. 22), for example, the sculpted male head is eyeing the thoughtful (or angry?) model contemplating him. In number 69 (fig. 23), a nude sculptor and model sit looking at each other in a highly charged pose, with a male sculptured head overturned on the floor so that it cannot witness the scene between them. The head looks directly out at us in sadness or perhaps frustration.

Indeed, the humor of the male bust's indignities is played up over and over in the Studio series. In number 75 (fig. 24), he is a gigantic mass standing directly before the lower body of a nude whose privates he observes with some interest. At the same time a nude model sits on him, resting on his stony hair those very parts he so covets. In number 76 (fig. 25), we find the final permutation in this game, with the classical male bust gazing at a nude cubist statue. His eyes are aimed again at her lower body, but she blocks his gaze by pressing her legs together. There is no communication between her blank-eyed modernist head and his noble, classicist face, and Picasso seems to be mocking the severity and formalism of his earlier style through the humorous sensuality of his later work. The vase with flowers before a half-curtained window suggests a still-life, aesthetic distance, and a Keatsian barrier between amorous contact and art.

Most of the Sculptor's Studio plates in fact place the action before a window, as if to reinforce the theme of vision with the archetypal model of Renaissance painting, the view through a window frame. Curtains and screens appear as well (for example, in numbers 41 and 42 (fig. 26), and introduce the opposite theme—the interruption of vision. In number 42 a figure draws aside a curtain to let more light in on the statue

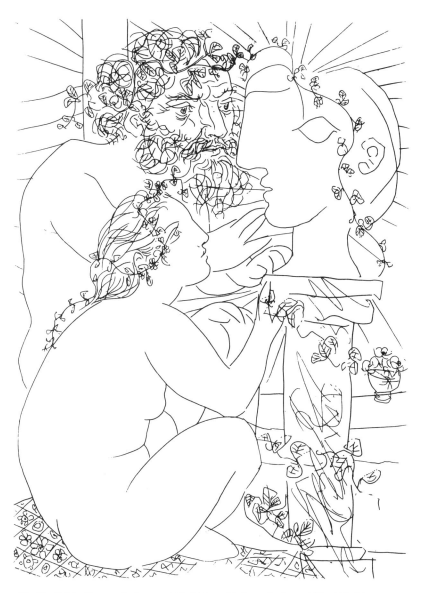

*Fig. 21.* Pablo Picasso, *Sculptor and Model Seated before a Sculptured Head.* Etching, c. 1933, no. 39 in the Vollard Suite. Copyright © ARS, New York/S.P.A.D.E.M. 1987.

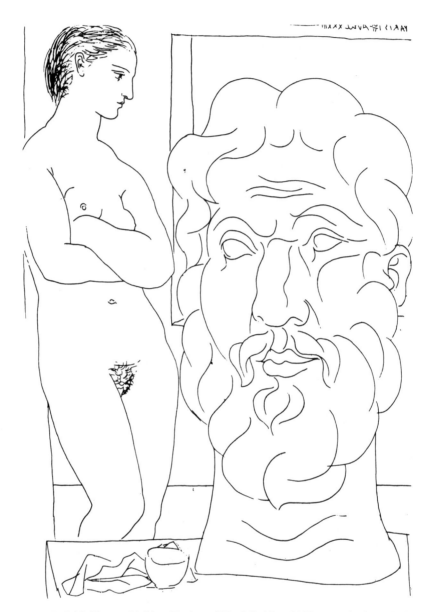

*Fig. 22.* Pablo Picasso, *Model and Sculptured Head.* Etching, 1933, no. 61 in the Vollard Suite. Copyright © ARS, New York/S.P.A.D.E.M. 1987.

she observes. But from our standpoint, she lights herself and her companion, and the statue—because of its roundness, its placement right before the window, the lines radiating out from it, and the "faulty" perspective of the plate—seems to be the sun illuminating everything around it.

In both the Rembrandt and the Sculptor's Studio plates the difference between figure and artwork is ambiguous. Is Rembrandt (in fig. 27) actually the artist standing before his model, or is he a self-portrait on the wall, being stared at by models wearing the exotic headdresses that their counterparts would have worn before the pictured artist long ago? With the relative scale of observers and staring busts so variable, one often needs the title to tell which is which, and even then, the ambiguity of words like "nude" intensifies the problem. The act of gazing turns people into works of art, and artworks, by gazing back on us as "speaking subjects," create us in their image.

Six of the hundred plates in the *Vollard Suite* are sleepwatching scenes, full of that contemplative awe and yearning that Leo Steinberg describes so beautifully. But in the same bedchambers, and often in almost the same pose, we see scenes of sexuality and even rape. "Sometimes it is as though Picasso could no longer bear this idyl of classical tranquility [i.e., the Sculptor's Studio], for both in theme and in composition the Battle of Love, created at the same time, represents the sharpest contrast to the restraint of the *Studio* series."[8] The elements of the contrast, however, are poles on the same continuum. The rapt sleepwatcher, like Psyche before the sleeping Cupid or Porphyro before Madeline, is in an aesthetic hypostasis of love. In contrast, the rapists or the combatants in the Battle of Love are, like Keats's revelers, sunk in a purely physical love. These figurative and literal extremes are always present as limit cases in romance, and Picasso includes them here among the other variants—humorous, ironic, and ideal.

The Minotaur sheets summarize all these themes. We see the human-beast drinking with artists and models; observing, caressing, embracing, and raping models; sleepwatched and sleepwatching; and also wounded and dying. For Picasso, "the Minotaur is the ideal union of man and animal. He represents him as a tender seducer (No. 84), he shows him carousing at a party in the sculptor's studio (Nos. 85, 92), as a lecherous creature rushing at a girl (No. 87), or bending in awkward tenderness over a sleeping woman (No. 93)" (Bollinger, p. xii). In the four Blind Minotaur plates, we see the creature finally deprived of sight, led forward by a little girl carrying flowers or a dove. In the first, number 94, she stares directly out at us, in the next she looks straight ahead

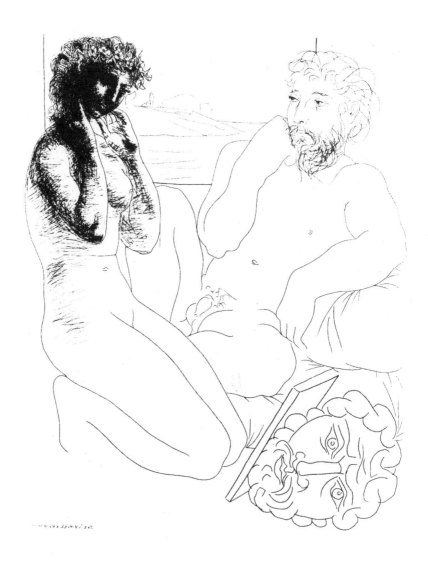

*Fig. 23.* Pablo Picasso, *Sculptor and Model by a Window*. Etching, 1933, no. 68 in the Vollard Suite. Copyright © ARS, New York/S.P.A.D.E.M. 1987.

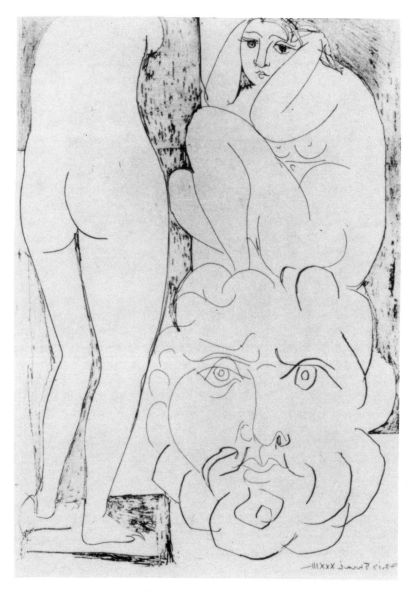

*Fig. 24.* Pablo Picasso, *Crouching Model, Nude, and Sculptured Head.* Combined technique, c. 1935, no. 75 in the Vollard Suite. Copyright © ARS, New York/S.P.A.D.E.M. 1987.

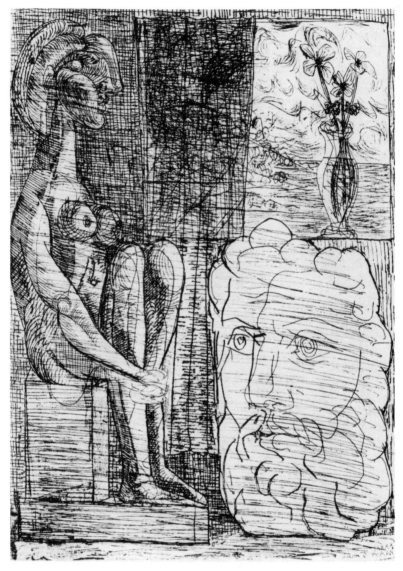

*Fig. 25.* Pablo Picasso, *Sculpture of Seated Nude, Sculptured Head, and Vase of Flowers.* Combined technique, 1933, no. 76 in the Vollard Suite. Copyright © ARS, New York/ S.P.A.D.E.M. 1987.

*Fig. 26.* Pablo Picasso, *Two Women before Sculptured Head.* Etching, 1933, no. 42 in the
Vollard Suite. Copyright © ARS, New York/S.P.A.D.E.M. 1987.

*Fig. 27.* Pablo Picasso, *Standing Nude with Flowing Headdress, and Portrait of Rembrandt with Palette.* Etching, 1934, no. 36 in the Vollard Suite. Copyright © ARS, New York/ S.P.A.D.E.M. 1987.

*Fig. 28.* Pablo Picasso, *Blind Minotaur Led through the Night by Girl with Fluttering Dove.* Combined technique, c. 1935, no. 97 in the Vollard Suite. Copyright © ARS, New York/S.P.A.D.E.M. 1987.

as the minotaur follows behind her, and in the last and most compelling (fig. 28), she turns her head to look toward him as he rests his hand for guidance on her shoulder. In this way she mimics the glance of the dove she cradles, who in all three of its appearances has been gazing on the blind minotaur. The creature deprived of physical sight receives a love, grace, and comfort that transcend sight. As the stars shine through the night sky, the figures are illuminated by a spectral glow.

Like the "Nausicaa" chapter of *Ulysses,* the *Vollard Suite* presents a continuum of romance versions, from erotic female model to guiding ideal, from prurient male gazer to humble blind wanderer, from carnal stare to spiritual vision. Picasso, like Joyce, connects love, vision, voyeurism, and aesthetic response in his romance of pictorial perception. The very assemblage of versions and possibilities relativizes their claims to truth. As in Joyce's parallax vision, all these "angles" on the subject are valid and may be simultaneously entertained, so that romance and irony—the extremes of Frye's modal paradigm—become inevitable counterparts.[9]

*Not that one and one make two but to go on counting by one
and one . . . one and one and one and one and one.*

Gertrude Stein

# 6  Divide and Narrate: Seurat, Warhol, and Lichtenstein

In the work of Joyce and Picasso, we have seen how modernism introduced irony into the painting-romance connection, problematizing intersubjectivity, love, and aesthetic perception. From the point of view of pictorial art itself, modernism performed another fundamental feat: it dissolved the temporal and spatial constraints that had banished narrativity from post-Renaissance painting. Now, seemingly nothing stood in the way of strong pictorial narrativity.

The conditions of this narrativity, we recall, are that the work depict more than one temporal moment, that a subject be repeated or at least implicated in the various moments, and that some approximation of realist representation be evoked. M. C. Escher's *Encounter* indicates how essential all three features are to pictorial narrativity. An identical subject must be repeated in the differential context of realist space and time in order for a design to give birth to a story.

As we have seen, in Western high art pictorial narratives with these three characteristics were abundant in medieval and quattrocento art, but virtually nonexistent thereafter. The logic of the Albertian model, in which a picture was to represent the view of a perceiver at a fixed distance from the scene viewed, demanded that that perception be atemporal, a single moment of vision. And so, desperately as some quattrocento painters tried to retain the semantic richness of narrative in the confines of vanishing-point perspective, "perspectival narrative" became an oxymoron by the high Renaissance, and realist representation entailed the excision of narrative process.

However, with modernism came the very fragmentation of pictorial unity necessary for the separate scenes and repeated subjects of narrative. One of the most distinctive traits of post-impressionism was this breaking up of the picture plane. Cézanne divided his canvas into small opposed color patches and blocked out larger flat areas of paint as well; the cubism that developed from Cézanne was a massive experiment in pictorial analysis.[1] Van Gogh's distinct brushstrokes broke the represented scene into vibrant, directional lines of force that stand behind the energetic dashes of Italian futurism and ultimately action painting. And the pointillists systematically divided their works into comparable minimal units whose combination produced an intensely representational, and at the same time abstract, effect.

Of the pointillists, Seurat is particularly instructive because his work reveals two facts. First, the effect of fragmentation was not to undermine pictorial representationality, but in many respects to enhance it by highlighting the opposition between what Peirce would term "iconic" and "symbolic" representationality. Second, as we shall see, divisionism in Seurat leads logically and inexorably toward narrativity.

Seurat was the inventor of pointillism and the direct source for Signac and several other practitioners of this art, in which semantically arbitrary minimal units—dots or points—combine to create the look of reality. Throughout his short career, Seurat also made many crayon drawings. He used soft black crayons on heavily tufted Michallet paper, and thus produced by purely mechanical means the effect of a dotted surface, like the benday dots of comicbooks or the pointillism of the television image. "When Seurat lightly stroked [the paper's] surface, the hooks caught the crayon here and there, leaving the valleys between them untouched. As a result, his greys are truly three-dimensional, with the white showing between the touches of dark."[2] These technically produced dots are negatives of Seurat's painted ones; light comes from dots produced by his *not* applying color to them.

Whereas the dotted surface of the crayon drawings might seem accidental or mechanical, the divisionism of the painted surface acquires a crucial semantic value. In canvas after canvas, Seurat plays with the dots, making some merely arbitrary portions of an expanse and others iconic representations of objects. In *Evening, Honfleur,* for example, some dots signify pebbles on a beach, whereas others represent nothing in themselves, their interaction (like that of phonemes in language) representing sky or water. The pebble-dots are iconic signs; the sky- or water-dots are semiotic symbols. Again, in *English Channel at Grandchamp,* some lozenges lie flat to signify symbolically the sky or sea, whereas others are oriented in all directions, like the leaves they signify iconically. Seurat

*Fig. 29.* Georges Seurat, *A Sunday in Summer at l'Ile de la Grande Jatte,* 1884–86, oil on canvas, 81 × 120-3/4″, Helen Birch Bartlett Memorial Collection, 1924.226. © Art Institute of Chicago. All rights reserved.

systematically switches between symbolic and iconic semiosis, thus making us switch our viewing strategies, as in *La Grande Jatte* (fig. 29). Here the sky-dots are arbitrary symbols and the leaf-dots are icons. But Seurat complicates the matter further with his sail and its reflection. The sail's dots are so uniformly white-blue that one hardly sees them, whereas the reflection—a natural icon of the sails—is conspicuously dotted. The iconic reflection is patently symbolic in look, and thus we are being instructed in the crucial difference between an object—even a painted object—and its image.

In such works we embark on a rather extensive exploration of the relation between signifier and signified, and Seurat conducts this exploration with great wit. In *Les Poseuses* (fig. 30) he paints dots for the wall that function at a base level of symbolic arbitrariness (like the sky-dots in the paintings already discussed), other points that iconically represent

the model's navel or nipples (almost dot for dot), and still other iconic points that mimic polka dots in the parasol. To carry this game still further, he has dots that are icons of his own previously painted dots in *La Grande Jatte,* the picture on the wall in *Les Poseuses.* The originals of these dots were in turn either arbitrary minimal symbols or icons, for example, of leaves, so that these dots in *Les Poseuses* are icons of symbols or icons of icons.

Early modernists can, I think, be characterized by their decision to break the canvas into either iconic or symbolic units. The drama played out at this time was a drama of parts versus portions—would a painter block out minimal units that signified coherent parts of objects (Seurat's leaves on trees or pebbles forming the beach, for example) or would these units represent a mere portion of a continuum (the sky, the sea)? In the first case we have iconic signs; in the second symbolic ones. With this extensive gridwork of standardized units, the artist could pose the opposition of iconicity versus symbolism in a peculiarly striking manner for anyone interested in the relation between visual and verbal art. For

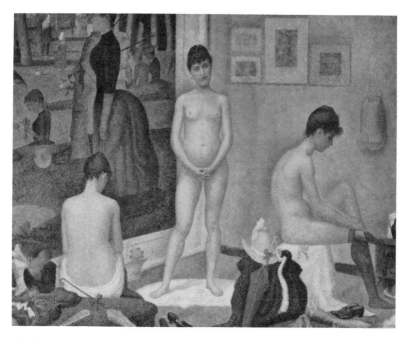

*Fig. 30.* Georges Seurat, *Les Poseuses.* Photograph © Copyright 1987 The Barnes Foundation, Merion, Pennsylvania.

*Fig. 31.* Pablo Picasso, *Portrait of Daniel-Henri Kahnweiler,* 1910, oil on canvas, 39-1/2 × 28-5/8″, Gift of Mrs. Gilbert W. Chapman in Memory of Charles B. Goodspeed, 1948.561. © Art Institute of Chicago. All rights reserved.

*Fig. 32.* Pablo Picasso, *Still-Life with Fruit, Glass, Knife and Newspaper.* Collection of Mr. and Mrs. David Lloyd Kreeger, Washington, D.C.

what is the difference between a part and a portion, but that a part is something with a name, whereas a portion is something not delineated enough to have a linguistic label? When Picasso represents a portion of a coat sleeve with a cubist facet in the *Portrait of Daniel-Henri Kahnweiler* (fig. 31) he is blocking out in paint a linguistically unclaimed region, dividing reality by paint. The eyelid or fingers in this portrait are quite a different matter—iconically represented body parts conforming to the linguistically ordered world.

The recognizability of a represented world in painting is directly related to the prevalence of parts over portions. Surrealism, for example, even though it often disrupts part-whole relations, as in Dali's *Soft Construction with Boiled Beans,* is brilliantly representational because it concentrates on parts rather than portions. Cubism became steadily more abstractive as portions predominated over parts in 1910 and 1911, until the switch to synthetic cubism when that hierarchy began to be reversed and the units of the painting became units with names. Picasso's *The*

*Three Musicians* (1921) is divided into leg-units, bow-units, hands, feet, tabletops, etc., with every unit a nameable part. Synthetic works between 1911 and 1920 often seem to be playing off units of one kind of sign against the other, as in Picasso's *Still-Life with Fruit, Glass, Knife and Newspaper* (1914; fig. 32), where the iconic grapes and the arbitrarily dotted expanses seem dialectical answers to each other. One might propose as a hypothesis that the clash between representational and nonrepresentational tendencies in modernist painting is often a tension between parts and portions, between the named and the unnamed, between iconic and symbolic minimal units in painting. Indeed, Husserl explains the difference between abstract and concrete through an exploration of the notions of independent and nonindependent wholes, which coincide with the idea of parts and portions.[3]

Seurat's basic strategy was to create comparable paint divisions whose semantic modes were not comparable. He did this at the smallest level with uniformly sized dots, but he extended the strategy to larger structures as well. *Farm Women at Work* divides the ground into broad alternating bands of color that might represent the relative elevations of the land and the resulting shadows, but might simply be arbitrarily colored pictorial swathes. Russell notes that Seurat also has a vocabulary of repeated poses and forms. "Seurat made use of certain recurrent forms in a way which, while never wresting them from their immediate identity, none the less suggests that they have a universal validity quite irrespective of the connotation which they bear at the moment" (Russell, pp. 107, 110). These standardized forms, obviously representational as they are, become almost arbitrary building blocks of scenes, like the ubiquitous guitars, pipes, and wineglasses in cubism or the comicbook images in pop art. Like pop artists, Seurat even borrows other painters' images; the little girl on the right in *La Grande Jatte,* for instance, echoes Gozzoli's Salome. And later art has in turn taken elements from Seurat's painting, such as the arabesques of *Le Chahut* (fig. 33) borrowed by art nouveau (p. 266).

It is a logical step from repeated dots, color bands, forms, and poses to repeated figures within a single canvas. In *Le Chahut,* the dancers are so standardized that they look like the same figures in various stages of motion. Indeed, Aaron Scharf and John Russell argue that in *Le Chahut* Seurat might have been inspired by Maray's serial-photography (Russell, p. 242), the recording of multiple stages of motion in a single image, which influenced Duchamp and the futurists as well.

One step further yet is the repetition of the same figure in different poses, and here we have Seurat's revolutionary move in *Les Poseuses.* Despite the plural of the title, we are obviously looking at a single model

*Fig. 33.* Georges Seurat, *Le Chahut*. Rijksmuseum Kröller-Müller, Otterloo, Netherlands.

*Fig. 34.* Roy Lichtenstein, *Step-On Can with Leg.* Provenance Leo Castelli Gallery, New York; private collection.

who appears in three different moments—standing, sitting with her back to us, and sitting facing to the side. She is also present in a "prior" pose as the female figure in *La Grande Jatte* shown on the wall. Though Seurat stresses the artfulness of that pose by painting her disrobing in the others, the nude views of her are equally stylized. She looks like any number of bathers or nymphs or standing girls or Susannahs caught in a state of undress.

But though we can read the painting as an array of poses, the fact that each is held by the same model leads us to read the painting as a narrative. We are seeing the girl pass from the act of modeling in *La Grande Jatte* to reenter "real life," a Hermione stepping down from her pedestal. But at the same time, the inability of the model to perform that transformation, once she has been painted and gazed upon, becomes clear. As she removes her costume she becomes for the artist and us not a naked woman but a nude, and she ends up posing in the center for the painting of her poses, *Les Poseuses.*

At a semantic extreme from the minimal dots, the narrative content here has been broken into units with a repeated subject. Yet just like

those dots, the semantic mode of the narrative units is ambiguous. They might be episodes in a story or merely isolated, abstract poses, like the plan and elevations of a building or sketches of a figure shown from different angles on the same street. Are these parts of a represented narrative or merely components of a pictorial composition? The oscillation between the two is an essential feature of the narrativity available to art through the modernist fragmentation of the picture plane.

Unfortunately Seurat died before he could carry the logic of modernism any further in the direction of narrativity. He did manage to show, however, that each of the narrative factors—multiple episodes, repetition of the subject, and the use of realist norms—could now both contribute to narrativity and undercut it. Indeed, those twentieth-century artists who felt free to experiment with storytelling did not simply continue from where the early quattrocento and its nineteenth-century imitators left off. Instead, they problematized pictorial narrativity as it had not been problematized since the Renaissance. In the process, they revealed once again the parallelism among the opposed pairs of repetition and narrative, design and story, image and romance, and formalism and contextualism. Pop art, the main occasion of this exploration, follows in the line of thought from Keats to Hawthorne, Seurat, Joyce, and Picasso.

In all the experimentation that took place in the early twentieth century, however, there was relatively little systematic exploration of narrativity. The other aspects of the Renaissance norm had been discarded long before the 1960s when Lichtenstein's narrative works appeared. Single-point perspective, chiaroscuro, the integrity of the represented object and the picture plane, and representationality per se had all been exploded forty years and more before *Step-on Can with Leg* (1961; fig. 34) or *As I Opened Fire* (1964; fig. 41). True, cubists had unfrozen the pictorial moment by presenting views of objects not visible at a single moment, surrealists had produced some narrative triptychs, and Duchamp and other futurists had rendered figures in various phases of movement. But canvases zoned for time, with portions representing spatial unities that are temporally distinct from each other, are not often to be found before Lichtenstein. We might legitimately ask why this move took so long, or, more to the point, what purpose it served for Lichtenstein.

The answer is not at all simple, for Lichtenstein has repeatedly implied that people are misled when they take his comicstrip paintings for narratives. Lawrence Alloway reports him as saying "apropos of his paintings derived from comics, that he wanted to compose, not to narrate."[4] "What I do is form," he told G. R. Swenson, "whereas the comic

strip is not formed in the sense I'm using the word; the comics have shapes but there has been no effort to make them intensely unified. The purpose is different, one intends to depict and I intend to unify."[5] And when the question was put to him directly: "You have never been particularly interested in a sequence of images as in the comics?" he answered, "No."[6] Small wonder that critics such as Richard Hamilton concluded that "Lichtenstein opposes the narrative character of his sources" (Russell and Gablik, p. 90) when the artist, at the height of his comicbook phase, declared that "the formal statement in my work will become clearer in time" (Alloway 1974, p. 118). But the question remains what this "formal statement" is, or rather, why it depends on the evocation of narrative techniques absent from high art for almost five hundred years.

The issue is particularly piquant when we note how tantalizingly Lichtenstein skirts the bounds of narrativity. He paints any number of works depicting the traditional "pregnant moment"—for Lessing the only proper narrative mode for the visual arts, but one lacking the temporal discreteness necessary to narrative. In *Knock! Knock!* (fig. 35), for example, we see a door with the words "Knock! Knock!" emanating violently from it, implying an undepicted earlier point when someone came to the door, and a future point when the door will either be opened or not. Moreover, the analogy between the door frame and a picture frame raises the possibility that we are the occupants of the "room" and the artist is "knocking" on our door with his painting. Here the proto-narrative shifts from the virtual realm of pictorial reference to the actual realm of pictorial reception: Will we let the painter in? *Finger Pointing* makes this kind of meaning explicit by catching the finger in the act of pointing at us, and *Watch* literally stops time on a watch while issuing a punning command, which we have already obeyed, to pay attention. Through this pun, Lichtenstein implicates vision in temporality, if not in narrativity as such. Among his other "pregnant moments" are *Spray Can,* with a hand in the act of spraying; *Trigger Finger,* with a finger resting on a trigger; and *Draw,* with a hand poised at the holster. Again we see the puns on the pictorial situation, with "draw" not only the challenge of a cowboy but of an artist (or viewer), the spray not only a cleaning solution or bug poison but perhaps paint, and all the guns a reference to the violence of art, and reciprocally, of vision.

Lichtenstein's favorite subject, in fact, is the explosion, which he not only paints repeatedly but sculpts. Walter Benjamin has described dadaist art as "an instrument of ballistics. It hit the spectator like a bullet, it happened to him, thus acquiring a tactile quality."[7] But Lichtenstein's

*Fig. 35.* Roy Lichtenstein, *Knock! Knock!* Provenance Leo Castelli Gallery, New York; private collection.

arrested motion stops not only the depicted action but the implied act of viewing, fills it with danger, menace, and violence, and simultaneously laughs it off as a silly joke on dada, action painting, the viewer, and himself. With the play of title and drawing he invokes the norms of traditional pictorial narrativity, and then undercuts them through self-reference.

When Lichtenstein paints a frame lifted from the comics, he goes even further toward narrativity. Comicbooks are, of course, full-fledged

pictorial-verbal narratives, which remind us that the Renaissance pro-hibitions against multi-episodic images held only for high art, and there only for single canvases. Frescoes, architectural adornment, and other large-scale productions were often strongly narrative even after Alberti, and in popular art, pictorial storytelling was perennial. Moreover, as in many popular art forms, plot is the dominant element in the comics, and the most typical plots are "debased" romances: love stories, adventures, quests, encounters with alien worlds. Though the single frames that Lichtenstein borrows from the comics do not represent more than one temporal instant, they do contain the drama of the "pregnant moment." *Conversation*, for example, shows an intense emotional moment between a comicstrip woman and man. Works of this sort frequently have present-participial titles—*Drowning Girl, Crying Girl, Sleeping Girl, Blond Waiting*—further stressing their relation to process and action.

Though none of Lichtenstein's works mentioned so far is strongly narrative, the proto-narrative quality of his art in the early sixties is pronounced. As Diane Waldman states, "By 1962, . . . his subjects, for the most part, appeared to be portrayed in an act which is not completed—a zipper not quite closed, a conversation still in progress. . . . His figures appeared to be fraught with anxiety."[8] What is particularly interesting about the "pregnant moments" taken from the comics is that they not only stop the action represented but isolate the comicstrip that represents it. This arresting of temporal medium as well as narrative content is worth note. Lichtenstein is able, without producing literal narratives, to evoke a host of narrative modes in this way—the narrative of represented events, the comicstrip medium as a temporal vehicle with a formal beginning, middle, and end, and the narrative of the painting's production and reception.

It now seems a relatively small step to the minimal narratives proper of *Step-on Can, Bread in Bag,* or *Like New,* and in fact these bifurcated works predate many of the "pregnant moments" mentioned. Lichtenstein went on to paint the comicbook diptychs and triptychs of the early to mid-sixties, such as *Bratatat* or *Whaam!* (fig. 43); pictorial variations, such as the Rouen Cathedral works of 1969, which "establish a serial image with various points of view and compositional changes and a direct statement about process, with their Monet-derived scenario"[9]; and, in the mid-seventies, multipanel works like the *Cow Triptych,* which shows the transformation of a pop art version of van Doesburg's cow into a work of abstraction. Several other narrative modes thus receive our scrutiny: the minimal narrative of cause-and-effect or before-and-after; adventure and love stories as told in the comics; the quasi nar-

rative of an object's changes in light, atmosphere, and formal means; and the narrative of stylistic transformation and hence of art history itself. There has rarely been a painter so systematically concerned with the way that narrativity relates to painting, and yet we have his own word that he was not interested in narrating.

The story sequences that Lichtenstein produced are indeed very strange narratives, despite or perhaps because of the fact that they are faithful replicas of their comicbook sources. The peculiar temporality of the pictures in the comics may come as a surprise to the nonspecialist, but scholars note that "the image in the comics is not fixed in some point in time but inserts itself within the time-flow of the narrative. It is a *diffuse* image whose projection in space, overlapping from one frame to another, mirrors a projection in time, forward and backward." [10] This diffuseness, this lack of fit with the discrete temporality of the verbal narrative, is everywhere apparent in Lichtenstein's comicbook borrowings.

Just as often, however, the verbal text is temporally diffuse. Lichtenstein has a genius, in fact, for discovering the most unlikely conjunction of picture and story. *Takka Takka* (fig. 36), for example, conjoins the words of the title, shot out of heavy artillery, with the text: "The exhausted soldiers, sleepless for five or six days at a time, always hungry for decent chow, suffering from the tropical fungus infections, kept fighting!" This suspension of the main narrative clause by a series of phrases referring to the past or the unpictured present is typical of the frames Lichtenstein paints.

My favorite is *Mad Scientist* (fig. 37): "As soon as I throw the switch, those light-impulses—in KHANDARA—on the island of Rhodes—and near the museum—hidden by my mirage duplicates before they tried to steal those souvenirs—will go into operation!" The ludicrous deferral of syntactic closure here is perhaps in keeping with the suspense of the moment, as the mad scientist stands with his hand poised on the switch. But the speaker is trying to insert a whole narrative buildup into the space between the throwing of the switch for the light-impulses and their going into operation. The inadequacy of the image to these words throws us back onto that verbal text, and there we begin to find another meaning: 'The light-impulses near the museum were hidden by the mad scientist's mirage duplicates before souvenirs were stolen.' Lichtenstein elsewhere exposes us to the threatening gaze of the mad scientist defending the secret of his image duplicator (fig. 38). He is that comicbook villain Lichtenstein, with his slide projector and silk screens, hiding the light-impulses with his mirage duplicates near the museum

THE EXHAUSTED SOLDIERS, SLEEP-LESS FOR FIVE AND SIX DAYS AT A TIME, ALWAYS HUNGRY FOR DECENT CHOW, SUFFERING FROM THE TROPICAL FUNGUS INFECTIONS, KEPT FIGHTING!

*Fig. 36.* Roy Lichtenstein, *Takka Takka*. Wallraf-Richarz-Museum, Cologne.

before souvenirs can be stolen. The real interruption to the act of throw-ing the switch is the comedy of Lichtenstein's own art.

Even such "pregnant moments" as in *Blang* (fig. 39) indicate the problematic fit between verbal text and visual image. The picture shows the impact of a shell shot from guns on the lower right. But actually a temporal spread is represented from shot to impact to explosion in the trail of smoke joining the guns to the explosion. The moment of impact is indicated by the word "Blang," which recedes in depth like the fumes billowing out from the explosion. The fact that the letters recede in the reverse order from the progresson of sound in the word "Blang" is typi-cal of Lichtenstein (compare *Knock! Knock!*). This is a "slip" that a con-crete poet would not make, and it performs an important service by in-tensifying the sense of cause and effect in the painting. Just as the line

*Fig. 37.* Roy Lichtenstein, *Mad Scientist*. Provenance Leo Castelli Gallery, New York; private collection.

from gun to explosion star indicates a temporal and spatial direction, the order of reading the letters of "Blang" propels us out at a different angle from that center in a kind of ricochet, one echoed indirectly in the contrast between the direction of the tank's wheels, chassis, and lower gun and the orientation of the tank cabin and upper gun. The immediacy of the shot, the impact, and the explosive aftermath contrast sharply with the narrator's block in the upper left-hand corner, which not only introduces a moment prior to the action of the image with its words and directional ellipses, but stresses the difference between story time and narrative time. The "now" of the pictorial explosion is the "just then" of the narrator, and the vertigo of pictorial immediacy and narrative distance is forced upon us.

Such disjunctions are everywhere apparent in the single-frame comic-

strip borrowings, though these works are still not narrative in the fullest sense. In *O.K. Hot Shot* (fig. 40), the speaker-shooter, an explosion, and another airplane are all present, but arranged in such a way that the speaker could not have produced the explosion or have been aiming at the other airplane. We might be seeing a friendly airplane behind the speaker and the destruction of a third airplane—"VOOMP"—by the hated "hot-shot." Then the pilot's anger and his "pouring" would be focused at a target outside the picture, somewhere in our vicinity, and

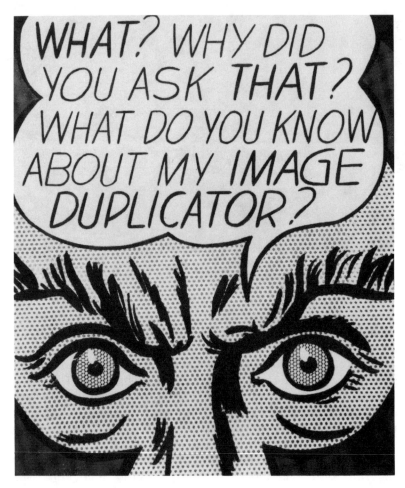

*Fig. 38.* Roy Lichtenstein, *Image Duplicator*. Provenance Leo Castelli Gallery, New York; private collection.

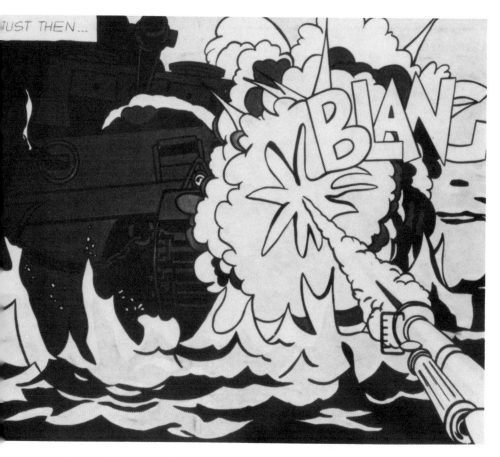

*Fig. 39.* Roy Lichtenstein, *Blang*. Provenance Leo Castelli Gallery, New York; private collection.

the explosion and accompanying plane would provide the narrative cause for the pilot's words. However, because of the narrative intensity of the image, it is tempting to see the airplane behind the pilot as the enemy hot-shot's, and the explosion as the later result of the pilot's "pouring." In that case, the interlocutor is in the painting (where he belongs, we might self-protectively feel), and the narrative is completed in the righteous "VOOMP" that envelops him. In the first reading we are left in tremendous suspense and personal threat as the painting converges upon us with its pouring. In the second reading we see the narrative sequence of the anger, its object, and its successful venting, but in a wholesale destruction of the spatial and temporal unity of the picture plane.

Perhaps Lichtenstein's most harmonious marriage of word and im-

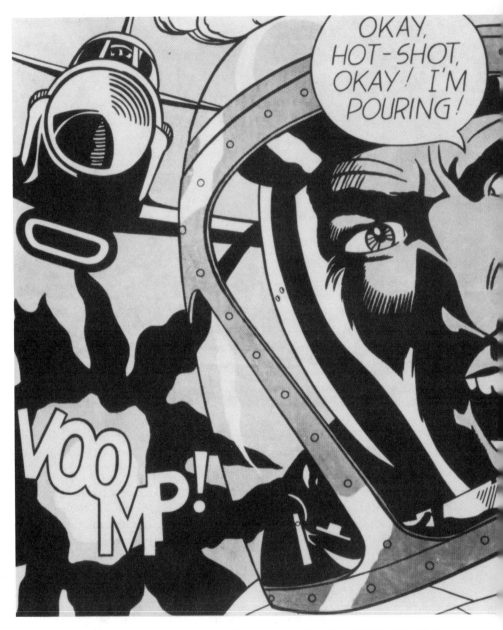

*Fig. 40.* Roy Lichtenstein, *O.K. Hot Shot*. Provenance Leo Castelli Gallery, New York; private collection.

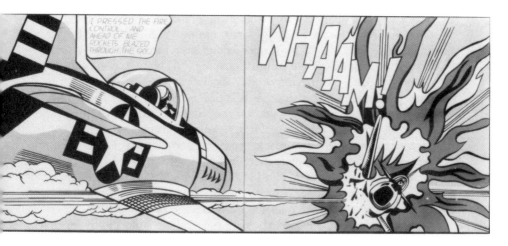

Fig. 41. Roy Lichtenstein, *Whaam!* Tate Gallery, London. © Lichtenstein, 1987/VAGA, New York.

age and time and space is the narrative diptych *Whaam!* (fig. 41), in which the factors that complicate the other paintings are largely absent. The order of the pilot's words describing the events matches the order of those events, and the ellipses intensify that temporal progression, culminating in the "Whaam!" in the right-hand panel. The two airplanes are spatially oriented so that the speaker could indeed shoot the other airplane through the vector marked from his wing to the exploding aircraft. Moreover, this vector recedes into the depth of the pictorial field, while the exploding flames and aircraft fragments advance forward, intensifying not only the cause-and-effect relation but the sense of depth so important to realistic depiction. The letters of "Whaam!" this time emanate from the impact in their proper order, partly no doubt because the shot is coming from the opposite direction from that in *Blang,* so that the ricochet of energy could be produced only in this way. The coincidence of pictorial and verbal order here creates a much less problematic narrative situation than any of the other comicbook works. The acts of pressing the fire control and seeing the rockets blazing in the sky are indicated in the upper left, where all Western reading begins; the shot streams from the left foreground into the right depth, and the explosion and its verbal analogue burst outward and toward us.

Commentators, nevertheless, have been struck by the "apparent bald incompatibility between component canvases" in *Whaam!,* "especially in the contrast between the centralized explosion panel and the more

irregular, more obviously truncated imagery in the panel containing an otherwise intact plane."[11] Lichtenstein has provoked this sense of disjunction by writing, "I remember being concerned with the idea of doing two almost separate paintings having little hint of compositional connection, and each having slightly separate stylistic character" (Morphet, p. 35). However, this separate stylistic character simply intensifies the narrative power of the work, for the truncated airplane on the near left seems to be caught flying past us, its direction and contingent quality forcing us to look toward the explosion beyond it. As Lichtenstein, ever cool, notes, "Of course, there is the humorous connection of one panel shooting the other" (ibid.), and one might argue that Lichtenstein is consistently exploiting the verbal coincidence of airplane and picture plane to suggest an analogy between the violence that his paintings narrate and the violence the pictorial medium suffers in the act of narrating.

But the narrative unity of *Whaam!* is unusual in Lichtenstein. The triptych *As I Opened Fire* (fig. 42) is much more the norm, with its text split from frame to frame in nothing resembling a narrative progression. It begins with the words "As I opened fire," which do relate to the pictorial image with its minimal gun firing "Brat!" But the main clause concerns the speaker's realization of "why Tex hadn't buzzed me," a past nonevent that has little to do with the painting. In the same frame, the speaker realizes that "if Tex had"—but there the text ends until the second frame, where we learn what would have happened had Tex buzzed: "the enemy would have been warned. . . ." What they would have been warned we do not discover until we get to the final frame with the legend, "that my ship was below them. . . ." The content of this text does refer to the content of the three images, which show wing-mounted guns, in two of the three cases from underneath. The force of the correspondence, however, is weakened because these words are merely a contrary-to-fact noun clause—what the enemy would have known had Tex buzzed, but he did not.

More disconcertingly, if the viewpoint under the guns indicates the speaker's (and our) position, then we must revise our reading of the first frame, which we assumed shows the speaker's airplane firing "brat!" as he talks about opening fire. If that airplane is the enemy's, the speaker is *not* below it, but slightly to the right of it and in front. In that case, the reason Tex did not buzz the speaker could not have been that his ship was below the enemy's. He does not get below it until the second frame. Perhaps the second frame is chronologically first, the third second, and the first a complete shift in vantage point to the speaker's airplane. Or

*Fig. 42.* Roy Lichtenstein, *As I Opened Fire.* Stedelijk Museum, Amsterdam.

perhaps the order is chronologically consistent, and we shift viewpoint from the speaker's airplane in frame one to the speaker's view of the enemy's airplane in frames two and three. But then why do the airplanes look so much alike, why do the images seem to show a smooth progression from long shot to middle-range to close-up, and why are the speaker's words about opening fire mimicked with the initial "brat!" of frame one and continued in the "bratatatata!" of frame two and the endlessly extended "bratatata" of frame three? We are obviously being misled in terms of spatial, temporal, and psychological viewpoint. Though Suzy Gablik's claim is certainly true that "on the intermingling of language and content [Lichtenstein] is difficult to beat" (Russell and Gablik, p. 37), the effect of this intermingling is extreme conflict and disorientation.[12] As always in Lichtenstein's war-comics works, the real target seems to be us.

Given the elaborate struggle between word and image in the war narratives, it is striking that verbal text and pictorial image seem so mutually reinforcing in the panels lifted from comicbook romances. There, titles seem precisely correlated with images, bubbles contain words consonant with their speakers' facial expressions, and words actually constitute whole panels with pictures matched against them, image to text. The word panel on the left in *Eddie Diptych* presents the narrative past of thought and emotion behind the dramatic interchange between mother and daughter on the right. In *We Rose Up Slowly* (fig. 43), also a diptych, the words act as a direct gloss for the picture on the right. Lichtenstein sometimes pushes the correspondence of words and images to a humor-

*Fig. 43.* Roy Lichtenstein, *We Rose Up Slowly.* Provenance Leo Castelli Gallery, New York; private collection.

ous extreme, as in *Cold Shoulder,* which shows a woman in a sleeveless dress with icicles hanging from her word bubble.

The perfect correspondence of thought and event, of word and expression, is characteristic of the yearning of both high and popular romance. Allied with it is the desire for intersubjectivity suggested in another Lichtenstein title, *I Know How You Must Feel, Brad.* In *We Rose Up Slowly,* the thirst for intersubjectivity and the merging of minds, bodies, words, and images is symbolized by the lines joining the lovers' lips into a composite mouth and the eyebrows and jawlines answering each other. And yet, of course, the sheer depth of cliché here in word and pictorial rendering trivializes and undercuts the unities presented. The climactic moment of love or generational conflict is loaded with high romance resonance and at the same time with cliché, superficiality, and stereotype; such canvases simultaneously draw us into narrative involvement and thrust us back out. Whereas the war-comic panels prob-

lematize narrativity through the clash of word and image, the romance works do so through the very ease of the fit between them.

If in the war works the perceiver is both involved and misled by the painting, becoming at times one with the hero's viewpoint and one with the enemy's, in the romances the perceiver is likewise drawn in and rejected, like the dupe of a cruel lover. Pictorial perception is thus made analogous not only to physical aggresson but to love. Like the other artists and writers we have examined, Lichtenstein makes much of this connection. In *Masterpiece,* he shows a woman looking intently at a male artist and saying, "Why, Brad darling, this painting is a MASTER-PIECE! My, soon you'll have all of NEW YORK clamoring for your work!" She looks greedily at him, he looks at the painting, and we look at the back of his canvas, which bears a suspicious resemblance to some of Lichtenstein's later landscapes. More directly still, *Him* (fig. 44) shows a photo of a smiling man held in a woman's hands. She holds and loves the picture for what it depicts, as we might be tempted to do as well if Lichtenstein did not make us hate ourselves so much for doing so.

Thus, seemingly all narratives in Lichtenstein lead back to the subject of his art and to the relation between the work and its audience. Whenever we are tempted to apply the parallelism among aesthetic perception, communication, and love, Lichtenstein trips us up, making us feel simultaneously that we grasp the work and that we are fooling ourselves in thinking so, that we are having an aesthetic experience and that such "romantic" encounters with art are passé or deluded.

Lichtenstein uses narrative not only as a way of problematizing pictorial communication. He constantly opposes image to story. In fact, pop art may be seen as a movement examining things and the stories that a culture tells about them, or analogously, artworks and their contexts of meaning. We are back again at the contrast between the transcendent work of art and the social-historical contingency that modifies its significance; that is, between the aesthetic attitudes that I have been terming formalism and contextualism. Thus, when Oldenburg staged a "Happening" by displaying his art objects in a ready-made "store," he was creating not only the works but the context for them. The more typical move of pop artists is to rip popular images out of their habitat and deposit them in the one place they should not be—the museum. Indeed, pop art can be seen as split between the exuberant contextualizing of the Happening and the isolating move of painters like Warhol and Lichtenstein. "The Happening stays close to 'the totality of nature,'" as Alloway puts it, "whereas Pop artists work from the artifacts of culture and retain the compact identity of art" (Alloway 1974, p. 2).

The concern with context helps to explain the paradoxical referentiality of pop art. For "any common object, if looked at hard enough and long enough, will lose its temporal identity and become an abstract form" (Russell and Gablik, p. 38). Pop art is perched on the wall between abstraction and representationality. In explaining Jasper Johns's role for the movement, Lucy Lippard writes, "Once it was realized that the question 'Is it a flag or is it a painting?' had no answer—was not important—the way was open to Pop Art."[13] The ambiguity arises, of course, because pop art systematically represents ready-made images; that is, it paints images from advertising, the comics, and the world of public relations. As a result, it poses new questions for art. "How close to its source can a work of art be and preserve its identity? How many kinds of signs can a work of art be at once?"[14] And hence, in how many narratives can it figure?

These questions, though seemingly applicable to much of cubist and surrealist collage and in fact to any art parodying or otherwise appropriating earlier images, have a special relevance for pop art. For no movement has so literally and so exclusively copied preexisting images. For the first time, pictorial art approached literature in being what the Tartu semioticians would call a "secondary modelling system,"[15] a sign system like literature whose medium, language, is already a sign system. Lichtenstein not only appropriated a vocabulary of ready-made images for his paintings, but he then made further paintings, such as *Artist's Studio, Look Mickey,* or the *Cubist Still Life* works of 1974, that were formed out of those previous paintings. By nesting signs within signs within signs, he came close to a literal realization of the infinite regress of signification, so that Lawrence Alloway is being very precise in describing pop art as "neither abstract nor realistic. . . . The core of Pop art is at neither frontier; it is, essentially, an art about signs and sign systems" (Alloway 1974, p. 7).

Here again I would like to stress the uniqueness of this situation for those who would claim that every painting is ultimately involved in an infinite regress of meaning. The choice of advertising and comicbook imagery stresses this withdrawal of referent, source, and value particularly strongly, thrusting it into the realm of thematics. For the crucial thing about an ad or comic image is its nonuniqueness, the fact that it appears in endless copies, none of which is more "proper," original, or important than another. Pop copies mere tokens, so diffused in their being that they have become the common furniture of the urban world.

I would contrast photo-realism (also called super realism) to pop in order to stress this point. Critics seem to agree that pop is the source of photo-realism, since the movements share a number of artists and a

*Fig. 44.* Roy Lichtenstein, *Him.* St. Louis Art Museum; Museum Purchase: Eliza McMillan Fund and Friends of the St. Louis Art Museum Funds.

great many technical similarities.[16] Lichtenstein, Warhol, Rosenquist, and other pop artists imitate the look of newsprint, magazines, and billboards, so that "reproducing a Lichtenstein is like throwing a fish back into water."[17] Similarly, photo-realists are after the look of photography as a medium, and suffer the same irony as Pop Art in that their works are most often seen not in the original but in the very media their paintings imitate: "the more a work of art looks like a photograph, the more misleading it will be to encounter it only in the form of photographs and reproductions."[18] Certainly, in this respect the bewildering regress of signs in both movements is very similar. The reception of this art through books serves to multiply its ambiguities, and it is even possible that artists have exploited the fact for their own purposes. As Jack Cowart says of Lichtenstein, "His imagery consistently refers to the phenomenon and effects of the current deluge of illustrated art books in which everything is changed by small scale, juxtaposition, black-and-white cuts, or four-color process plates and where all visual realities are annulled. Ironically, these items will, no doubt, remain our primary vehicles for learning about and 'seeing' art, including the art of Roy Lichtenstein" (Cowart, p. 15).

As do Lichtenstein or Warhol, photo-realists represent ready-made images. These images may appear in variable sizes depending on whether the Campbell's Soup label is on a can or a billboard, the pointed gun is a comicbook image or a film frame or a projected film image, or the photo-realist source is a contact print or a blowup. The represented image is indeterminate, and exists only in versions.

However, pop and photo-realist images do differ in what their represented images themselves represent. A photo-realist painting depicts a photograph, and that photograph depicts a specific, unique, stopped-action moment in reality. However far the retreat of signification may extend outward from photograph to painting to photographic reproductions in art books and catalogues, the reference inward has a unique origin—that place and that time when the shutter opened with the artist/photographer there, pressing the button. There is normally no such originary referent for pop art.

It is true that photo realists often include advertising signs and other images in the photographs they paint. But the result is to individuate through a specific context those otherwise homeless images. Photo-realists thus paint unique images of the extra-artistic context of pop art, the urban forest of multiple, flashing, reflected signs. In fact, this emphasis on the generic leads photo-realists to avoid painting photographs of historical events strongly rooted in time and place, and many eschew

even action as much as possible.[19] As Robert Bechtle states, "A photograph often gives the feeling of a particular moment in time, and you get the sense of how that is bracketed in with the before and after. I like the kind of photograph that tends to just be. You sense that what came before was exactly the same as what is shown, and that what comes next is going to be exactly the same. It is a kind of extension of time, which is a very traditional aspect of painting. . . . painting is essentially a static art" (Alloway 1973, n.p.). Lessing would have been delighted at such a remark, but the rootedness of photo-realist works in a real, historical here-and-now is an essential fact of their reception that mitigates the semiotic regress they seem to initiate.

It is interesting to note in contrast that when pop artists, particularly Andy Warhol, paint photographs, they very frequently use not only narrative but strongly historical shots, as in the canvases of repeated car crashes, race riots, or Jacqueline Kennedy at her husband's assassination and funeral. The other main photographic subject for Warhol's paintings is celebrity shots, especially of film stars whose fame has raised their images to the level of commercial commodities separate from their normal lives. As with Lichtenstein's comicbook narratives, Warhol's photographic subjects involve either violent action or the stuff of romance. They could not be further from the content of the photo-realists' pictures.

If we look at this configuration of features in pop art—the radical homelessness of the image and the perennial recourse to romance and war—the importance of narrative might seem more understandable. Lichtenstein's stark, decontextualized images, like the advertising images on which they are based, are radically problematic in terms of value. As we have seen, the search for meaning in them simply leads us to another sign and still another, in a futile and absurd quest. In contrast, romance and war adventures in popular culture are structures of meaning specifically designed to ground value. They polarize good and evil, beauty and ugliness, order and disorder in an attempt to characterize people, actions, and commodities, for without such polarized opposites there can be no values. "One function of the mass media is to act as a guide to life defined in terms of possessions and relationships. The guide to possessions, of course, is found in ads on TV and cinema screens, hoardings, magazines, direct mail. But over and above this are the connections that exist between advertising and editorial matter: for example, the heroine's way of life in a story in a woman's magazine is compatible with consumption of the goods advertised around her story" (Russell and Gablik, p. 41). What Lichtenstein does by problematizing

meaning in these narratives is to dismantle modern scripts for value and thus keep those images of products floating in a realm of frustrating incompletion.

It is possible to see this process as subversive to what the sixties called the "military-industrial complex." If popular heroines sell a lifestyle compatible with the goods in their advertising, the purveyors of those goods have a stake in promoting the imitation of those heroines. Adrienne Rich presents such an analysis of the relations between products and soap opera romance. "The implications for the television industry of a massive withdrawal of women from its audience, particularly from daytime viewing, are interesting to contemplate. It is clearly in the interests of the industry and its advertisers to keep women addicted, not merely to TV but to the social arrangements which isolate us in the house and which reinforce economic dependency and apolitical panaceas for political problems."[20]

I do not see Lichtenstein or Warhol as interrogating signs, images, and values with the hope of bringing about any specific political change, nor is pop art used very often to reinforce political messages. The argument from homeless sign to romance to female oppression was part of the ideology surrounding pop art in the sixties, and at times pop art has been associated perceptively with the unliberated woman.[21] But for Lichtenstein, I think, the problem is to situate art in this world of proliferating images and clichéd value stories. Art's distinctive value claims, lodged in the ideology of high romance, have been undermined not only by an audience overstocked with clichés and stereotypes from art and advertising, but by artists intent on shocking that audience and breaking with past artistic practice.

Twentieth-century art can be seen as a systematic emptying out of the value structures in painting. If we appropriate for the visual arts the Jakobsonian model of communication, with its sender, receiver, message, code, channel, and referential context,[22] we can see each of these avenues of value subverted in successive modernist movements. Nonrepresentationality severely reduced the work's ability to transmit value in terms of a referential context. Conceptual art undercut the work's status as aesthetic object, often degrading it through the use of forbidden bodily substances in place of aesthetic materials. The channel of painting was sometimes violently disrupted in such art, with messages invisible or inaudible, with views impeded or forestalled. The assault on the painting code—the systems of genre, mode, and style making up the traditional core of the pictorial—was wholesale in Happenings, but significant as well in virtually every modernist movement. And the appeal to the receiver was reduced to the violence of the dadaist assault we

*Fig. 45.* Roy Lichtenstein, *Yellow and Green Brushstrokes*. Provenance Leo Castelli Gallery, New York; private collection.

saw thematized in Lichtenstein. This is not to say, of course, that such works are without value or that all value systems are destroyed in any given movement. But taken as a totality, twentieth-century painting is a scene of intense axiological dispute.

The movements immediately preceding pop art—abstract expressionism and action painting—had focused value on the sender and the originary act of applying paint. These Lichtenstein derided in his meticulously benday-dotted *Brushstroke* works (fig. 45). It is ironic, then, that some critics have tried to "save" pop art by drawing a parallel between it and abstraction.

Art criticism has generally refused to say that an object can be equated with a meaningful or aesthetic feeling, particularly if the object has a brand name. Yet, in a way, abstract art tries to be an object which we can equate with the private feelings of an artist. Andy Warhol presents objects we can equate with the public feelings of an artist. . . . A great deal that is good and valuable about our lives is that which is public and shared with the community. It is the most common clichés, the most common stock responses which we must deal with first if we are to come to some understanding of the new possibilities available to us in this brave and not altogether hopeless new world.[23]

The upbeat tone of this statement is perhaps more in keeping with pop art than is the political intensity of Adrienne Rich. But the analogy between pop and abstraction is misleading. The abstract "thing" is a unique, handmade object valued and understood specifically through

the fact that it represents only what it is—which is one of a kind—or the unique thoughts and actions that went into its one-time making. The clichés and stock responses registered in pop art are just the opposite. Rather than standing for what is publicly deemed a "good," they present the smug face of the enigmatic value situation in which objects can be attached to any context, in which any narrative may be told of them. For values depend on the connecting of images to stories, and Lichtenstein and Warhol do all they can to problematize the relations between the two.

In painting the mass-produced image, these artists were providing new complications in the situation Walter Benjamin described in his remarkable essay, "The Work of Art in the Age of Mechanical Reproduction." There Benjamin terms the value emanating from an object's uniqueness its "aura," and associates it with history and narrative extension. "The authenticity of a thing is the essence of all that is transmissible from its beginning, ranging from its substantive duration to its testimony to the history which it has experienced. . . . that which withers in the age of mechanical reproduction is the aura of the work of art. . . . the technique of reproduction detaches the reproduced object from the domain of tradition. By making many reproductions it substitutes a plurality of copies for a unique existence" (Benjamin, p. 221). The transformation of a unique being—whether an artwork or some aspect of life—into a reproducible image deprives it of history and "aura" and is precisely the opposite of the embedding of that unique being in a narrative context. When painting, traditionally nonnarrative, depicts an image that is already emptied out of "aura," that nonnarrative tendency itself becomes an object of attention in art, and the pop art work becomes the occasion for a meditation on values.

Of course, the gain from mechanical reproduction, like that from the endless reproducibility of language (its model), is the convenience of seeming appropriation. We need to appropriate things that are not present, and so we mint tokens of them. In fact, we are driven in this not only by need but by desire. "Every day the urge grows stronger to get hold of an object at very close range by way of its likeness, its reproduction. Unmistakably, reproduction as offered by picture magazines and newsreels differs from the image seen by the unarmed eye. . . . To pry an object from its shell, to destroy its aura, is the mark of a perception whose 'sense of the universal equality of things' has increased to such a degree that it extracts it even from a unique object by means of reproduction" (Benjamin, p. 223).

But even recognizing the consumerist urge to draw essences from copies, we might properly ask what the point is in making a unique

copy in paint of a comicbook token of a romance stereotype. Who would feel the urge to get hold of the ubiquitous comicstrip frame at close range by way of its unique likeness in paint? The answer is: no one, least of all Lichtenstein. What he is doing is running the progression from thing to reproduction backward. His copies of mass-produced images are unique starting-points—the specific one-of-a-kind things that paintings are, with all the history and "aura" that accrue to them. At the same time, the very literalness of their copying makes obvious their posteriority to the copies they propose to generate. It is a tense paradoxical posture that pop maintains between source and copy, image and context. The reasoning behind it can perhaps be seen in John Cage's often-cited essay on Jasper Johns: "The situation must be Yes-and-No not either-or. *Avoid a polar situation*" (Russell and Gablik, p. 23). Yet, as the romance concern with contraries shows, value as we know it depends on the polar opposition.

The complexity of this reversal of value structures is also apparent in Lichtenstein's treatment of technology. Benjamin depicts painting withering in the presence of the reproductive powers of film: "for contemporary man the representation of reality by the film is incomparably more significant than that of the painter, since it offers, precisely because of the thoroughgoing permeation of mechanical equipment, an aspect of reality which is free of all equipment. And that is what one is entitled to ask from a work of art" (Benjamin, p. 234). Film is thus an image of pure unmediated reality achieved paradoxically by loading the filmed environment with technology, invisible only in the direct line between camera and scene. In contrast, Lichtenstein's famous benday dots are the very image of technology mediating the depicted world, as are the brushstrokes, canvases, and backs of canvases that he paints so fastidiously.

Yet Lichtenstein's mode of painting technology is strangely akin to the film situation that Benjamin describes. The process of his painting is unabashedly mechanical. He projects comic or ad images onto a screen, copies them by hand or stencils them onto silk screens, and then prints them. Warhol even left the printing to his assistants. The environment of reproduction is thus saturated with equipment. Though what is reproduced seems to be the technology of reproduction, Lichtenstein's benday dots and expressionist brushstrokes are like no mechanical means ever used. They are painterly ideas of technical means, each unique and artfully formed, and they are transmitted in the pure blank perfection of airblown paint. "I want my painting to look as if it has been programmed," he says. "I want to hide the record of my hand" (Coplans, p. 12). Pop art gives us an unmediated view of media, and thus overturns the alleged authority of film over painting.

The effect of the reversal can be exhilarating or infuriating—Lawrence Alloway speaks of the "malicious ambiguity [brought] to bear on the ideas of expression and depth" by pop art (Alloway, p. 78), and yet the motivation for this desperate complication seems clear enough. "In 1955, during the heyday of Abstract-Expressionism, [Ray Johnson, soon to emerge as a pop artist] altered a photograph of Elvis Presley by dripping red paint from the eyes. He called it 'Oedipus' and said, 'I'm the only painter in New York whose drips mean anything'" (Russell and Gablik, p. 17). This need to revitalize art by valorizing its technology (red paint drips) as capable of representation (Oedipus's blood) is a perennial modernist move. Indeed, Johnson's statement sounds like Gertrude Stein's comment on "A rose is a rose is a rose": "in that line the rose is red for the first time in English poetry for a hundred years."[24] By stressing the verbal matter itself through repetition, Stein was forcing aesthetic and referential value back into language.

In fact, this connection between pop art and Stein is directly relevant to narrative. Stein believed that the old-style story with beginning, middle, and end was inappropriate to the twentieth century, because of the high-pitched intensity of modern media-filled life. Instead of projecting one forward in time to a final resolution, a modern narrative should force one into the fullness and depth of each moment, and should proceed as a succession of such moments. Each should be a copy of the last, with only tiny differences from it, as the succeeding frames of movie film repeat each other with only minimal differences.

Thus, Stein advocated a new kind of narration, exemplified by "a rose is a rose is a rose is a rose": "I caressed completely caressed and addressed a noun."[25] This calling on the noun over and over again is like Stein's "natural way to count": "not that one and one make two but to go on counting by one and one. . . . One and one and one and one and one" (G. Stein, "Poetry and Grammar," p. 227). Such writing resembles narrative in creating a progression in time, but unlike narrative it is not oriented toward an end or goal. Instead, it focuses on each iteration of a name or number. Its now is the reader's now. In reading repetitions we do not project ourselves into the future or contaminate the present with memories of the past but live in the immediacy of each moment.

The idea that repetition is artistically vital both for formal and expressive purposes is a far cry from the standard modernist attitudes toward it. In Freud, repetition is usually sinister, linked to the death wish or an unresolved trauma that dominates the psyche.[26] In literature, repetition is the realm of the factory and the machine, the dehumanized nemesis of uniqueness and creativity.[27] Walter Benjamin's "The Work of Art in the Age of Mechanical Reproduction," as we have seen, is an

*Fig. 46.* Andy Warhol, *Jackie* (1964). Provenance Leo Castelli Gallery, New York; private collection.

analysis of the adjustments necessitated in art by the advent of serial production, photography, and motion pictures. Yet Stein and pop artists made a virtue of this necessity. They subverted narrative into repetition, and then filled repetition with a powerful expressive potential.

As we have seen throughout this study, the borderline between repetition and narrative progresson is a precarious one. Among the indispensable requisites of pictorial (and literary) narrative is the repetition of a subject, but each instance of that subject must be modified by unique temporal-spatial circumstances. Narrative is repetition with a difference; exact repetition is design, as Escher's *Encounter* reveals. Without the subject's modification by context—which might be a fundamental way of characterizing realism—one is thrown back onto the very opposite of narrative—the two-dimensional picture plane as a non-referential design world.

Fascinated with this borderline situation, pop art is crowded with repetition. Its basic move is to reproduce an image preexisting in mass copies in the outside world. But Warhol and Lichtenstein also repeated images within canvases, splitting the picture plane into the requisite zones of narrative, and then filling them perversely with identical images. There is probably no better parallel to Gertrude Stein's early narratives than Andy Warhol's split-image works such as *Five Deaths Eleven Times in Orange* or *Jackie* (fig. 46), in which a photograph of an event or a face is stenciled over and over onto a canvas in neat rows and columns. In the multiple images of a traffic accident or Jacqueline Kennedy's face, the repetition initially deprives the image of any impact, since the whole appears to be an intricate, beautiful design. A close examination of the work, however, reveals the content of the image, and the shock of this transformation of catastrophe into design still works today, no matter how many times we have seen through it. This play at the boundary between narrative and design inevitably poses the issue of value.

The status of the publicity image was thus a primary concern of pop art. Stein had based her argument against narrative and plot on the hyperabundance of stories transmitted by the popular media: "what does it really matter what anybody does. The newspapers are full of what anybody does and anybody knows what anybody does but the

thing that is important is the intensity of anybody's existence."[28] The idea of things going on happening without their making any difference, of modern life battering us with endlessly repeated messages without consequences or context, is the idea of the publicized world as Stein described it and pop explored it. In the sixties, nothing was more familiar among intellectuals than the kind of analysis Lawrence Alloway provided: "our senses are so overloaded with artificial emotion from politicians' speeches, bad movies, bad art, ladies' magazines, and TV soap operas that a *stark* repetition like Warhol's means more than an ultraexpressionist portrayal of accident victims ever could. . . . [Pop repetition] is an unequivocal act that is both simple-minded and intellectually complex" (Lippard, p. 99).

By turning numbing repetition back upon itself, pop combined simple-mindedness and intellectual complexity and in the process put the perceiver in a classic double bind. We cannot take pop "seriously," because seriousness is so antithetical to its stance. The slick "cool" of pop simply sheds political and emotional intensity. At the same time it is dealing with issues of great importance, including the issue of its own superficiality. Warhol infuriated the public by presenting these ideas openly. "I think everybody should be a machine," he said. "I think everybody should like everybody. [Interviewer:] *Is that what Pop Art is all about?* Yes. It's liking things. *And liking things is like being a machine?* Yes, because you do the same thing every time. You do it over and over again. *And you approve of that?* Yes, because it's all fantasy."[29] How can one invoke the sixties orthodoxy of deploring the machine if it means rejecting the sixties panacea of fantasy? Like Stein's essays and interviews, Warhol's work is a mixture of oracle and tease.

Warhol's seemingly illogical connection here between repetition and fantasy is a key insight in pop art, and further accounts for these artists' concern with the romance narrative. Mass media repetition detaches the image from its real referent in the world and from its original context as an image. Such free-floating, endlessly interreferential images are the very heart of romance. The movie star as a phenomenon depends on it. Benjamin claims that we do not identify with movie actors but with the camera, because the actor is there only as a repeatable celluloid image. Consequently, "the film responds to the shriveling of the [actor's] aura with an artificial build-up of the 'personality' outside the studio" (Benjamin, p. 231). Or as Warhol put it, "Repetition adds up to reputation."[30] He exemplified this dictum in his open-shutter film of the Empire State Building, which repeats a single image over time rather than space. In this cityscape become narrative, Warhol transformed the Empire State Building into what he called his first superstar.[31]

In the meditation on value at the ideological core of pop art lies the notion that values accrue to images precisely because images differ from the real. "It's not the thing I want so much as the idea of the thing," says one of Warhol's characters. "'Then that's just advertising,' I reminded him" (Warhol, p. 195). "If you didn't have fantasies you wouldn't have problems because you'd just take whatever was there. But then you wouldn't have romance, because romance is finding your fantasy in people who don't have it" (p. 55). Warhol presents himself accordingly as a contentless image-maker—a mirror (p. 7)—and says that his wife is a tape recorder. Love in Warhol is the equivalent of brand loyalty.

Warhol actually went on to write a consumerist romance which contains one of the most extraordinary media heroines since Gerty MacDowell. She is a "B," one of a number of interlocutors of that initial who talk on the telephone with Warhol's "A" in *The Philosophy of Andy Warhol (From A to B and Back Again)*. Like Gerty, this "B" is a product of women's magazines and advertising. She is a Frankenstein's monster—a character from a laundry detergent commercial come to life. But more, she is an artist of the clean. For twenty-four consecutive pages she describes exactly how she cleans her apartment, disposes of her garbage, and washes and cares for herself. Like the "Nausicaa" chapter, this monologue disconcertingly mingles the technology of grooming with its ideology and presents a rather harrowing picture of self-absorption. Both monologues consequently end in masturbation, or talk of it, but unlike Gerty's observer Bloom, "A" loses interest when the technology of feminine cleanliness shifts to the technology of satisfaction. For "A," boring sex is too far away from the excitement of pure images.

But more striking still, both Gerty's and "B"'s monologues connect the public image to painting. Joyce's "Nausicaa" chapter is dedicated to the art of painting, and Warhol's "B" is herself an artist. Worried that she will never be able to keep her art supplies clean, she decides to throw them down the toilet, filming them as they go. The paints, of course, make a disposable Jackson Pollock.

Then I decided I could do Roy Lichtenstein in the toilet so easily. I wanted to get rid of all those little round balls that I have from the 60s Psychedelic Art sticker period, so I went through a drawer and as I went through I thought to throw all the dots from Childcraft, throwing all the dots in the clean white toilet and they were floating around and looking so pretty because the bowl was clean—I'd put Comet in before, green Comet—and used a johnny brush, so it was really white—and I took a Polaroid of the dots and it looked just like a Lichtenstein, and then I flushed the dots and the painting was gone. And then I had some little American flags . . . and so I thought I'd do some Jasper

Johns on the toilet. I threw all my American flags into the toilet and then I had a polaroid Jasper Johns. I did a Warhol in the john too.

<div align="right">(Warhol, pp. 216–17)</div>

This deadpan allegory is hard to take seriously, but, of course, that is just the point. The ever-effacing toilet (like the tide washing away chalk paintings in "Nausicaa") is the cliché for artistic history itself. Pop is art thrown down the toilet—Warhol later urinated in order to produce art[32]—and the pun on "Johns" and "john" only stresses the suitability of the arrangement. Yet each artwork is saved on Polaroid—the instant copy of the unique moment irretrievably lost.

If Lichtenstein has never presented pop ideology as openly as Warhol, he has pressed some of pop's paradoxes and tensions further. Whereas Warhol's repeated images make pattern and representationality problematic, Lichtenstein's stress the delicate line between design and narrative. "The small diptych *Step-on Can* explores the narrow borderline between dispassionate repetition and a lateral reading as sequence" (Morphet, p. 35). The pun in the title—Is "Step on" a hyphenated adjective or an imperative verb plus a preposition?—accents the ambiguity. In *Cow Triptych,* the three panels progressively transform the image from a representational, to a cubo-abstractionist, to an abstract rendering. Yet the artificiality of all three drawings vis-à-vis a "real" animal makes one hesitate to read the work as a progression from left to right at all. Instead it might be three independent works.

Commentators consistently note the hesitation between narrative and static scene in Lichtenstein's multi-image works. In trying to read the *Grapefruit Triptych* (fig. 47), for example, Jack Cowart notes two possibilities. "The first view may be that each panel is a segment of one large panorama of nine grapefruits from which we are missing the intervening space. In this view the scene is static. The second view may be that each panel is literally the same picture but that some unseen event has taken place so that it is the grapefruits that have moved or been moved. In this case, we are missing the intervening time" (Cowart, p. 64). There is no way to choose between these views, another suspension of the "either/or" in pop art. Thus, though Lawrence Alloway is right to claim that "Warhol believes in repetition . . . whereas Lichtenstein believes in progression, the advancement of his sets of images from one point to the next" (Alloway 1974, p. 19), Lichtenstein's narrative progression seems ready to disintegrate at any moment into a mere collocation or design. In *Modular Painting with Four Panels* (fig. 48) he actually does paint identical elements that coalesce into a design.

*Fig. 47*. Roy Lichtenstein, *Grapefruit Triptych*. Private collection, London.

Lichtenstein carries on this balancing act between representationality and abstraction, narrative and design, and violent depicted emotion and cool pictorial technique with the intrigued intensity of an explorer. Mechanical reproduction, far from marking the end of painting, for him signals a new ground of opportunity. The conceptual artist, in contrast, pronounces the demise of representational art in the face of photographic mimesis: "The act of painting slowly and laboriously what the camera can record quickly and effortlessly becomes a metaphor for the essentially meaningless act of existence" (Lucie-Smith, p. 10). Unafflicted by existential angst, Lichtenstein shows that copying in paint is meaningful precisely because it differs from photographic copying. It raises the mechanical image to the contemplation accorded its painted counterpart, contextualizing it ever anew in works built upon works built upon popular images. It explores the humor, irony, and ambiguities of the second-order sign system.

Moreover, by insisting on the act of imitation—if not a secure meaning lodged in the resulting image—Lichtenstein maintains the same disciplined balance between representationality and self-reflexivity that the cubists had demanded. By exploring this balance in terms of narrative he goes even further, anticipating the direction of David Hockney (another pop artist in the sixties) who has recently been developing a pictorial narrativity that fuses cubism and medieval story-painting techniques. In explaining this idea, Hockney turns to the language of romance: "Art is about correspondences—making connections with the world and to each other. It's about love in that sense—that is the basis of the truly erotic quality of art. We love to study images of the world, and especially images of people, our fellow-creatures." [33] The line from painting to narrative to value runs through romance. Lichtenstein revealed these connections by interrogating them, by isolating images

*Fig. 48.* Roy Lichtenstein, *Modular Painting with Four Panels.* Wallraf-Richarz-Museum, Cologne.

from their narrative contexts and then locating them in the world, by walking the tightrope between narrative and design, by subverting romance unities while insisting on the intense compositional unity of his own works, by multiplying the regress of signs in the uniquely originary moment of his art.

Thus, to answer my earlier questions, Lichtenstein played with narrative because it is the crucial supplement to the image in the creation of value. It opens up that system of oppositions between self-enclosure and contingency that lie behind any artistic exploration of meaning, and particularly one like pop art in which meaning, value, and the aesthetic are terms fraught with ambivalence. Correspondingly, twentieth-century art took so long to attempt multi-episodic narrative painting because

the delicate balance between representationality and self-reflexiveness in cubism was tipped for so long toward abstraction. As David Hockney argues: "The great misinterpretation of twentieth-century art is the claim . . . that Cubism of necessity led to abstraction. . . . Cubism was about the real world. It was an attempt to reclaim a territory for figuration, for depiction. Faced with the problem that photography had made figurative painting obsolete, the Cubists performed an exquisite critique of photography" (Wechsler, p. 38). That critique advanced one step further in pop art, where not only the representational facility of photography but the very ideology of mechanical reproduction was examined. There, the strain of turning picture into story is palpable, and yet the potential gains for both figuration and compositional complexity are enormous.

# Conclusion

The romance-painting connection flourishes in postmodernism. In 1969, after twenty years of apparent retirement from art, Marcel Duchamp unveiled his final statement: a room-sized environment entitled *Etant Donnés: 1) La chute d'eau; 2) Le gaz d'éclairage*. It is a bare room with an old wooden door locked against the viewer. In the door are two peepholes, through which one sees a brick wall broken to reveal

an extremely realistic-looking nude woman, life-size, lying with her feet toward us and her head thrown back, the features obscured by a mass of blond hair; she lies on her back on a bed of dry twigs and branches (real twigs and branches), holding in one raised hand an antique gas lamp; her sex is explicitly modeled, and hairless; behind her, a naturalistic, "pretty" landscape (painted in perspective) with woods, hills, a pond, white clouds in a blue sky, and at the far right a sparkling waterfall (mechanical). The scene is bathed in brilliant light, the theatrical light of an afternoon in midsummer.[1]

As his final artistic statement, Duchamp recreated us as voyeurs, forced to view the scene exactly as he intended. We peek through barrier after barrier at the stereotype of an erotic object in a stereotypically realist setting. But however lifelike the setting and the subject, this is an artwork that cannot be adequately photographed, for the room with the peepholes and the scene on the other side are not simultaneously available to a camera.

In another postmodernist treatment of the gaze, Italo Calvino's Mr. Palomar, named for an observatory and obsessed with the act of vision,

walks on the beach and notices a woman sunbathing with naked breasts. He averts his eyes, so that the woman will not cover herself, for he wishes to guarantee "his civil respect for the invisible frontier that surrounds people."[2] But upon reflection, he is dissatisfied with his refusal to see. "My not looking," he muses, "presupposes that I am thinking of that nakedness, worrying about it; and this is basically an indiscreet and reactionary attitude" (Calvino, p. 10). He passes by the bather again, this time fixing his eyes straight ahead, so that the naked breasts are simply one more item in the indifferent landscape. But in doing so, Mr. Palomar worries that he has acted the traditional male chauvinist, reducing woman to an object. So he strolls past again. His glance now shifts at the sight of the bosom, acknowledging its difference from the other elements of the scene. And yet this glance still does not seem right. It may have relegated the breasts "to the semidarkness where centuries of sexomaniacal puritanism and of desire considered sin have kept it" (p. 11). Mr. Palomar disapproves of such puritanism and wishes to encourage the modern openness to sexuality. He turns around and passes the woman again, intending to have his eyes linger on her breasts, including them "in an impulse of good will and gratitude for the whole, for the sun and the sky, for the bent pines and the dune and the beach and the rocks and the clouds and the seaweed, for the cosmos that rotates around those haloed cusps" (pp. 11–12). But the woman jumps up, covers herself, and walks away in irritation, and Mr. Palomar concludes that "the dead weight of an intolerant tradition prevents anyone's properly understanding the most enlightened intentions" (p. 12). On the dust jacket of *Mr. Palomar*, Calvino reproduces the woodcut from Dürer's *Instruction in Proportion* that we examined in chapter 2.

The dynamic of image and romance turns up in other postmodernist fiction as well. In Tom Robbins's *Still Life with Woodpecker*, the picture on a Camels cigarette box comes to life as the hero tries to discover "how to make love stay." In Thomas Pynchon's *Crying of Lot 49*, the heroine, Oedipa Maas, sees a surrealist painting in which maidens work in a tower, weaving a tapestry that flows out through the windows to fill and be the world. This painting is actually part of a triptych by Remedios Varo, the third panel of which shows one of the maidens escaping with her lover by means of a trap she has woven into the tapestry. Likewise, Oedipa Maas, imprisoned in a symbolic tower of repetition and solipsism, is released by the book's action into the escape/trap of the romance quest.

Films are a particularly rich source of romance–visual art examples. In Brian De Palma's *Dressed to Kill* and *Body Double*, for example, the ethics of vision enter the realm of the cinema. Men watch women through binoculars and telescopes, and in a variety of doomed and al-

most funny ways try to make contact with them, not only to gaze but to "speak, kneel, touch, kiss," or kill. The beauty and menace of the visual object and the alternate destructiveness and inefficacy of the gaze are central themes in De Palma's art, where the analogy among filmmaking, violence, and film-viewing is clearly and disconcertingly drawn. As a mother cautions her little daughter in *Dressed to Kill*, "it isn't nice to stare." And yet, why else, De Palma asks, do we go to the movies?

The cult film *Liquid Sky* surveys postwar movements from beat to hippie, pop, camp, and punk through an even crazier association of voyeurism, sex, art, and drug experience. Male and female models (played by the same actress) are constantly posed and "set up" by representatives of various aesthetic/ethical styles until an extraterrestrial force puts an end to the girl's exploitation. The oversexed mother of the male model munches Chinese shrimp as she spies on the incredible goings-on through a telescope.

In postmodern literature, visual art, and film, pictures of romance abound. They exploit the same contrasts between stasis and flow, design and story, repetition and narrative that we have seen throughout this study, and inevitably problematize the audience of the work of art. What are the power and responsibilities of aesthetic perception? How far should the audience extend the magic circle of art into the widening spheres of extra-aesthetic experience? What do we actually know about the boundary between formal and contextual interpretation?

# Notes

## Introduction

1. William York Tindall, *A Reader's Guide to James Joyce* (New York: Farrar, Straus and Giroux, 1959), p. 193.

2. In Richard L. Stein's stimulating *Ritual of Interpretation: The Fine Arts as Literature in Ruskin, Rossetti, and Pater* (Cambridge, Mass.: Harvard University Press, 1975), pp. 7–8, Keats is contrasted to the Victorians, on the grounds that his poetry ignores the issue of audience or specifically isolates the audience from the text.

## Chapter One

1. The quotation from von Haller that forms the epigraph was translated by Howard Nemerov. Nemerov, *Collected Poems* (Chicago: University of Chicago Press, 1977), p. 471.

2. Victor Turner, "Social Dramas and Stories about Them," *Critical Inquiry* 7, 1 (Autumn 1980): 167: "'Narrate' is from the Latin *narrare* ('to tell') which is akin to the Latin *gnarus* ('knowing,' 'acquainted with,' 'expert in') both derivative from the Indo-European root *gna* ('to know') whence the vast family of words deriving from the Latin *cognoscere*, including 'cognition' itself, and 'noun' and 'pronoun,' the Greek *gignoskein*, whence gnosis, and the OE p.p. *gecnawan*, whence the ModE 'know.' Narrative is, it would seem, rather an appropriate term for a reflexive activity which seeks to 'know' (even in its ritual aspect, to have gnosis about) antecedent events and the meaning of those events." One might compare "history," from the Greek *historia*, "a learning or knowing by

inquiry, an account of one's inquiries, narrative, history," and *histor*—"knowing, learned, wise man, judge" (*Oxford English Dictionary*).

3. Sol Worth, "Pictures Can't Say Ain't," *Vs.* 12, 3 (1975): 85–108.

4. "Laokoön," *Selected Prose Works of G. E. Lessing,* ed. Edward Bell (London: G. Bell, 1879).

5. Norman Bryson, *Word and Image: French Painting of the Ancien Régime* (Cambridge: Cambridge University Press, 1981), p. xvi.

6. Leonardo da Vinci, *Treatise on Painting*, vol. 1, translated and annotated by A. Philip McMahon (Princeton, N.J.: Princeton University Press, 1956), p. 18.

7. See Joseph Frank, "Spatial Form in Modern Literature," in *The Widening Gyre* (New Brunswick, N.J.: Rutgers University Press, 1963), and Jeffrey R. Smitten and Ann Daghistany, eds., *Spatial Form in Narrative* (Ithaca, N.Y.: Cornell University Press, 1981). Formalists such as Šklovskij have unwittingly contributed to this belief by associating the chronological chaining of represented events with necessity, and the narrative manipulation of this order with art. Thus, to tell a "natural" story is to follow time as in a chain; to tell an artful story is to rearrange the links into a configuration. But the identification of art with what is added to chronological sequence is certainly not uniform among the formalists and is belied by the theories of virtually every narratologist. See Peter Steiner, *Russian Formalism: A Metapoetics* (Ithaca, N.Y.: Cornell University Press, 1984), pp. 115–16.

8. Among the few extended discussions of narrative art are: Richard Brilliant, *Visual Narratives: Storytelling in Etruscan and Roman Art* (Ithaca, N.Y.: Cornell University Press, 1984); Louis Marin, *Etudes Sémiologiques: Ecritures, Peintures* (Paris: Klinsieck, 1971); and Martin Meisel, *Realizations: Narrative, Pictorial, and Theatrical Arts in Nineteenth-Century England* (Princeton, N.J.: Princeton University Press, 1983).

9. John Canaday, for example, wrote that "with *The Slave Ship* Turner's development toward a final abstract statement of romantic emotionalism was nearly complete. The title of the picture still clings to literary associations not inherent in the painting as an independent work of art, and it is with a kind of disappointment that we discover the narrative incident in the foreground right, where a shackled leg disappears into the water, surrounded by devouring fish. This bit of storytelling appears as an afterthought, a concession to popular standards in a picture that was not only complete without it but is reduced from grandeur by its inclusion." *Mainstreams of Modern Art* (New York: Holt, Rinehart and Winston, 1956), p. 96.

10. Sacheverell Sitwell, *Narrative Pictures: A Survey of English Genre and its Painters* (New York: Schocken Books, 1969), p. 1.

11. Nancy Wall Moure, *American Narrative Painting* (New York: Praeger, 1974).

12. Carl H. Kraeling, ed., *Narration in Ancient Art: A Symposium* (Chicago: Oriental Institute, 1955), p. 44.

13. Gerald Prince, "Narrativity," in *Axia: Davis Symposium on Literary Evalua-*

*tion,* ed. Karl Menges and Daniel Rancour-Laferrière (Stuttgart: Akademischer Verlag Hans-Dieter Heinz, 1981), pp. 74–75.

14. William Labov, *Language in the Inner City* (Philadelphia: University of Pennsylvania Press, 1972), p. 366.

15. Note the similarity of Labov's notion to Alberti's stress on the importance of the pictorial commentator, "who admonishes and points out to us what is happening there; or beckons with his hand to see; or menaces with an angry face and with flashing eyes, so that no one should come near; or shows some danger or marvellous thing there; or invites us to weep or to laugh together with them. Thus whatever the painted persons do among themselves or with the beholder, all is pointed toward ornamenting or teaching the *istoria*" (Leon Battista Alberti, *On Painting,* trans. John R. Spencer [New Haven, Conn.: Yale University Press, 1956], p. 78.) This notion is examined in detail in chapter 2.

16. Michael Fried, *Absorption and Theatricality: Painting and Beholder in the Age of Diderot* (Berkeley: University of California Press, 1980), p. 73.

17. For a discussion of this subgenre, see Hugh Witemeyer, *George Eliot and the Visual Arts* (New Haven, Conn.: Yale University Press, 1979), p. 111.

18. G. A. Gaballa, *Narrative in Egyptian Art* (Mainz-am-Rhein: Verlag Philipp Von Zabern, 1976), p. 5.

19. See John Fisher, "Entitling," *Critical Inquiry* 11 (December 1984): 286–98, for a discussion of titles in the arts.

20. Paul Ricoeur, "Narrative Time," *Critical Inquiry* 7, 1 (Autumn 1980): 169.

21. Gerald Prince, "Aspects of a Grammar of Narrative," *Poetics Today* 1, 3 (1980): 49–50.

22. I discuss this more fully in *The Colors of Rhetoric: Problems in the Relation between Modern Literature and Painting* (Chicago: University of Chicago Press, 1982), pp. 41–48.

23. Barbara Herrnstein Smith would consider it fallacious, however, to speak of the priority of a story to its telling. See "Narrative Versions, Narrative Theories," *Critical Inquiry* 7, 1 (Autumn 1980): 213–36.

24. Labov (pp. 360–61) unaccountably confuses the order of the story with the order of its telling in his distinction between free and narrative clauses. He claims that a change in the placement of a narrative clause will lead to a semantic alteration in the narrative, whereas a change in the placement of free clauses will not, since these refer to general events or states of affairs. However, even narrative clauses can appear in different orders without the narrative meaning's being changed when prepositions and conjunctions indicate the priority of events narrated later to those earlier, and vice versa. It is only a change in the *story* order that would produce a different narrative.

25. Nelson Goodman in "Twisted Tales; Or Story, Study, and Symphony," *Critical Inquiry* 7, 1 (Autumn 1980): 103–20, has argued for limits to the discourse distortion of story order. When these limits are transgressed, he claims, we no longer have a narrative. I would amend this position as follows: there is no limit to the discourse distortion of story order in narrative; however, not

every presentation of a story *is* a narrative. The presence or absence of narrativity is a function of factors other than mere ordering.

26. See Viktor Šklovskij, "Sterne's *Tristram Shandy:* Stylistic Commentary," in *Russian Formalist Criticism: Four Essays,* trans. and ed. Lee T. Lemon and Marion J. Reis (Lincoln: University of Nebraska Press, 1965), pp. 25–57.

27. Seymour Chatman, "What Novels Can Do That Films Can't (and Vice Versa)," *Critical Inquiry* 7, 1 (Autumn 1980): 122.

28. These works are cited by Joseph Kestner, "Secondary Illusion: The Novel and the Spatial Arts," in *Spatial Form in Narrative,* ed. Smitten and Daghistany, p. 104.

29. Kurt Weitzmann, "Narration in Early Christian Art," in *Narration in Ancient Art: A Symposium,* ed. Kraeling, p. 83.

30. Seymour Chatman, *Story and Discourse* (Ithaca, N.Y.: Cornell University Press, 1980), p. 34.

31. One might compare publishers' instructions for the compiling of proper name indexes, which urge compilers to exclude any names that are mentioned once merely to "set a scene."

32. Roland Barthes, *S/Z,* trans. Richard Miller (New York: Farrar, Straus and Giroux, 1974), pp. 82–83.

33. Hayden White, "The Value of Narrativity in the Representation of Reality," *Critical Inquiry* 7, 1 (Autumn 1980): 9, 19.

34. Ann Perkins, "Narrative in Babylonian Art," in *Narrative in Ancient Art: A Symposium,* ed. Kraeling, p. 55.

35. Frank Kermode, "Secrets and Narrative Sequence," *Critical Inquiry* 7, 1 (Autumn 1980): 84–85.

36. Helen J. Kantor, "Narrative in Egyptian Art," in *Narrative in Ancient Art: A Symposium,* ed. Kraeling, p. 55.

37. George M. A. Hanfmann, "Narrative in Greek Art," in *Narrative in Ancient Art: A Symposium,* ed. Kraeling, p. 74.

38. E. H. Gombrich, *Art and Illusion* (Princeton, N.J.: Princeton University Press, 1960), p. 129.

39. Leonardo da Vinci, *On Painting,* trans. Carlos Pedretti (Berkeley: University of California Press, 1964), pp. 9n, 17, 30, 117, 119.

40. Mark W. Roskill, *Dolce's "Aretino" and Venetian Art Theory of the Cinquecento* (New York: New York University Press, 1968), p. 121.

41. Jack Matthew Greenstein, "*Historia* in Leon Battista Alberti's *On Painting* and in Andrea Mantegna's *Circumcision of Christ*" (Ph.D. diss., University of Pennsylvania, 1984), p. 30.

42. Michael Fried discusses Poussin's painting as well, pointing out the relation between unities in painting and in drama: "Le Brun praised Poussin's *Israelites Gathering Manna* for its unity of action, which he seems to have regarded as all the more impressive because of the painting's many figures and diversity of actions and expressions. . . . The notion of unity of action was closely linked to one of unity of time, which like the first was based on an analogy with drama. Roughly, a painter was held to be limited to the representation of a single mo-

ment in an action, an idea that brought certain crucial differences between the two arts, if not yet into focus, at least into view. . . . what was felt to be important was not the apparent instantaneousness of the representation but rather that the painter, having made the best possible choice among the principal phases of the action, confine himself to that phase and not trespass upon the others more than was absolutely necessary for the most effective presentation of his subject. Above all, the juxtaposition within the same canvas of manifestly incompatible or contradictory phases of the same action was to be avoided in the interest of *vraisemblance*. Failure to observe these strictures was held to result in a loss not only of unity but also of intelligibility" (Fried, p. 83).

43. Norman Bryson has criticized the commonly held belief, which I am here endorsing, that the Albertian system held sway until post-impressionism. He claims that this "is a prejudice 'of the left' and concerns a mythical continuity: that 'Quattrocento' space reigns unchallenged from Giotto until Cézanne" (Bryson, p. 89). In light of my argument it might be more accurate to speak about quattrocento time/space, which does seem to have remained remarkably consistent in its overall traits for the four-hundred-year period in question.

44. National Gallery of Art (Washington, D.C.), gallery notes to *Scenes from the Life of Saint John the Baptist* by the Master of the Life of Saint John the Baptist, Kress Collection number 1147, Gallery 1.

45. Bernard Berenson, *The Italian Painters of the Renaissance* (Ithaca, N.Y.: Phaidon, 1952), p. 64.

46. Fern Rusk Shapley, "A Predella Panel by Benozzo Gozzoli," *Gazette des Beaux Arts* (February 1952): 88.

47. See Helen Grace Zagona, *The Legend of Salome and the Principle of Art for Art's Sake* (Geneva: Librairie E. Droz, 1960).

48. Charles Seymour, Jr., *Art Treasures for America* (London: Phaidon, 1961), pp. 18, 23.

49. National Gallery of Art (Washington, D.C.), gallery notes to Sassetta's paintings from the *Life of Saint Anthony,* Kress Collection, numbers 817, 818, and 404, Gallery 3.

50. Patricia A. Parker, *Inescapable Romance: Studies in the Poetics of a Mode* (Princeton, N.J.: Princeton University Press, 1979), p. 88.

51. Keats outlines this notion in a letter to J. H. Reynolds of May 3, 1818, in a passage beginning, "I compare human life to a large mansion of many apartments." *Letters of John Keats,* ed. Hyder Edward Rollins (Cambridge, Mass.: Harvard University Press, 1958), vol. 1, p. 280. In connection with the emblem, Ernest Gilman argues that Renaissance writers frequently understood the wholeness of a narrative in architectural terms: "The 'idea' or 'foreconceit' of the poem . . . for Sidney is that unitive prevision of the whole to be bodied forth sequentially, and secondarily, in language. The reader's task then is to reverse the procedure by using 'the narration' of a poem 'but as an imaginative groundplot of a profitable invention.' The key term here, borrowed from the vocabulary of architecture, suggests an 'imaginative' conception of the text as a floor plan on which the writer constructs—and from which the reader reconstructs—the full

spatial volume of the work" (paper presented at Modern Language Association Conference, December 28, 1982).

52. Cennino d'Andrea Cennini, *The Craftsman's Handbook,* trans. Daniel V. Thompson, Jr. (New York: Dover, 1933), p. 15.

53. Mary Pittaluga, *Filippo Lippi* (Florence: Del Turco Editore, 1949), p. 117: "La contenutezza . . . a un alto significato artistico, ed è, pur essa, un elemento prebotticelliano: mette la sordina, se si puo dire, alla manifestazione dei sentimenti, converte il clamore in bisbiglio, l'atmosfera di dramma in atmosfera di mistero dolente."

54. See my *Colors of Rhetoric,* chapter 1, for a discussion of Peirce's terms *icon, index,* and *symbol.*

## Chapter Two

1. Lily Briscoe paints Mrs. Ramsay as seen through a window in part 1 of *To the Lighthouse,* which is itself called "The Window," and Hugh Witemeyer has discovered such scenes in George Eliot's novels: "The best pictorial analogue for the window-scenes in *Middlemarch* is not to be found in landscape painting at all but in a pop motif of nineteenth-century Romantic genre painting: the figure looking out a window who presents his or her back to a viewer located inside the room. The motif is operative in European painting from the seventeenth century well into the twentieth. . . . Romantic *Fensterbilder* are an appropriate analogue to the window-scenes in *Middlemarch* because Dorothea's presence in those scenes is always visualized as carefully as the landscape itself, and because the quality of her apprehension is the true center of the audience's interest" (Witemeyer, p. 155).

2. See Chapter 3 for Leo Steinberg's description of the sleepwatcher as he or she appears in art up to the time of Picasso.

3. Longus, *Story of Daphnis and Chloe,* ed. W. D. Lowe (Cambridge: Deighton Bell, 1908), p. 5.

4. Of course, the term "romance" cannot be defined with any hope of critical consensus. It governs a range of texts from books of the Bible to Thomas Pynchon, from *The Faerie Queene* to soap operas. The romance is too formally diverse to constitute a genre, and yet it has not been canonized among the great modes of lyric, epic, and drama. Under the genius of Northrop Frye, it expands imperialistically to include all of literature; at the same time, medievalists and nineteenth-century scholars make nice distinctions between the romance and the epic or the romance and the novel.

I have no desire to enter the definitional controversy, which I take to be doomed from the start. My thesis in this chapter is that many literary texts that are termed romances use visual artworks for their imagery and symbols. They do so because romances subvert realist conventions, particularly the treatment of identity, time, and interpretation, and because painting *establishes* its claim to realism by a similar treatment of these factors. But of course, to assert this is to beg all the questions that the term romance (and realism) may evoke. My only

excuse is that such is the way of aesthetic scholarship, employing imprecise notions to assist in textual analyses that in turn illuminate or modify those initially imprecise ideas.

5. A. Bartlett Giamatti, *Exile and Change in Renaissance Literature* (New Haven, Conn.: Yale University Press, 1984), p. 83.

6. Patricia Parker shows how central the theme of interpretation is to both Spenser and Milton. Of the description of Gloriana in the Proem to Book II of *The Faerie Queene,* she writes: "the veil is there for the reader to pierce, . . . where the metaphor of the veiled 'testament' is combined with the common Renaissance concept of the veiled surface of allegory protecting truth from the eyes of the vulgar. 'Reading,' then, becomes part of the process of revelation, of moving from 'magic to miracle,' like the moments of revelation, of the lifted veil of Una or the raised vizor of Britomart" (Parker, pp. 79–80). And of Milton, "the knight's quest becomes, as in Bunyan, a pilgrim's progress, but the pilgrim is now the reader himself" (p. 128).

7. Northrop Frye, *The Secular Scripture: A Study of the Structure of Romance* (Cambridge, Mass.: Harvard University Press, 1976), pp. 108, 109. Theodore Ziolkowski gives a survey of literature in which statues come to life, portraits move, and mirrors speak in *Disenchanted Images: A Literary Iconology* (Princeton, N.J.: Princeton University Press, 1977).

8. Ovid, *The Metamorphoses,* trans. Mary M. Innes (Harmondsworth: Penguin, 1955), p. 86.

9. See Frederick Goldin, *The Mirror of Narcissus in the Courtly Love Lyric* (Ithaca, N.Y.: Cornell University Press, 1967) for a discussion of the centrality of this myth in medieval romance.

10. Giamatti characterizes this oscillation between change and permanence as the conflict between romance's Ovidian and Virgilian traditions. "When in the chivalric romance the moment of vision or revelation occurs, we are summoned from shimmering vistas of magic to stable peaks of miracle. We are delivered, if only briefly, from the sway of Ovid to the certainties of Virgil. Ovid is the patron saint of Romance mutability, Virgil the father of its visionary core. The narrative modes of Romance are all implicit in Daphne's flight from Apollo, while Romance's visionary impulse, its radical hunger for certainty and divinity, is incarnate in Venus, revealed as a goddess to her errant, baffled son. Ovid stands behind the Angelicas and Florimells fleeing their tormentors; Virgil behind Hermione stepping down to Perdita" (Giamatti, p. 77). This oscillation is crucial to romance, and particularly so to Ovid's *Metamorphoses.* The narratives within it resolve a transformation into an eternal stasis. The tragedy of Narcissus is mitigated by his change into a flower, which eternally marks the transformation; so, also, with the laurel for Daphne and the stars for Castor and Pollux. These frozen forms become the unchanging images of change, of plot, and thus incorporate the central dialectic of all romance.

11. Longus's *Story of Daphnis and Chloe,* one of the earliest romances, begins with the narrator's discovery of "a story of love told by a painter's hand . . . which showed skill and taste in the unfolding of the love-story" (Longus, p. 3).

This painting hangs on a tree in the midst of a grove, but beautiful as nature's setting is, the narrator is more charmed by the painting, and while gazing on it suddenly is "seized by a longing to write an idyll to describe it. So I have found a man to explain it for me and I have written a story in four books" (p. 4). From nature to painting to explication to literary narrative, the purported genesis of this tale is paradigmatic for romance.

12. Hayden White, *Metahistory: The Historical Imagination in Nineteenth-Century Europe* (Baltimore and London: John Hopkins University Press, 1973), pp. 8–9. White goes on here to contrast romance with satire, "a drama dominated by the apprehension that man is ultimately a captive of the world rather than its master, and by the recognition that, in the final analysis, human consciousness and will are always inadequate to the task of overcoming definitively the dark force of death, which is man's unremitting enemy" (p. 9). I would object that many romances are precisely what White terms satire, and I would point to *Sir Gawain and the Green Knight,* and in fact the entire Arthurian cycle, as support for my claim. The polarization of values that is so marked in romance interconnects the modal extremes that White would segregate into separate genres.

13. *The Dialogic Imagination of M. M. Bakhtin,* trans. Caryl Emerson and Michael Holquist (Austin: University of Texas Press, 1981), p. 105.

14. Eugène Vinaver, *The Rise of Romance* (Oxford: Clarendon, 1971), p. 92.

15. "The quest has been absorbed [in Augustine, Rousseau, Proust] into the movement by which the hero . . . becomes *who he is.* Memory, therefore, is no longer the narrative of external adventures stretching along episodic time. It is itself the spiral movement that, through anecdotes and episodes, brings us back to the almost motionless constellation of potentialities that the narrative retrieves. The end of the story is what equates the present with the past, the actual with the potential. The hero *is* who he *was.* This highest form of narrative repetition is the equivalent of what Heidegger calls fate (individual fate) or destiny (common destiny), that is, the complete retrieval in resoluteness of the inherited potentialities that *Dasein* is thrown into by birth" (Ricoeur, p. 186).

16. David Mickelson, "Types of Spatial Structure in Narrative," in *Spatial Form in Narrative,* ed. Smitten and Daghistany, p. 65. For a criticism of the concept of spatial form, see my *Colors of Rhetoric,* pp. 37–38.

17. Tsvetan Todorov, *The Poetics of Prose,* trans. Richard Howard (Ithaca, N.Y.: Cornell University Press, 1977), p. 123.

18. Robert Scholes, "Afterthoughts on Narrative II: Language, Narrative, and Anti-Narrative," *Critical Inquiry* 7, 1 (Autumn 1980): 210–11.

19. Frank Kermode speaks of narrative in general as a dialogue between story and interpretation (Kermode, p. 86).

## Chapter Three

1. M. H. Abrams, *The Mirror and the Lamp* (New York: Oxford University Press, 1953).

2. Roy Park, "'Ut Pictura Poesis': The Nineteenth-Century Aftermath," *Journal of Aesthetics and Art Criticism* 28, 2 (Winter 1969): 159.

3. Tilottama Rajan, *Dark Interpreter: The Discourse of Romanticism* (Ithaca, N.Y.: Cornell University Press, 1980), p. 99. Of the dangers of romance, Patricia Parker writes, "'Romance' was an ambivalent mode, then, because its charms were indistinguishable from its snares. Hazlitt's famous description of the Spenserian stanza—'dissolving the soul in pleasure, or holding it captive in the chains of suspense' and 'lulling the senses into a deep oblivion of the jarring noises of the world, from which we have no wish to be ever recalled'—had its counterpart in the attractions and dangers of romance itself, a dream from which there was potentially no awakening and a 'suspension' from which there might be no exit" (Parker, p. 163).

4. All quotations from Keats are taken from *The Poetical Works of Keats*, ed. Paul D. Sheats (Boston: Houghton Mifflin, 1975).

5. Ian Jack in *Keats and the Mirror of Art* (Oxford: Clarendon, 1967) tries to show that in Keats's circle this analogy was anything but passé, quoting Leigh Hunt and Hazlitt to this effect and pointing to the arrival of the Elgin Marbles in London just then, the impressive flowering of British painting, and the founding of the *Annals of the Fine Arts*, a journal for both visual and literary artists.

6. Like Rajan, I "assume that Keats's major lyrics rehearse on a smaller scale the positions assumed in his narrative poetry" (Rajan, p. 98n).

7. Letter 43 to Benjamin Bailey, 22 November 1817: "The Imagination may be compared to Adam's dream—he awoke and found it truth" (Keats, *Letters*, vol. 1, p. 185).

8. Letter 159 to George and Georgiana Keats, 14 February–3 May 1819 (Keats, *Letters*, vol. 2, p. 106).

9. Erich Neumann, *Amor and Psyche: The Psychic Development of the Feminine* (Princeton, N.J.: Princeton University Press, 1971), pp. 143–44.

10. Harold Bloom, *The Visionary Company*, rev. ed. (Ithaca, N.Y.: Cornell University Press, 1971), p. xviii.

11. *The Golden Legend of Jacobus de Voragine*, trans. Granger Ryan and Helmut Ripperger (New York: Arno, 1969), pp. 110–11. I have been unable to discover whether Keats used this source, but it was in wide circulation in translation at the time. My thanks to Professor Jack Stillinger for advice on this point.

12. The scene contrasts as well with one in the first book of the *Aeneid* (trans. C. Day Lewis [New York: Doubleday, 1952]), where Venus reveals herself to Aeneas:

> She turned away; and as she turned, her neck
> Glowed to a rose-flush, her crown of ambrosial hair breathed out
> A heavenly fragrance, her robe flowed down, down to her feet,
> And in gait she was all a goddess.
>
> (ll. 402–5)

Madeline is both not revealed and not a goddess.

13. See Robert Gittings, *John Keats, The Living Year* (Cambridge, Mass.: Harvard University Press, 1954), pp. 73–74, for a discussion of Keats and Apuleius's Neoplatonism. Manley Thompson in "Categories," *Encyclopedia of Philosophy,* vol. 2 (New York: Macmillan, 1967), says of Porphyrius: "In Porphyry's short commentary on Aristotle's *Categories,* generally known as the *Isagoge* ('Introduction'), he accepted Aristotle's list of ten but raised Plotinian questions about the way they exist. He noted that categories are genera and asked whether genera and species subsist (exist outside the understanding) or are in the naked understanding alone; whether, if they subsist, they are corporeal or incorporeal; and finally, whether they are separated from sensibles or reside in sensibles. He remarked that these questions are too deep for an introductory treatise." Boethius translated the *Isagoge* and answered "Porphyry's unanswered questions, and thus began a tradition, which persisted throughout the medieval period, of accepting Porphyry's questions as presenting the fundamental issues for any account of categories. . . . The medieval 'problem of universals' thus arose from Porphyry's questions about Aristotle's categories" (pp. 52–53).

14. See Alexander J. Denomy, *The Heresy of Courtly Love* (Gloucester, Mass.: Peter Smith, 1965).

15. Apuleius, *The Golden Ass or Metamorphoses,* trans. Robert Graves (Harmondsworth: Penguin, 1950), p. 133.

16. We should note that Arthur's quest in *The Faerie Queene* is motivated by his dream of a beautiful woman, whose original he then sets out to find. The dream vision is another static image in romance that plot attempts to bring to life.

17. My reading thus would reinforce Clifton Adelman's interpretation of the poem and dispute Jack Stillinger's contention that Madeline's sorrow upon waking from her dream reflects distress at being tricked by Porphyro into giving up her virtue (Clifton Adelman, "The Dangers of Enthrallment," and Jack Stillinger, "The Hoodwinking of Madeline"; both in *Twentieth Century Interpretations of "The Eve of St. Agnes,"* ed. Allan Danzig [Englewood Cliffs, N.J.: Prentice-Hall, 1971]). It also challenges Rajan's belief that "the poem vacillates uneasily between Madeline's desire to preserve the unravished purity of illusion, and Porphyro's desire to awaken into reality, his fear of lapsing into the undifferentiated unity of sleep" (Rajan, p. 113). Madeline instead invites Porphyro to violate that purity when she sees him dangerously close to paralysis and sleep. The elaborate symbolism of the visual arts in *The Eve of St. Agnes* conditions the meaning of Madeline's dismay at seeing Porphyro a statue. She cannot bear to see her passionate vision reduced to a static, cold form.

18. Leo Steinberg, "Picasso's Sleepwatchers," in *Other Criteria* (London: Oxford University Press, 1972), pp. 98–99, 101. This is a wonderfully evocative essay to which I am much indebted.

19. Helen Vendler, *The Odes of John Keats* (Cambridge, Mass.: Harvard University Press, 1983), p. 6.

20. Claude Lee Finney, *The Evolution of Keats's Poetry* (New York: Russell and Russell, 1963), p. 614.

21. Vendler speaks of "the timeless mythological bower of *Psyche*" (Vendler, p. 91), and Parker notes that by Keats's time the romance had become "increasingly synonymous with one of its own archetypes—the protective but potentially indolent bower" (Parker, p. 8).

22. Letter 159 to George and Georgiana Keats, 14 February–3 May, 1819 (Keats, *Letters,* vol. 2, p. 67).

23. Helen Vendler also links these two poems: "the two central odes, *Nightingale* and *Urn* . . . I see as meditations, respectively, on the nonrepresentational art of music and the representational art of sculpture." She continues, "I believe the odes contain Keats's controlled experiments with sensation: he suppressed all senses in *Psyche,* he reserved one sense each (suppressing all others) for *Nightingale* and *Urn,* he allowed the 'lower senses' to enter in *Melancholy,* and he reintegrated the complex of sensation in *Autumn*" (Vendler, p. 13).

24. Vendler writes that in the *Ode on Melancholy* Keats uses "all his 'languages' at once—the language of Greek mythology, the language of allegorical frieze, the language of descriptive sensation, the language of heroic quest, the language of gothic medievalizing, the language of the courtly-love (or 'Provencal') tradition, the temporal language of fugitive experience, and the propositional language of eternal verities" (Vendler, p. 152). This semantic repleteness is certainly apparent in *Melancholy,* but its model in this respect is the romance cornucopia of *The Eve of St. Agnes.* Likewise, when Vendler finds in *Melancholy* "the new notion of incalculable significance for Keats, that a poem could press toward Sensation and Truth" (ibid.), I would point to *The Eve of St. Agnes,* which combines the two as well.

25. Letter 193 to Sir Joshua Reynolds, 21 September 1819 (Keats, *Letters,* vol. 2, p. 167). Jerome McGann, in "Keats and the Historical Method in Literary Criticism," *Modern Language Notes* 94 (1979): 1018, writes that the personified figures in *To Autumn* "enter the poem via Keats's experience of them in the aesthetically mediated forms of various eighteenth-century paintings and engravings, and the landscapes of Poussin and Claude."

## Chapter Four

1. See, for example, Stanley Fish, *Is There a Text in This Class?: The Authority of Interpretive Communities* (Cambridge, Mass.: Harvard University Press, 1980), chapter 1.

2. Nathaniel Hawthorne, *The Marble Faun; or, the Romance of Monte Beni* (New York: Pocket Library, 1958), p. 360. Quotations from Hawthorne's other works are taken from *The Complete Novels and Selected Tales of Nathaniel Hawthorne,* ed. Norman Holmes Pearson (New York: Modern Library, 1937).

3. See Edgar A. Dryden's interesting discussion of voyeurism in *The Blythedale Romance,* in *Nathaniel Hawthorne: The Poetics of Enchantment* (Ithaca, N.Y.: Cornell University Press, 1977), pp. 73–74.

4. For the nineteenth century, "effect"—"the impression produced upon the

mind by the sight of a picture" (Meisel, p. 72)—was thought to be created by the exhibition of "consequences without their causes" (p. 71).

5. Evan Carton writes that *The Marble Faun* "at once explores varieties of fragmentation or alienation and varieties of parasitism or copying. These two motifs are peculiarly conjoined, since they constitute opposing challenges—to relation and to originality, respectively—and thus define a text that achieves neither formal integration nor imaginative integrity" (Evan Carton, *The Rhetoric of American Romance: Dialectic and Identity in Emerson, Dickinson, Poe, and Hawthorne* (Baltimore: Johns Hopkins University Press, 1985), p. 169. Carton takes the book's preoccupation with fragmentation and copying as an indication of its failure to achieve wholeness. "To the extent that the text may be seen as the culminating instance of a long formal and imaginative breakdown, . . . Hawthorne's novelistic career after *The Scarlet Letter* may be plotted as a steady decline" (ibid.). I would argue instead that fragmentation and copying are part of an essential dialectic in Hawthorne between formalist and contextualist interpretation, and that he makes rather brilliant use of these devices in his late work.

6. "For Hawthorne, man's relations to other people are modified to some extent by the context in which they occur, a context which consists of the natural, the historical, and the social. Human relationships, in other words, always take place in a world with a horizon that is the sign of a complicated structure" (Dryden, p. 39).

7. See W. J. T. Mitchell, *Iconology: Image, Text, Ideology* (Chicago: University of Chicago Press, 1986).

8. Compare Thomas Pynchon's "direct, epileptic Word, the cry that would abolish the night," *The Crying of Lot 49* (New York: Bantam, 1967), p. 87.

9. We might note the similarity of this view to those of critics contemporary with rococo, the movement against which the call for absorption and "perspicuous unity" was directed. "Père Bouhous, while generally demanding clarity and artistic presentation, adds this rider: 'great art consists . . . in leaving others to perceive more than one says'; and Père André claims that 'There is a kind of beauty in expression which comes from saying only as much as will allow *personnes d'esprit* the pleasure of supplying the rest'" (Bryson, p. 103). The contrast between a rococo-like "incompletion" and neoclassical overdetermination is an essential dialectic in *The Marble Faun,* marking the extremes that Hilda entertains.

## Chapter Five

1. Richard Ellmann, *The Consciousness of Joyce* (Toronto and New York: Oxford University Press, 1977), pp. 97–134.

2. Frank Budgen, *James Joyce and the Making of Ulysses* (New York: Harrison Smith and Robert Haas, 1934).

3. Richard Ellmann, *James Joyce* (New York: Oxford University Press, 1959), p. 489. See Lazlo Moholy-Nagy, *Vision in Motion* (Chicago: Theobald, 1947) for a detailed treatment of Joyce and the visual arts, particularly cubism.

4. James Joyce, *Ulysses* (New York: Vintage, 1966), p. 366.

5. The connection between popular romance forms (as well as high romance) and the visual arts is very direct, and was frequently a cause of critical disapproval. Percy Fitzgerald condemned romantic melodrama, for example, because "we go not so much to hear as to look. It is like a giant peep-show, and we pay the showman, and put our eyes to the glass and stare" (quoted in Meisel, p. 49). Gertrude Stein claimed that she learned to appreciate the theater by going to French melodramas as a teenager in San Francisco. She could not understand the words, but that did not matter because, she claimed, the drama is actually a visual art ("Plays," *Lectures in America* [Boston: Beacon Press, 1985 (1935)], pp. 115–16).

6. For a detailed presentation of this notion, see chapter 4 of my *Exact Resemblance to Exact Resemblance: The Literary Portraiture of Gertrude Stein* (New Haven, Conn.: Yale University Press, 1978), and chapter 3 of my *Colors of Rhetoric*.

7. Steinberg describes this work, *Meditation* (also called *Contemplation*), as follows: we see "the artist at 23. He is doing none of the things self-portrayed artists usually do. He is not searching his mirror reflection, nor staring defiance, nor eyeing a model. He appears neither at work nor at ease, but deeply engaged in inaction: watching a girl sleep" (Steinberg, p. 93).

8. Hans Bollinger, Introduction, *Picasso's Vollard Suite* (New York: Harry N. Abrams, 1977), p. xi.

9. Northrop Frye, *Anatomy of Criticism* (New York: Atheneum, 1967).

## Chapter Six

1. See my *Exact Resemblance to Exact Resemblance,* chapter 4, for a discussion of Cézanne's fragmentation and its relation to Stein and cubism.

2. John Russell, *Seurat* (New York: Oxford University Press, 1965), p. 65.

3. "The difference between 'abstract' and 'concrete' contents . . . is plainly the same as Stumpf's distinction between *dependent* (non-independent) and *independent* contents," Husserl writes in *Logical Investigations,* vol. 2, trans. J. N. Findlay (London: Routledge and Kegan Paul, 1970), p. 435. Truly nonindependent contents, of course, cannot be represented as such in paintings, because they cannot be imagined or perceived separately (e.g., quality and extension or movement and the moving body). But Husserl understands independence and nonindependence as poles on a continuum. What I have been calling parts are "relatively independent[;] they have the character of mutually-put-together pieces" (p. 437). Portions, on the contrary, are less independent. "The intuitively unseparated content forms a whole with other coexistent contents, but is not cut off . . . in the whole; it is not merely bound up with its associates, but blends with them. . . . The parts of an intuitive surface of a uniform or continuously shaded white are independent, but not separated" (p. 449). Though portions are thus not identical to truly nonindependent wholes, I do think that modern art has engaged in its experiments in large part to try to represent the

visually unrepresentable and the linguistically unnamed. It is trying to depict a world in which categories as we know them would become problematic, in which one might even someday be able to tell the dancer from the dance.

4. Lawrence Alloway, *American Pop Art* (New York: Collier Macmillan, 1974), p. 7.

5. Robert Rosenblum, "Pop Art and Non-Pop Art," in *Pop Art Redefined,* ed. John Russell and Suzi Gablik (London: Thames and Hudson, 1969), p. 93.

6. G. R. Swenson, "roy lichtenstein: an interview," in *Roy Lichtenstein,* by John Coplans (San Diego: Pasadena Art Museum, 1967), p. 15.

7. Walter Benjamin, "The Work of Art in the Age of Mechanical Reproduction," in *Illuminations,* trans. Harry Zohn (New York: Schocken Books, 1969), p. 238.

8. Diane Waldman, *Roy Lichtenstein: Drawings and Prints* (New York: Chelsea House, n.d.), p. 20.

9. Jack Cowart, *Roy Lichtenstein 1970–1980* (New York: Hudson Hills Press, 1981), p. 62.

10. Maurice Horn, *75 Years of the Comics* (Boston: Boston Book and Art, 1971), p. 12.

11. Richard Morphet, "Roy Lichtenstein," in *Roy Lichtenstein* (New York: Arno Press, 1968), p. 35.

12. Diane Waldman (pp. 20–21) describes another aspect of this disorientation: "Rather than using the title as appendage or accessory to the visual, as a label clue or as a play on illusion, Lichtenstein forces a direct confrontation between the verbal and the visual. Both the verbal and visual statements are forced into visual co-existence, so that the image forms a totally integrated unit. But the spectator response to the set of visual phenomena is quite separate from the reaction to the verbal phenomena. We are encouraged to read, hum, sing, and in fact talk back to the drawings."

13. Lucy Lippard, "New York Pop," in *Pop Art,* ed. Lucy Lippard (New York: Praeger, 1966), p. 70.

14. Lawrence Alloway, "The Development of British Pop," in *Pop Art,* ed. Lippard, p. 27.

15. Jurij Lotman, *The Structure of the Artistic Text,* trans. Ronald Vroon (Ann Arbor: Michigan Slavic Materials, 1977), chapter 1.

16. "Super Realism's immediate predecessor was the Pop Art of the early and middle sixties, an attempt, half celebratory and half-ironic, to create high art out of the values, attitudes and characteristic artefacts of mass culture and the consumer society. There is in fact no clear break between Pop Art and Super Realism," Edward Lucie-Smith, *Super Realism* (Oxford: Phaidon, 1979), p. 8. "It is this aspect of photographic realism, its conversion of channel to subject matter, that led to its being called Post Pop art. Note that Roy Lichtenstein's comic strip imagery simulates another channel of information as well as an appropriated image," Lawrence Alloway, introduction to *Photo-Realism: Paintings, Sculpture, and Prints from the Ludwig Collection,* 4 April–6 May 1973, Serpentine Gallery, London, fn. 6.

17. Richard Hamilton, "Roy Lichtenstein," in *Pop Art Redefined*, ed. Russell and Gablik, p. 91.

18. Robin Campbell and Norbert Lynton, preface to *Photo-Realism*, by Alloway.

19. The super realists "produce still-lifes, landscapes and portraits, and occasionally what can perhaps be described as genre scenes. The only category to be almost absent is the history-picture, whose large aspirations are diametrically opposed to everything the new figurative painting stands for. Its place is taken, appropriately enough, by the kind of sarcastic parody of the Old Masters produced by John Clem Clarke" (Lucie-Smith, pp. 42, 46).

20. Adrienne Rich, *On Lies, Secrets and Silence* (New York: Norton, 1979), p. 12n.

21. The heroine-victim in Brian De Palma's *Dressed to Kill* sits before a pop art work making up a shopping list. Ignoring pop's message—the relation it implies between clichéd romance surface and the violence of vision—she is victimized by this ideology. See my "Brian De Palma's Romances," *Michigan Quarterly Review* (Summer 1982): 385–99.

22. Roman Jakobson, "Concluding Statement: Linguistics and Poetics," in *Style in Language*, ed. Thomas A. Sebeok (Cambridge, Mass.: M.I.T. Press, 1960), pp. 350–77.

23. G. R. Swenson, quoted in *Pop Art*, ed. Lippard, p. 10.

24. James R. Mellow, *Charmed Circle* (New York: Praeger, 1974), p. 404.

25. Gertrude Stein, "Poetry and Grammar," in *Lectures in America*, p. 231.

26. See Ernest Jones, *The Life and Work of Sigmund Freud*, vol. 3 (New York: Basic Books, 1957), pp. 269–73.

27. John Dos Passos's *Manhattan Transfer*, Ortega y Gasset's "The Dehumanization of Art," and Charlie Chaplin's *Modern Times* are among the countless examples of this idea in modernist writing and film.

28. Gertrude Stein, "Portraits and Repetition," in *Lectures in America*, p. 182.

29. Andy Warhol interview with G. R. Swenson, in *Pop Art Redefined*, ed. Russell and Gablik, p. 116.

30. Christopher Finch, *Pop Art: Object and Image* (New York: Dutton, 1968), p. 150.

31. Andy Warhol, *The Philosophy of Andy Warhol (From A to B and Back Again)* (New York: Harcourt Brace, 1975), p. 231. The cult film *Liquid Sky* (1983, dir. Slava Tsukerman), takes off from this idea with the superstar Manhattan skyline forming the featured constancy behind a romance parody of beat, hippie, pop, bourgeois, and punk. This movie demonstrates the connections among vision, voyeurism, love, romance, and the visual arts in a programmatic fashion.

32. See Carter Ratcliff, *Andy Warhol* (New York: Abbeville Press, 1983), p. 94.

33. Lawrence Wechsler, "True to Life," in *Cameraworks*, by David Hockney and Lawrence Wechsler (New York: Alfred A. Knopf, 1984), p. 39. A tremen-

dous amount of photography and painting currently is experimenting with split images, e.g., Gilbert and George's massive assemblies of separately framed images or pieces of images, or Nancy Hellebrand's composite portraits. Hockney seems to be the most directly interested in narrative.

## Conclusion

1. Calvin Tomkins, *Off the Wall* (New York: Doubleday, 1980), p. 276.

2. Italo Calvino, *Mr. Palomar,* trans. William Weaver (New York: Harcourt Brace Jovanovich, 1985), p. 9.

# Bibliography

Abrams, M. H. *The Mirror and the Lamp*. New York: Oxford University Press, 1953.

Adelman, Clifton. "The Dangers of Enthrallment." In *Twentieth Century Interpretations of "The Eve of St. Agnes"*, edited by Allan Danzig. Englewood Cliffs, N.J.: Prentice-Hall, 1971.

Alberti, Leon Battista. *On Painting*. Translated by John R. Spencer. New Haven, Conn.: Yale University Press, 1956.

Alloway, Lawrence. *American Pop Art*. New York: Collier Macmillan, 1974.

———. "The Development of British Pop." In *Pop Art*, edited by Lucy Lippard, pp. 27–68. New York: Praeger, 1966.

———. *Photo-Realism: Paintings, Sculpture, and Prints from the Ludwig Collection*. Serpentine Gallery, London, 4 April–6 May 1973.

Apuleius. *The Golden Ass or Metamorphoses*. Translated by Robert Graves. Harmondsworth: Penguin, 1950.

Bakhtin, M. M. *The Dialogic Imagination of M. M. Bakhtin*. Translated by Caryl Emerson and Michael Holquist. Austin: University of Texas Press, 1981.

Barthes, Roland. *S/Z*. Translated by Richard Miller. New York: Farrar, Straus and Giroux, 1974.

Benjamin, Walter. "The Work of Art in the Age of Mechanical Reproduction." *Illuminations*, translated by Harry Zohn. New York: Schocken Books, 1969.

Berenson, Bernard. *The Italian Painters of the Renaissance*. Ithaca, N.Y.: Phaidon, 1952.

Bloom, Harold. *The Visionary Company*. Rev. ed. Ithaca, N.Y.: Cornell University Press, 1971.

Bollinger, Hans. Introduction to *Picasso's Vollard Suite*. New York: Harry N. Abrams, 1977.

Brilliant, Richard. *Visual Narratives: Storytelling in Etruscan and Roman Art.* Ithaca, N.Y.: Cornell University Press, 1984.

Bryson, Norman. *Word and Image: French Painting of the Ancien Régime.* Cambridge: Cambridge University Press, 1981.

Budgen, Frank. *James Joyce and the Making of Ulysses.* New York: Harrison Smith and Robert Haas, 1934.

Calvino, Italo. *Mr. Palomar.* Translated by William Weaver. New York: Harcourt Brace Jovanovich, 1985.

Campbell, Robin, and Norbert Lynton. Preface to *Photo-Realism.* See Alloway 1973.

Canaday, John. *Mainstreams of Modern Art.* New York: Holt, Rinehart and Winston, 1956.

Carton, Evan. *The Rhetoric of American Romance: Dialectic and Identity in Emerson, Dickinson, Poe, and Hawthorne.* Baltimore: Johns Hopkins University Press, 1985.

Cennini, Cennino d'Andrea. *The Craftsman's Handbook.* Translated by Daniel V. Thompson, Jr. New York: Dover, 1933.

Chatman, Seymour. *Story and Discourse.* Ithaca, N.Y.: Cornell University Press. 1980.

———. "What Novels Can Do That Films Can't (and Vice Versa)." *Critical Inquiry* 7, 1 (Autumn 1980): 121–40.

Coplans, John, ed. *Roy Lichtenstein.* New York: Praeger, 1972.

Cowart, Jack. *Roy Lichtenstein 1970–1980.* New York: Hudson Hills Press, 1981.

Da Vinci, Leonardo. *On Painting.* Translated by Carlos Pedretti. Berkeley: University of California Press, 1964.

———. *Treatise on Painting.* Vol. 1. Translated and annotated by A. Philip McMahon. Princeton, N.J.: Princeton University Press, 1956.

Denomy, Alexander J. *The Heresy of Courtly Love.* Gloucester, Mass.: Peter Smith, 1965.

Dryden, Edgar A. *Nathaniel Hawthorne: The Poetics of Enchantment.* Ithaca, N.Y.: Cornell University Press, 1977.

Ellmann, Richard. *The Consciousness of Joyce.* Toronto and New York: Oxford University Press, 1977.

———. *James Joyce.* New York: Oxford University Press, 1959.

Finch, Christopher. *Pop Art: Object and Image.* New York: Dutton, 1968.

Finney, Claude Lee. *The Evolution of Keats's Poetry.* New York: Russell and Russell, 1963.

Fish, Stanley. *Is There a Text in This Class?: The Authority of Interpretive Communities.* Cambridge, Mass.: Harvard University Press, 1980.

Fisher, John. "Entitling." *Critical Inquiry* 11 (December 1984): 286–98.

Frank, Joseph. "Spatial Form in Modern Literature." *The Widening Gyre.* New Brunswick, N.J.: Rutgers University Press, 1963.

Fried, Michael. *Absorption and Theatricality: Painting and Beholder in the Age of Diderot.* Berkeley: University of California Press, 1980.

Frye, Northrop. *Anatomy of Criticism*. New York: Atheneum, 1967.
———. *The Secular Scripture: A Study of the Structure of Romance*. Cambridge, Mass.: Harvard University Press, 1976.
Gaballa, G. A. *Narrative in Egyptian Art*. Mainz-am-Rhein: Verlag Philipp Von Zabern, 1976.
Giamatti, A. Bartlett. *Exile and Change in Renaissance Literature*. New Haven, Conn.: Yale University Press, 1984.
Gittings, Robert. *John Keats: The Living Year*. Cambridge, Mass.: Harvard University Press, 1954.
Goldin, Frederick. *The Mirror of Narcissus in the Courtly Love Lyric*. Ithaca, N.Y.: Cornell University Press, 1967.
Gombrich, E. H. *Art and Illusion*. Princeton, N.J.: Princeton University Press, 1960.
Goodman, Nelson, "Twisted Tales; Or Story, Study, and Symphony." *Critical Inquiry* 7, 1 (Autumn 1980): 103–19.
Greenstein, Jack Matthew. "*Historia* in Leon Battista Alberti's *On Painting* and in Andrea Mantegna's *Circumcision of Christ*." Ph.D. diss., University of Pennsylvania, 1984.
Hamilton, Richard. "Roy Lichtenstein." In *Pop Art Redefined*, pp. 88–91. See Russell and Gablik.
Hanfmann, George M. A. "Narrative in Greek Art." In *Narrative in Ancient Art*. See Kraeling.
Hawthorne, Nathaniel. *The Complete Novels and Selected Tales of Nathaniel Hawthorne*. Edited by Norman Holmes Pearson. New York: Modern Library, 1937.
———. *The Marble Faun; or, The Romance of Monte Beni*. New York: Pocket Library, 1958.
Horn, Maurice. *75 Years of the Comics*. Boston: Boston Book and Art, 1971.
Husserl, Edmund. *Logical Investigations*. Vol. 2. Translated by J. N. Findlay. London: Routledge and Kegan Paul, 1970.
Jack, Ian. *Keats and the Mirror of Art*. Oxford: Clarendon, 1967.
Jacobus de Voragine. *The Golden Legend of Jacobus de Voragine*. Translated by Granger Ryan and Helmut Ripperger. New York: Arno, 1969.
Jakobson, Roman. "Concluding Statement: Linguistics and Poetics." In *Style in Language,* edited by Thomas A. Sebeok, pp. 350–77. Cambridge, Mass.: M.I.T. Press, 1960.
Jones, Ernest. *The Life and Work of Sigmund Freud*. Vol. 3. New York: Basic Books, 1957.
Joyce, James. *Ulysses*. New York: Vintage, 1966.
Kantor, Helen J. "Narrative in Egyptian Art." In *Narrative in Ancient Art*. See Kraeling.
Keats, John. *Letters of John Keats*. Edited by Hyder Edward Rollins. Vols. 1 and 2. Cambridge, Mass.: Harvard University Press, 1958.
———. *The Poetical Works of Keats*. Edited by Paul D. Sheats. Boston: Houghton Mifflin, 1975.

Kermode, Frank. "Secrets and Narrative Sequence." *Critical Inquiry* 7, 1 (Autumn 1980): 83–101.

Kestner, Joseph. "Secondary Illusion: The Novel and the Spatial Arts." In *Spatial Form and Narrative*. See Smitten and Daghistany.

Kraeling, Carl H., ed. *Narration in Ancient Art: A Symposium*. Chicago: Oriental Institute, 1955.

Labov, William. *Language in the Inner City*. Philadelphia: University of Pennsylvania Press, 1972.

Lessing, Gotthold Effraim. *Selected Prose Works of G. E. Lessing*. Edited by Edward Bell. London: G. Bell, 1879.

Lippard, Lucy. "New York Pop." In *Pop Art*, edited by Lucy Lippard, pp. 69–138. New York: Praeger, 1966.

Longus. *Story of Daphnis and Chloe*. Edited by W. D. Lowe. Cambridge: Deighton Bell, 1908.

Lotman, Jurij. *The Structure of the Artistic Text*. Translated by Ronald Vroon. Ann Arbor: Michigan Slavic Materials, 1977.

Lucie-Smith, Edward. *Super Realism*. Oxford: Phaidon, 1979.

Marin, Louis. *Etudes Sémiologiques: Ecritures, Peintures*. Paris: Klinsieck, 1971.

McGann, Jerome. "Keats and the Historical Method in Literary Criticism." *Modern Language Notes* 94 (1979): 988–1032.

Meisel, Martin. *Realizations: Narrative, Pictorial, and Theatrical Arts in Nineteenth-Century England*. Princeton, N.J.: Princeton University Press, 1983.

Mellow, James R. *Charmed Circle*. New York: Praeger, 1974.

Mickelsen, David. "Types of Spatial Structure in Narrative." In *Spatial Form in Narrative*. See Smitten and Daghistany.

Mitchell, W. J. T. *Iconology: Image, Text, Ideology*. Chicago: University of Chicago Press, 1986.

Moholy-Nagy, Lazlo. *Vision in Motion*. Chicago: Theobald, 1947.

Morphet, Richard. *Roy Lichtenstein*. New York: Arno Press, 1968.

Moure, Nancy Wall. *American Narrative Painting*. New York: Praeger, 1974.

Nemerov, Howard. *Collected Poems*. Chicago: University of Chicago Press, 1977.

Neumann, Erich. *Amor and Psyche: The Psychic Development of the Feminine*. Princeton, N.J.: Princeton University Press, 1971.

Ovid. *The Metamorphoses*. Translated by Mary M. Innes. Harmondsworth: Penguin, 1955.

Park, Roy. "'Ut Pictura Poesis': The Nineteenth-Century Aftermath." *Journal of Aesthetics and Art Criticism* 28, 2 (Winter 1969): 155–65.

Parker, Patricia A. *Inescapable Romance: Studies in the Poetics of a Mode*. Princeton, N.J.: Princeton University Press, 1979.

Perkins, Ann. "Narrative in Babylonian Art." In *Narrative in Ancient Art*. See Kraeling.

Pittaluga, Mary. *Filippo Lippi*. Florence: Del Turco Editore, 1949.

Prince, Gerald. "Aspects of a Grammar of Narrative." *Poetics Today* 1, 3 (1980): 49–63.

———. "Narrativity." In *Axia: Davis Symposium on Literary Evaluation,* edited by Karl Menges and Daniel Rancour-Laferrière, pp. 61–76. Stuttgart: Akademischer Verlag Hans-Dieter Heinz, 1981.

Pynchon, Thomas. *The Crying of Lot 49.* New York: Bantam, 1967.

Rajan, Tilottama. *Dark Interpreter: The Discourse of Romanticism.* Ithaca, N.Y.: Cornell University Press, 1980.

Ratcliff, Carter. *Andy Warhol.* New York: Abbeville Press, 1983.

Rich, Adrienne. *On Lies, Secrets, and Silence.* New York: Norton, 1979.

Ricoeur, Paul. "Narrative Time." *Critical Inquiry* 7, 1 (Autumn 1980): 169–90.

Rosenblum, Robert. "Pop Art and Non-Pop Art." In *Pop Art Redefined,* pp. 53–56. See Russell and Gablik.

Roskill, Mark W. *Dolce's "Aretino" and Venetian Art Theory of the Cinquecento.* New York: New York University Press, 1968.

Russell, John. *Seurat.* New York: Oxford University Press, 1965.

Russell, John, and Suzi Gablik, eds. *Pop Art Redefined.* London: Thames and Hudson, 1969.

Scholes, Robert. "Afterthoughts on Narrative II: Language, Narrative, and Anti-Narrative." *Critical Inquiry* 7, 1 (Autumn 1980): 204–12.

Seymour, Charles, Jr. *Art Treasures for America.* London: Phaidon, 1961.

Shapley, Fern Rusk. "A Predella Panel by Benozzo Gozzoli." *Gazette des Beaux Arts* (February, 1952): 77–88.

Sitwell, Sacheverell. *Narrative Pictures: A Survey of English Genre and its Painters.* New York: Schocken Books, 1969.

Šklovskij, Viktor. "Sterne's *Tristram Shandy:* Stylistic Commentary." In *Russian Formalist Criticism: Four Essays,* translated and edited by Lee T. Lemon and Marion J. Reis, pp. 25–57. Lincoln: University of Nebraska Press, 1965.

Smith, Barbara Herrnstein. "Narrative Versions, Narrative Theories." *Critical Inquiry* 7, 1 (Autumn 1980): 213–36.

Smitten, Jeffrey R., and Ann Daghistany, eds. *Spatial Form in Narrative.* Ithaca, N.Y.: Cornell University Press, 1981.

Stein, Gertrude. *Lectures in America.* New York: Random House, 1935. Reprinted Boston: Beacon Press, 1985.

Stein, Richard L. *The Ritual of Interpretation: The Fine Arts as Literature in Ruskin, Rossetti, and Pater.* Cambridge, Mass.: Harvard University Press, 1975.

Steinberg, Leo. "Picasso's Sleepwatchers." *Other Criteria.* London: Oxford University Press, 1972.

Steiner, Peter. *Russian Formalism: A Metapoetics.* Ithaca, N.Y.: Cornell University Press, 1984.

Steiner, Wendy. "Brian De Palma's Romances." *Michigan Quarterly Review* (Summer 1982): 385–99.

———. *The Colors of Rhetoric: Problems in the Relations between Modern Literature and Painting.* Chicago: University of Chicago Press, 1982.

———. *Exact Resemblance to Exact Resemblance: The Literary Portraiture of Gertrude Stein.* New Haven, Conn.: Yale University Press, 1978.

Stillinger, Jack. "The Hoodwinking of Madeline." In *Twentieth Century Inter-pretations of "The Eve of St. Agnes"*, edited by Allan Danzig. Englewood Cliffs, N.J.: Prentice-Hall, 1971.

Swenson, G. R. "Andy Warhol interview with G. R. Swenson." In *Pop Art Redefined*, pp. 116-19.

———. "roy lichtenstein: an interview." In *Roy Lichtenstein*, by John Coplans. San Diego: Pasadena Art Museum, 1967.

Thompson, Manley. "Categories." *Encyclopedia of Philosophy*. Vol. 2, pp. 46–55. New York: Macmillan, 1967.

Tindall, William York. *A Reader's Guide to James Joyce*. New York: Farrar, Straus, and Giroux, 1959.

Todorov, Tsvetan. *The Poetics of Prose*. Translated by Richard Howard. Ithaca, N.Y.: Cornell University Press, 1977.

Tomkins, Calvin. *Off the Wall*. New York: Doubleday, 1980.

Turner, Victor. "Social Dramas and Stories about Them." *Critical Inquiry* 7, 1 (Autumn 1980): 141–68.

Vendler, Helen. *The Odes of John Keats*. Cambridge, Mass.: Harvard University Press, 1983.

Vinaver, Eugène. *The Rise of Romance*. Oxford: Clarendon, 1971.

Virgil. *Aeneid*. Translated by C. Day Lewis. New York: Doubleday, 1952.

Waldman, Diane. *Roy Lichtenstein: Drawings and Prints*. New York: Chelsea House, n.d.

Warhol, Andy. *The Philosophy of Andy Warhol (From A to B and Back Again)*. New York: Harcourt Brace, 1975.

Wechsler, Lawrence. "True to Life." In *Cameraworks*, by David Hockney and Lawrence Wechsler. New York: Alfred A. Knopf, 1984.

Weitzmann, Kurt. "Narration in Early Christian Art." In *Narration in Ancient Art*. See Kraeling.

White, Hayden. *Metahistory: The Historical Imagination in Nineteenth-Century Europe*. Baltimore and London: Johns Hopkins University Press, 1973.

———. "The Value of Narrativity in the Representation of Reality." *Critical Inquiry* 7, 1 (Autumn 1980): 5–27.

Witemeyer, Hugh. *George Eliot and the Visual Arts*. New Haven, Conn.: Yale University Press, 1979.

Worth, Sol. "Pictures Can't Say Ain't." *Vs.* 12, 3 (1975): 85–108.

Zagona, Helen Grace. *The Legend of Salome and the Principle of Art for Art's Sake*. Geneva: Librairie E. Droz, 1960.

Ziolkowski, Theodore. *Disenchanted Images: A Literary Iconology*. Princeton, N.J.: Princeton University Press, 1977.

# Index